This Model World

This Model World

Travels to the Edge of Contemporary Art

Anthony Byrt

AUCKLAND
UNIVERSITY
PRESS

To James,

for showing me what living looks like.

Contents

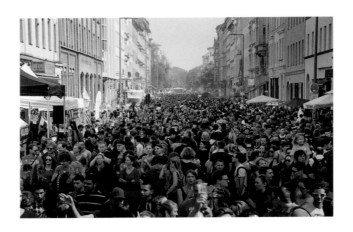

Carsten Koall
May Day in Berlin, Germany

Prologue **The First of May**

In Kreuzberg, the post-winter buds have popped and the new growth glows neon against a plane-streaked sky. To look up is glorious. Things at street level, though, aren't so pretty. The banks, pharmacies and supermarkets along Kottbusser Damm are boarded up. Several blocks have been kettled by cops in riot gear leaning against Polizei paddy wagons, tools for crowd dispersal at the ready. It is May Day, 2015.

Every year, Kreuzberg is the centre of Berlin's anti-capitalist protests. Sometimes things get ugly: car windows smashed, flags burned, bottles and paving stones thrown. But mostly, it's a kind of party. Entrepreneurial young locals – the children and grandchildren of Turkish migrants who moved to West Berlin for work in the 1960s – set up portable grills and mix make-do mojitos for the mainly white, mainly middle-class marchers. It is Occupy-chic; in one of the twentieth century's most avant-garde and politically traumatised cities, the physical and psychic dividing lines between left and right have gone, and the aesthetics of collective action have somehow managed to replace the disruptive power of protest.

I lived in Kreuzberg for about eighteen months. It's the neighbourhood where my son was born and the neighbourhood where most of my close friends in the city still are, including Anne, an art dealer. I've decided to stay with her for a few days before I go to the 56th Venice Biennale – the oldest and most important art event in the world – to see 'Secret Power', the much anticipated exhibition by New Zealander Simon Denny.

I'd arrived at Anne's apartment late the night before. She'd laughed at me when I'd told her my plans to meet someone at a local café the next day. I'd completely forgotten about the protests, because I'd been so focused on another event: Berlin's annual Gallery Weekend. This year, it is due to kick off simultaneously with the May Day protests: both an implicit 'fuck you' to the city's Marxist past and an attempt to capitalise on Venice, where me and thousands of other art worlders, from Auckland to Reykjavik, are headed next.

Late-afternoon on the first, Anne and I decide to take our chances and see if we can catch a train across town to Potsdamer Straße, where many of Berlin's best galleries have recently migrated. We step out of her building into the crush of half-drunk bodies and insouciant cops and push our way to Görlitzer Bahnhof. But the station is well and truly closed. Anne checks her phone, her signal glitching in and out as she tries to find a nearby vehicle on the app for the shared-car scheme she's a member of. As we get clear of the crowds and the police, her phone starts to work perfectly again. There's a car a couple of blocks away.

MY WIFE AND I MOVED to Berlin in 2010. We'd been in London for several years and decided to move to the German capital. At the time, the global financial crisis (GFC) was a stone around London's neck. We'd scraped through without losing our jobs or our flat, but we were tired and wanted to be somewhere else. Berlin seemed the best option. It was affordable, it was relaxed, and it was open.

It was also where, if I were going to write about art seriously, I would have the time, the space and the setting to do it. Over the past two decades, Berlin has become the centre of the European art world. Artists started moving there in search of cheap studio space after the Wall came down and their dealers soon followed. Now, as Gallery Weekend so starkly shows, heavy-hitting galleries are a major force in the city's gentrification.

I'd been an art critic on and off for years, but the move to Berlin was a crash course in how to be with contemporary art and the people who make it – whether in a studio, a museum or a bar at three in the morning. Berlin, ultimately, is a space of profound and concentrated artistic energy. Any artist, writer, designer or musician with EU citizenship can move there or come and go as they please. Those not blessed with a European passport can apply for artist visas. As a result, it's one of the most diverse art scenes in Europe: an environment where new encounters, ideas and intimacies constantly froth up and fade – a creative pulse that shapes contemporary art discourse as much as Paris did a hundred years earlier.

The difference now, of course, is that it isn't the *only* centre of art world influence. Since the turn of this century, contemporary art has become a major global game, and a site of eye-watering financial speculation. Later that May, for example – just days after the Venice Biennale opened – Christie's in New York traded more than a billion dollars' worth of art in just a few days, most of it modern and contemporary work.

With numbers like these, it's easy to see why the axis between art and money has become a subject of public fascination. But the figures, to me, are less interesting than the way contemporary art has also emerged as a popular form of middle-class entertainment. In the UK, the Tate Gallery read this changing appetite perfectly when it opened Tate Modern on the banks of the Thames in 2000. There, it developed an exhibition model that consciously positioned itself between experience, entertainment and academic interpretation. It was a hugely successful concoction.

The emergence of the Young British Artists in the 1990s, and the Turner Prize and its related controversies, had helped lay the groundwork for this shift. Even if people wanted to come only to laugh at Tracey Emin's bed or Damien Hirst's shark in a tank, or, later, Martin Creed's lights turning on and off and Mark Wallinger's video of himself in a bear suit wandering around an empty Berlin gallery, they came. And, as often as not, they had their opinions subverted or altered. The Tate/Turner blueprint has

been copied around the world ever since, including, to an extent, here in New Zealand.

With that increased public profile has come increased scrutiny. In 2008, the writer Sarah Thornton capitalised on this new curiosity about contemporary art with her book *Seven Days in the Art World*, an entertaining exercise in participant observation that occasionally makes the contemporary art scene look like a cross between a fashion week backstage party, a strange form of pseudo-academia and a giant money-laundering exercise – none of which is entirely inaccurate.

The British art critic Dan Fox has recently highlighted the tension between a genuine popular intrigue with contemporary art and the nagging fear that it's a con-job. Contemporary art, in Fox's words:

> epitomizes elitism and false affectation much more than it does creative experimentation and freedom of thought. More than in any other field, art is where the nastiest brawls over pretentiousness are fought. . . . Contemporary art is guilty until proven innocent. Yet for all the antipathy towards it, in 2014, Tate Modern had 5.7 million visitors, whilst New York's MoMA enjoys an annual average attendance of 3.5 million. That's a lot of people with an interest in the pretentious.

Fox argues that in an increasingly anti-intellectual era, we need the kinds of elitist and 'pretentious' challenges of contemporary art more than ever. I share his view. Because whatever the art world's failings and fooleries, there is, for me, always a hopeful promise at its heart: the possibility that every now and again, someone will do or make something that shifts the ground for all of us.

As much as the global art world is a commercial industry based on trade and exchange and conformity, it is also based on intense intellectual relationships, shared enthusiasms and understandings. Networking in the art world isn't just about hobnobbing with the right people (although, of

course, for many, it can be just that). It is also about finding, and creating, communities of activity, innovation and support.

That was exactly what I found in Berlin. There, I wasn't defined as a New Zealander, or even, for that matter, as a Londoner. I was a critic who hoped to take risks and do intelligent work. I wanted to write for the magazines that set the international art world's terms of conversation, like *Artforum International* in the US and *frieze* in Europe. And I wanted to work, and hang out with, the artists I most admired – from Germany, Denmark, the UK, the US, Switzerland, Australia and, yes, New Zealand too.

And that's what I did, until my universe changed the following spring.

IN LATE MAY 2011, Michael Parekowhai was putting the finishing touches on his work for the Venice Biennale. Ten years after New Zealand first exhibited at the event, Parekowhai's Venice project was the most ornate the country had ever sent: an elaborate installation involving, among other elements, a carved Steinway piano.

Ordinarily, I would have been covering the opening of Parekowhai's Venice exhibition. Instead, I was packing up my Berlin apartment and getting ready to move back to New Zealand.

I'd had absolutely no intention of moving home. Then, on an April evening, with a giant yellow moon hanging over the city, my son James was born. But only just.

The birth had been about as bad as things can get without losing either mother or child. A snowballing series of random events meant that, twenty-four hours after doctors had first tried to induce Kyra's labour, our son arrived in this world barely breathing. Things went from bad to worse over the coming days. As I held him on his first morning, seeing if he would take a bottle, he started to have a seizure. A nurse whipped him away and his doctors placed him on anti-epileptic drugs so strong, one

of them told me, I'd probably have been out cold too if I'd been given the same amount.

James was in intensive care for a week. I didn't sleep for four days of it; I either sat with him or numbly relayed messages to Kyra in another ward, the pair of us occasionally breaking down from confusion as much as anything else. Finally, his doctors insisted I go home and sleep. I bought a pizza from a Turkish guy who tried to chat with me while he cooked. When I got to the apartment, I collapsed in the hallway. I woke up ten hours later, somehow in bed.

Later that week, an MRI established what the doctors had first feared when they saw the seizure – his brain had been injured during the birth.

Suddenly, we were confronted with the prospect that James might have a very difficult life. The trouble was, even in that, the doctors couldn't be certain; they could only tell us what had happened, not what would happen from here. They outlined a spectrum of possibilities, almost all of which were grim.

Gradually, though, the three of us got to know each other. Once James was stable, we were all put in a room together while he was weaned off the drugs. For a week, we were oblivious to everything outside of that room. James, still sedated, was largely oblivious to us. We cried a lot. Alarms on his equipment, which monitored heartbeats and brainwaves, would go off during the night, summoning graveyard-shift nurses. But as the drugs wore off, we got the first inkling of who he was. We also decided, there and then, that we would do something we hadn't contemplated for several years; we'd move home to New Zealand.

Two weeks after we were admitted for a routine induced birth, we left hospital. We got in a taxi, went back to our apartment, and started to pack up. Nine weeks after that, we were gone.

WHEN WE ARRIVED in New Zealand, we closed ranks. Kyra and I didn't want to be here, and we certainly didn't want anyone telling us what to do with our son. Our families didn't know what to do with us; we'd come back because we'd told them that if James was going to need help, we were going to need a lot of support from them. Then we shut them out.

Sometime in those first few weeks, I caught up with the artist Judy Millar. She'd been back in New Zealand for a couple of months from Berlin, where she spends much of her time (she'd been one of our only visitors in hospital), but was getting ready to head back there for a while. I asked her what she was going to do with her house in Anawhata, on Auckland's west coast, while she was away.

We moved in at the start of September. The three of us alone, getting our water and power from the sky and, as spring turned into early summer, much of our food from Millar's garden. Our only connections to the outside world were a satellite internet link and a weekly trip into Henderson to buy groceries and wash laundry.

A lot of that time is foggy. I remember trying to watch the Rugby World Cup final and completely losing it after drinking too much whisky when James wouldn't stop crying. I remember watching the 2011 New Zealand general election a month or so later. I remember rolling an ankle so severely in the pitch-dark that we wondered whether I'd broken it (it was blue for days and still tweaks in the cold). I remember the rubbish truck on its weekly run driving straight into our car, with all of us in it.

But I also remember, on a clear day, seeing the horizon bend. I remember carrying James on my back down to White's Beach and thinking it was probably the closest thing I'd ever experience to standing on the moon. I remember mashing broad beans from the garden and feeding them to him. And I remember watching him roll over and press up on his hands: an early sign that maybe things were going to turn out okay.

Millar's house saved us. As James started doing better, we did too. And I started to write again.

7

FOR THE FIRST few months in New Zealand, I eked out a living doing weird freelance gigs for advertising agencies in Germany, London and the Middle East. I came up with backstories for the mascots of the new Formula 1 race-track in Abu Dhabi. I scripted lame YouTube gags for a giant American car company. I wrote websites for British banks trying to sell their pension plans.

I also started to write about New Zealand art again and, slowly, to reacquaint myself with the scene. Smart new dealers like Hopkinson Cundy (now Hopkinson Mossman) had opened in Auckland and many of those who had been around for a while – Michael Lett, Starkwhite, Gow Langsford – had improved their programmes with emergent talents and top overseas artists. There had also been an art school explosion, all conferring degrees and bursting at their seams.

Traffic between 'here' and 'there' had increased dramatically. Many gifted young artists – graduates of Auckland art schools and my contemporaries, like Simon Denny, Ruth Buchanan, Alicia Frankovich, Fiona Connor and Kate Newby – had moved overseas and were doing well. Even if they weren't moving for good, New Zealanders were winning scholarships, being awarded prestigious international residencies and finding their way into museums and galleries around the world. So were our curators, taking up senior positions in Canada, Eastern Europe, Ireland and Australia.

The New Zealand art scene, it seemed to me, was increasingly dynamic, outward-focused and healthy.

Much of this was down to the artists themselves. But there were also a number of infrastructural shifts which, though in place when I first left in the early 2000s, had firmly bedded in and become substantial forces in the New Zealand art world's growing internationalism.

The Auckland Triennial, the last of which was held in 2013, was one example. The biennale circuit, as will be seen time and again in this book, is one of the most important forces for dialogue in the international art world. Launched by the Auckland Art Gallery in 2001 for precisely this purpose, the triennial quickly became a major event on the New Zealand art calendar, its

key focus to show New Zealand and overseas artists side by side – to create meaningful conversations between them as peers.

As the Turner Prize has shown over a couple of generations in the UK, there's nothing like an art award to generate public discussion and debate about contemporary art. With the support of leading patrons Dame Jenny Gibbs and Erika and Robin Congreve, the Auckland Art Gallery inaugurated the Walters Prize, named after the late Gordon Walters, in 2002. Fifty thousand dollars goes to the winner. The rules are pretty simple: a local jury selects what they deem to be four significant contributions to New Zealand art in the previous two years, whether first shown in New Zealand or abroad. An overseas judge then comes in, stone cold, and picks the winner. The Walters has so far gone to Yvonne Todd (2002), et al (2004), Francis Upritchard (2006), Peter Robinson (2008), Dan Arps (2010), Kate Newby (2012) and Luke Willis Thompson (2014). Three of them – Todd, Robinson and Thompson – are discussed in this book, as are other Walters nominees, including Kalisolaite 'Uhila, Shannon Te Ao and Simon Denny.

The Walters and the Auckland Triennial have been instrumental in bringing influential curators to New Zealand. Many of these professionals (rightly or wrongly) have a kind of elevated status in the international art world, as arbiters of taste who constantly travel the globe, often curating biennales. Within the art world, they're household names: Okwui Enwezor, Hans Ulrich Obrist, Massimiliano Gioni, Nicolaus Schafhausen, Carolyn Christov-Bakargiev, Klaus Biesenbach, Jens Hoffmann and Hou Hanru (curator of Auckland's 2013 Triennial) are some of the best known. Several have come to New Zealand over the past fifteen years – some on multiple occasions – and have created overseas opportunities for our artists. Schafhausen's support for Billy Apple, for example, is discussed later in this book.

Residency programmes have also been vital. Creative New Zealand supports a year-long stint in Berlin (alternating writers and artists) and a four-month residency in New York. Artists who are selected for international

residencies outside of these officially sponsored programmes can apply for Creative New Zealand funding to help with costs. The Wallace Arts Trust supports several residencies every year in New York, Switzerland, San Francisco and Vermont. And the Asia New Zealand Foundation has been an active force in getting New Zealand artists to Asia, with programmes in cities including Bangalore, Yogyakarta, Kuala Lumpur, Taipei and Bangkok.

Leading art dealers have played their part too. Many now routinely attend overseas art fairs – the art world's equivalent of trade shows – developing their own international profiles and those of the artists they choose to take with them.

But participation in the Venice Biennale is by far the most important way the New Zealand art scene thinks through its relationship with the rest of the world. New Zealand first tested Venetian waters in 2001, sending two artists, Peter Robinson and Jacqueline Fraser. Since then, the country has sent Michael Stevenson (2003), et al (2005), Judy Millar and Francis Upritchard (2009), Michael Parekowhai (2011), Bill Culbert (2013) and Simon Denny (2015). Lisa Reihana has been selected for 2017. Venice has had an enormous impact on the aspirations of New Zealand's leading artists, not just for its promise of reaching global audiences but also as an opportunity to produce new work on a grand scale.

THIS BOOK IS a picture of what I've seen and experienced of New Zealand art over the five years I've been back. It is built, primarily, around a series of long studio conversations with prominent artists within the country's art scene.

Often these conversations are serious. Sometimes they're funny. At times, they get a bit prickly. But they are also built around intimacy – a growing closeness, over many meetings, with the artists and the ideas behind their work. Becky Nunes has also shot new photographs of the artists' workspaces. In each case, the artist was present at the shoot. But we felt that to shoot the

artists themselves would be both a distraction and a cliché. In my experience, it is the spaces, rather than the faces, that reveal the most about how artists think.

Each of these longer chapters is punctuated by a shorter encounter with a single work by another artist – a way to add another textural, and textual, quality to the book. These works have also helped me to see a bigger picture – to start recognising some of the patterns and threads driving my thinking about contemporary New Zealand art.

All of this culminates, in the final chapter, in a long encounter with Simon Denny's 'Secret Power' at the Venice Biennale. It's easy to see Venice as the holy grail for New Zealand artists – the pinnacle of what an artist from here can achieve. In Denny's case, though, it feels more like a stepping stone; a platform not just for his ever-increasing reputation but also his growing ambition to be one of the key shapers of international art conversations about technology, corporate culture and surveillance. 'Secret Power' is also, in my view, an exhibition of quite radical political force.

My hope is that these portraits and encounters accumulate into a picture of an art scene that, far from being isolated and distant, has an extremely mature and sophisticated engagement with the wider art world. Globalisation, as I suggest throughout, hasn't just shifted our artists' ambitions but also transformed the way we might understand how, and when, the specificities of our 'local' can find meaning in, and form a feedback loop with, broader international narratives.

Since the Berlin Wall came down, we've watched the world become one giant circulatory system dependent on uninterrupted flow: of currencies, capital, labour, images, ideas and human beings. We've witnessed what happens when that flow grinds to a halt: the seizures caused by 9/11 and the GFC, and the disruptions caused by WikiLeaks, Anonymous and Snowden. Lately, we've seen how terrified the West becomes when the circulation itself is hijacked by forces beyond its control: the possibility of Ebola's exponential spread if someone coughs up blood at Heathrow; the fear that a single

mosquito bite could be enough to deform our offspring; the dark appeal of IS on one side of the world and Donald Trump on the other; the tide of Syrians flooding the Mediterranean, whose movement is testing Europe's open borders and making a mockery of its claims to humanitarian tolerance.

To that circulatory system we can also add contemporary art. The art world of today is a product of the same economic and political forces. The birth of the mega-gallery, like Gagosian, White Cube and Hauser & Wirth, shows that private businesses are now instrumental not just in setting the price of contemporary art, but also the terms of its discourse. There's been a massive expansion of biennales and art fairs, an exponential growth of the secondary market and an opening up of new markets in China, the Middle East, Latin America and the former Soviet Union. A handful of elites – art dealers and uber-curators – now operate like the art world's hedge fund managers, trading in ideas as much as objects. They are always the first to get paid off, if not financially, then certainly in terms of reputation. They set the agendas the rest of us are supposed to chase.

None of these are standalone issues – they form a complex web of relationships and interdependencies capable of consuming and commodifying any form of critique thrown at them. The question that recurs in this book is how our best artists navigate this terrain. Having spent so much time with them over the past two years, I'm convinced that many are now exploring the social role and political function of their art with new vigour and urgency. The artists, living in a world after the GFC, after Snowden, and in the throes of some of the most dangerous geopolitical crises since World War II, are as interested in investigating globalisation's consequences as they are in exploiting its opportunities.

To that end, it felt important for me to hit the road too, and see how travel might open up my understanding of the kinds of themes and ideas they're addressing in their work. For example, what does it mean to think about Yvonne Todd's images of affluent, suburban Auckland in near-bankrupt Detroit? What does it mean to see Shane Cotton's paintings of Māori remains

in Brisbane? What does it mean to travel to Copenhagen and think about how Judy Millar's work might relate to some of the most complex art-political movements of the twentieth century? And what does it mean to stand in the middle of the Texas desert and wonder what Peter Robinson was thinking when he stood in the same spot?

THIS IS NOT, as is probably becoming apparent, an art history. What I'm concerned with is showing readers what it's like to spend your life chasing contemporary art and the people who make it. It's also an attempt to show readers why they should care about art; why they should be interested in the ways artists test the boundaries where our bodies hit the world – the space, as Millar describes it, of the imagination.

During the process of writing, this book has also turned into an exercise in pattern recognition. One of the most striking consistencies that has emerged for me is the way almost every one of the artists tackles questions about the efficacy, and legacies, of late capitalism. And they do this with an awareness that they operate within an art world that is itself a product of that same economic system. Todd's visions of white suburbia, for example, which I've deliberately juxtaposed with Kalisolaite 'Uhila's embodiment of homelessness; Billy Apple's simultaneous attempt to pay the bills and 'live like everybody else' while also exploiting new biotechnologies so he can live forever; Millar's impassioned plea that we recognise the imagination as a site of political resistance; Robinson's questions about labour, capital and collective action; and Denny's examination of the interconnections between American imperialism, New Zealand politics and corporate power.

Many of the artists overlay this with an exploration of the legacies of colonialism – a well-worn path in New Zealand art, but this is something different from the postcolonial work that first emerged in the 1990s. There have been various attempts to describe this shift – as the decolonial, the

post-postcolonial. Rather than putting a label on it, I frame it here as symptomatic of the same post-GFC, internet-age malaise from which the artists' reflections on neoliberalism's consequences spring: Shane Cotton's problematic paintings, for example, which explore the impact of the online world on the ways we perceive the value of Māori objects of reverence; Shannon Te Ao's video work, which becomes symbolic both of nineteenth-century colonisation and the current refugee crisis; Luke Willis Thompson's decision to use his childhood home as the locus for a simultaneous reflection on death, the history of the readymade and contemporary Pacific identity; and the latent questions about bicultural hierarchies and their connections with formalism in Peter Robinson's work.

There is also a lot of magic and transformative force on display. There's Robinson's ability to turn materials like felt and polystyrene into cascading chains of association, or the way Millar's work lurks between image and illusion. There's Te Ao's shapeshifting between the animal, mythic and human worlds, Steve Carr's magical elevation of the most banal, everyday things, and Apple's attempts to disappear. The artists show that disruption and radicality don't just come in the form of obvious political acts. To imagine and perform a quiet act of wonder is just as likely, if we're attentive to its effects, to change how we think and feel about the world.

What I'm offering here isn't the only truth about contemporary New Zealand art, nor is it the only way to view these particular artists. But it has, in the act of writing, become my truth; a portrait of the inside of my head, or at least the part that grapples with contemporary art; the part finding ways to co-exist with its complexities, ambivalences and multiplicities. A very smart artist once told me that our job, as writers and makers, is to take responsibility for the consequences of our thoughts. This is my attempt to do that.

Or at least, that's what I imagine the book could be as Anne and I weave away from the protesters and through Berlin, crisscrossing the line that split the world for three decades, largely invisible now unless you know the

city well. We get to Potsdamer Straße, where she pulls into a courtyard and finds a park in front of one of the enormous galleries – high-ceilinged white boxes with absurdly expensive lighting systems – that have been built in the years I've been away. There are people everywhere: artists and fashionable young things rubbing shoulders with ultra-rich collectors who are being chauffeured from gallery to gallery by a BMW-sponsored car service. Anne and I go our separate ways and promise, just like we did four years earlier when I told her I'd booked a plane ticket home, that we'll find each other again later.

Clammy Pipes, and Other Monsters

At a sushi shop in a Birkenhead strip mall, Yvonne Todd has a pair of tongs, a flimsy plastic container and a doubtful expression.

'I suppose I should have one of those carrot rolls,' she says.

'That is a lot of carrot.'

She nods and takes one anyway. Todd, a vegan, also takes one deep-fried piece, for the novelty as much as anything else. In thirty minutes' time, she'll spit it out mid-interview when she discovers the meat inside it.

We get back in her car and drive to the Northcote house she shares with her husband Colin and their three cats. Although I've known Todd since 2004, this is the first time I've been to her home, which doubles as her studio. When we arrive, we pull into a carport next to a pond of toxic-looking sludge.

'Sorry,' she says. 'Colin hasn't cleaned the pool for a while.'

'That could be the title for your next show.'

She snorts. We go inside and sit down for lunch. 'Fuck!' she yells. 'Look how much wasabi they gave you!'

This tends to be the shape of conversations with Todd. She is a committed swearer and a consistent side-tracker. One of her most endearing traits is her ability to laugh at herself – so much so that it's difficult to know whether she ever takes herself seriously. There's a close correlation between this quality and the humour of her photography.

For the first couple of years I knew her, I was never quite sure whether I was talking to Yvonne Todd or 'Yvonne Todd', a constructed persona

developed as a way to divert and disrupt journalists. It isn't completely implausible; Todd was a child actor. She is also an outstanding mimic, channelling the voices of various curators and dealers whenever she recounts amusing or scandalous anecdotes.

Yet for all that, and despite creating some of the strangest images in New Zealand's photographic history, Todd is pretty normal. In her early forties, she has been with Colin for over twenty years. She hasn't travelled much, and has lived almost all her days on Auckland's North Shore. Her work does have some international traction, though, particularly in Australia.

In late 2014, City Gallery Wellington held a major mid-career retrospective of her work. It was a shame the exhibition didn't also travel to Auckland, because the North Shore is more than just home for Todd; it has also played a huge role in her practice. The last and arguably finest example of this was 2009's 'Wall of Man' series: faux-corporate portraits of men in their sixties – the kinds of things that hang in boardrooms all over the world – except that Todd's men weren't captains of industry. They were well-intentioned locals with time on their hands. Todd had placed an advertisement in the *North Shore Times* for men of a certain age to take part in a photographic project. After receiving an enormous response, she met the applicants one by one in a local coffee shop. The shortlisted men then came to her home, changed into suits she provided, and posed to her specifications.

The results were as absurd as they were remarkable. Some were captured standing awkwardly behind vice-presidential chairs; others with a fountain pen raised or a suit jacket tossed over one shoulder after a satisfying day of fictional capitalist endeavour. In Todd's hands, average North Shore grand-dads and retired loners turned into *International Sales Director, Image Consultant* and *Independent Manufacturing Director*. 'It was the most fun series I've ever made,' she says. 'I've done quite a few series now where I've advertised for participants. I find casting the net into the wider community to see what returns really interesting, like beachcombing after a storm.'

Hospital Director, 2009

In many ways, the photographs in 'Wall of Man' are typical Todd images: the studio lighting, the costumes, the impeccable technical detail, the weird emphasis on hands and teeth. But they also signal a radical shift within her practice. Most obviously, they are, as the title expresses, all of men – the first, and so far only, series Todd has dedicated exclusively to the opposite sex. Up until that point, her gaze had been focused on young women, at most in their mid-twenties but often as young as twelve or thirteen. With 'Wall of Man', she'd gone to the opposite end of the gender and age spectrums: not just guys, but *old* guys. It was, she says laughing, her least successful series sales-wise. Collectors were far more comfortable having her creepy adolescent girls on their walls than successful doctors and former CEOs.

There is also something economically aspirational, and distinctly Freudian, in Todd, the daughter of an accountant, framing older men as models of long-term success and distinction.

'I did spend a lot of time as a child listening to mind-numbingly boring conversations about tax,' she says. 'But I was more interested in the fact that corporate photography has to convey a sense of infallibility and paternal love. I wanted to see if I could replicate that, using ordinary blokes from the North Shore. Although, when I was installing the photos at Christchurch Art Gallery, the installation team had a game called "Whose dungeon" as in, "Whose dungeon would you least like to be captured in?" For some reason, that series always makes people talk about sexual deviancy, even though they could pass for corporate portraits. That wasn't intentional – it's just what people hook into.'

This isn't Todd dodging the question about her dad so much as offering a kind of implicit shrug. Freud is in everything she does; as she admits, she 'sees deviancy everywhere'. Her photographs exude the energies of natural-born suburban troublemakers: they are passive-aggressive, hysterical and hypersexual. They also seem to demand a biographical reading; we need and want to know the correlation between Todd dressing

up old North Shore men and her dad's job. Or we want to see her extensive use of fake hair in light of the fact that, while a student, she worked at a shop called Wigworld.

'I had to work Sundays,' she recalls, 'so I was often incredibly hungover, if not still pissed. There was a little room where women could try wigs in private, and I'd shut myself in there and lie on the floor. There was a gap at the bottom of the door, and if I saw any feet come in, I'd stagger out with sleep-creases on my face.

'David Sedaris wrote about working as a Christmas elf in Macy's, and he describes how the adults who sat on Santa's knee always asked for the same things – a goldcard or a BMW – as if they were the first person to think of it. It was like that at the wig shop. Women would come in and say one of two things. Either: "I want to see what I look like as a blonde" or "My husband wants to see me as a blonde". That was endless. Then there were groups of teenage girls who'd come in and try wigs on and scream at themselves in the mirror like packs of chimpanzees, pointing. That was constant too. Not many genuine customers though; I sold fuck-all wigs.'

The shop wasn't her first encounter with synthetic hair. 'When I got my first job – it was at a warehouse that distributed bicycle componentry – I bought a wig with my first pay cheque. It was quite expensive – $330. Which, in 1991, was like a grand or something. I used to go out wearing it.'

I remind her that she'd previously revealed her eight-year-old self had compulsively plucked out her hair, strand by strand, until she gave herself a bald spot.

'Jesus, you're psychoanalysing me,' she says, laughing. 'But I don't feel like I have any mental problems, because I have an outlet for all my anxieties and eccentricities. There's a place to funnel them, to channel and manage them. The process is quite healthy. Also, I have to interact with people to get the results I want: the people who process and scan the work, models, modelling agencies and so on. There has to be a professional element that means I can't lose myself in problematic behaviour.'

Moon Sap, 2011

WRITERS AND CURATORS have been trying to get to the truth of Todd ever since she won the inaugural Walters Prize in 2002. The Auckland Art Gallery had secured Harald Szeemann, one of the most influential curators of the late twentieth century, as the judge. The shortlist was a field of three well-established men – Gavin Hipkins, John Reynolds and Michael Stevenson – and Todd, not yet thirty and hardly known. She was the rank outsider. Despite this, Szeemann chose her series 'Asthma & Eczema' as the winner, and the media-bait was laid.

The *New Zealand Herald* opened its coverage of her win with the following paragraph:

> A 28-year-old Auckland photographer [she was actually 29 at the time] who used to moonlight as a wedding photographer and waitress at strip joint Showgirls has tonight won the inaugural $50,000 Walters Prize for contemporary art.

The intro was a statement of facts, all notionally true. But the implications, here and across subsequent media coverage, were insidious. It could just as easily have read: 'Ex-strip club worker wins big money for bad photographs.'

The truth is, I'd been horrified by Todd's victory too, not because of her backstory but because of the work itself – I just didn't get it. I didn't understand why anyone cared about her wheezy, brittle, Hallmark-gone-off photos. Even the title suggested something scrofulous and listless in both its concept and content.

But the blatantly dumb coverage of her success was more offensive. Eighteen months or so later, I also realised I was completely wrong.

My about-face came when I saw Todd's exhibition '11 Colour Plates' (a typical Todd title given that there were only ten photographs in the show). I still remember walking into Ivan Anthony Gallery on K Road and being confronted with *Roba*, an enormous sepia image of a woman wearing a flowing dress and unflattering glasses, with a petrol can at her feet. There was also *Bo-Drene*: a demented-looking teenager with Coke-bottle specs

and good legs, sitting stiffly on a dining chair. *Fractoid* was a faceless blonde on wooden crutches standing heroically in a speckled studio. *Resulta* was a horrific portrait of Todd herself as an anorexic. And *Methylated Puddle* was an innocuous, boggy patch of grass transformed into a noxious purple trap.

These are still among Todd's best works, and for me, made one of the defining shows of the early 2000s. So I made my declaration in print: Todd was the best New Zealand artist of her generation. Szeemann had been bang-on; he'd recognised that the wheeziness of 'Asthma & Eczema' was also its problematic strength, and that its twenty-nine-year-old author had seen something in the world the rest of us had missed – something that had been hiding in shadows the whole time. Todd, right from the start, was an artist who revelled in digging up, and showing us, our monsters.

I THOUGHT A LOT about Todd towards the end of 2013 when I spent a few months at Cranbrook Academy of Art, just north of Detroit. Detroit was at that moment starting its bankruptcy proceedings – the largest municipal insolvency in US history. It is also, statistically, one of America's most dangerous, and poorest, cities. Despite this, I was safely ensconced twenty minutes up the road on the Cranbrook campus, in one of Michigan's wealthiest suburbs, Bloomfield Hills.

Driving south along Woodward Avenue from Bloomfield Hills to Detroit is like sliding down a perfectly paced graph of American socio-economics. After the leafy McMansions surrounding Cranbrook, you pass through the almost-as-well-heeled but slightly denser neighbourhood of Birmingham, then through aspirational-young-family Royal Oak, and finally gay-friendly, hipster-ish Ferndale.

But just after that, you cross 8 Mile Road, the deep gouge of freeway that marks Detroit's northern limit, and the universe changes. Woodward's asphalt becomes scarred and torn. Henry Ford's Model T factory – the

factory that transformed Western industrialism forever – slowly collapses under its own, unmaintained weight. Magnificent apartment blocks and mid-century churches look like the damaged remnants of London's Blitz.

Look left and right and you glimpse desolation in the cross streets: multi-storey, middle-class redbricks falling down, stripped of their copper wiring, plumbing and anything else that can be sold for scrap. Drive all the way to the end of Woodward and you arrive in a semi-deserted metropolis, where GM's Renaissance Center looms like the Death Star over the straits that separate the US from Canada. A giant monument to Joe Louis's fist points across the water. On the other side, Kenny Rogers glares back, just outside Joe's reach, from the looming billboards of Windsor's cheesy casinos.

Detroit is in bad shape, but it's not alone. The United States, and particularly the Midwest, is strewn with similar medium-sized industrial cities struggling to redefine themselves in the early twenty-first century. The fight to keep Detroit solvent is classic domino theory – if it goes, others will tumble too. Detroit is also America's most definitively 'American' city: the place where the birth of the automobile laid the groundwork for several interconnected, culture-shaping forces: the freeway, the suburb, and Motown music among them. Detroit changed the way all of us moved, and with it the way we lived, what we ate, what we listened to, what we watched, what we bought. Its contemporary decline is a deep wound in the American psyche.

But it isn't all doom and gloom. Art in particular is countering Detroit's woes. Young artists are moving into the city, attracted by ludicrously affordable studio space. The Detroit Institute of the Arts (DIA) is still one of America's great art museums. And there is MOCAD – the Museum of Contemporary Art Detroit – which is trying to energise the city's contemporary art scene.

At the back of MOCAD, just next to its parking lot, is a white mobile home which, attached to a permanent structure, mimics the suburban gravitas of a textbook middle-class house. There are planters out front, a welcoming

veranda, a garage for the family car, a manicured lawn. No one lives there though. It's the last major commission by the artist Mike Kelley, who died in 2012. Called *Mobile Homestead*, it's a replica of the Detroit house he grew up in.

Kelley arguably did more than any other artist of recent decades to expose the psychic cracks in America's modern condition. Seeing suburbia, consumption and repression as connected forms of cultural infection, Kelley cooked up a remedy of Freudian catharsis. He made complex installations out of stuffed toys and crocheted blankets, which, far from evoking childhood safety, hinted at the formation of sexuality, separation anxiety and object fetishism. He made abject performance and video works with fellow artist Paul McCarthy, in which the pair enacted bizarre Oedipal rituals and restaged the children's classic *Heidi* as a decidedly adult horror film. And he made *Educational Complex*, 1995: meticulous scale models of every school he attended, as well as his childhood home.

Mobile Homestead is a late extension of the *Educational Complex* models – a piece in which architecture is recreated not just for its internal spaces but for its formative power. Here, it's done at 1:1 scale. It's also classic Kelley. At ground level, the house behaves like a model citizen: home to free medical check-ups, community exhibitions, a library and various forms of social support for Detroit's impoverished residents. But beneath its surface – literally – is is a subterranean world that Kelley intended for 'private rites of an aesthetic nature'.

Mobile Homestead has two below-ground levels that mirror the floorplan of the space above, except the below-ground rooms are linked by ladders, rather than doorways. It isn't open to the public. The only people who can access it are select artists, musicians and arts groups. It was Kelley's final gift to his peers – a mini-labyrinth for them to get lost in, confront their own monsters, and figure out how to give them form.

In Kelley's house, Todd's suburban visions start to make a different kind of sense. Created half a world away, they tap into the same histories,

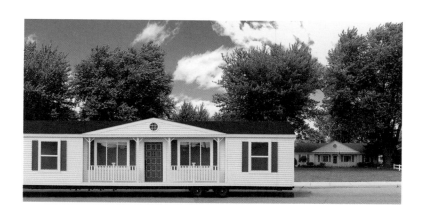

Mike Kelley
Mobile Homestead, 2010

the same forces of capital and the same archetypes. They act as a kind of mirror to Kelley's body of work, too: his examination of the relationships between Freud, suburbia and the formation of American masculinity given a feminine flip.

Todd hasn't been to Detroit, but it is nonetheless where many of the contemporary desires that shape her world – to be a consumer, to lust after inanimate things like cars, gadgets and houses, to live the safety of a suburban half-life – were created. Detroit may be in ruins but despite its troubles it still speaks back, showing us how monstrous and fragile our aspirations, of the type that sustained us throughout the twentieth century, can be.

MOST PEOPLE WHO grew up in the 'burbs in the 1970s and 1980s watched a lot of horror. We were the generation scared rigid by Freddy Krueger, Jason, *It* and *The Shining*; the generation happy to watch VHS tapes of men in leather masks jointing pretty girls for the barbecue. There's an obvious psychoanalytic read to be made here: bored, repressed kids discovering their sexuality and taste for violence at the same time.

Todd was no different. Early in her career, she revealed that as a teen she devoured VC Andrews' novels; the nascent artist absorbing a world occupied by disturbed young women, a world of incest, repression and monstrous mothers. Then there's her family setting – is there anything less sexy than tax-talk? Later, at the wig shop, she confronted the frisson of housewives wanting to spice things up for their husbands with a bored indifference. Finally, there was the stint at the strip club, serving beers to stag parties and lonely business travellers.

Todd's personal mythology makes her a pin-up for frustrated, horror-filled, suburban sexuality. But she's also a self-confessed liar. 'Often I'll say things in interviews and won't mean them,' she tells me, a little

alarmingly. 'Sometimes I don't know what to say, so I'll make something up on the spot. I did a lot of acting as a child, and I always found being in charac-ter easier than being myself. That's what I like about being an artist – you can hide behind the work, and choose how much of yourself to reveal. You can make provocative gestures, but you don't actually have to front up. The work is like that too. It doesn't know what it's there to say.'

This might sound like posturing, but in fact, this uncertainty is pre-cisely what makes Todd's monsters so unusual. Bruno Latour writes that: 'Dr Frankenstein's crime was not that he invented a creature through some combination of hubris and high technology, but rather that he *abandoned the creature to itself*.' In her photographs, Todd does exactly the same thing. Despite being shown in series, her individual subjects often seem lonely and confused. Rather than threatening to obliterate or maim, as we'd expect of most monsters, they try to connect with us through awkward smiles or uncomfortable poses that exude un-confidence.

They're remarkably adolescent in their emotional range. *Goat Sluice*, 2006, from the series 'Meat & Liquor', is a good example. In it, we see a young woman with flowing blonde hair and fake teeth, wearing a white dress and holding a startled kitten. She looks out at us as though perfectly prepared to tear the animal's head off. But of course, she never does, and never will. Instead, we're suspended in a perpetual game of chicken with her. Rather than being terrible or scary, she becomes unlikeable, passive-aggressive, even spoilt. Todd's monsters are, by and large, nervous teens, not yet sure of their place in the world but filled with a need to assert their presence anyway.

The profound banality of adolescent sexual formation – we all go through it but convince ourselves that our experience is uniquely complicated – is brilliantly mirrored in the still-lifes Todd includes in almost all of her series. In the 2006 exhibition 'Blood in its Various Forms' was *Inverse Funnel*: a transparent funnel on a mirror that becomes more breast-like the longer you stare at it. In 2005, *Wet Sock* was part of a show called 'Vagrants' Reception Centre', a masterful bit of staging in which a single, weirdly erotic drop

falls from a disembodied cotton sock. She also made *Clammy Pipes*, 2006, in which PVC plumbing sweats with a coital gleam.

In their unspokenness, these still-lifes often seem more charged than the faux-erotic glances of her teenage pretties. And they do this by co-opting, and usurping, the visual language of the glossy magazines teenage girls devour.

AT TIMES BETWEEN 2004 and 2009, Todd's adolescent moments became corny. The dresses were too puffy, the teeth too big, the wigs too bouffant. It tipped into camp. With 'Wall of Man' she simultaneously got back on track and started to use gentler forms of masquerade to evoke her trademark levels of desire and difference. What mattered now wasn't the extremity of her subjects' features; it was their commitment to a particular cause. In the case of 'Wall of Man', the cause was capitalist success.

For a solo exhibition at Melbourne's Centre for Contemporary Photography in 2012, Todd presented her photographs of old men alongside what is arguably her most technically accomplished series, 'Seahorsel'. 'Seahorsel' riffed on classic Todd themes: teenage girls, attractive but not quite right; contorted poses; absurdist titles; crazy costumes. The series also included men, such as *Morton*, posing like a sitter in a Dutch sixteenth-century portrait but with an unexplained neck-brace and an oversized scallop shell in front of him. *Morton*, though, is probably the most cartoonish character in the series, a ghost of Todd-past in the middle of a deeply innovative present.

'Seahorsel' is a slow-burning group of images that moved Todd out of the 'burbs for good and into murkier conceptual terrain. Her subjects are dancers: figures in skin-coloured unitards, frozen in ridiculous poses. In *Glue Vira*, for example, two young women are caught at hopelessly awkward angles in a game of statues, as their hair – wigs, of course –

blows across their faces. They could be mannequins, but for the human tension visible in their feet and hands. Similarly in *Moon Sap*, a man raises himself, with bent knees, onto the balls of his feet, casting bandy Dr Seuss shadows across the studio floor. His arms are tense, pulled down hard and straight from his shoulders, so that his hands hit his body mid-thigh, his fingers flaring out at right angles. There's a female dancer too, holding her arms in front of her, fingers dangling at right angles to her partner's, one leg kicking out.

Because we can't see their faces, we see *Moon Sap*'s dancing partners as pure form: as bodies in space transitioning from one pose to another, and from darkness to light. Except we can't be sure of this, because the only perceivable movement is in the woman's dress. But even that feels too stiff, given the fabric's lightness – like it's been shellacked on, or frozen solid before she slipped into it.

Todd is playing on one of the great clichés of photographic theory – the understanding we all have that the camera puts real life on ice and, in so doing, reveals things we don't notice when we're constantly in motion. This implicates 'Seahorse1' in a particular history of photography, a history that starts, and ends, with Eadweard Muybridge's motion studies in the late nineteenth century – remarkable technical achievements that ushered in the era of motion pictures and changed the way we saw the world forever.

But there was also something monstrous about Muybridge's achievement. He showed us too much of our mechanical being, reducing our sense of ourselves as coherent, self-contained creatures to a collection of balls and joints; he turned us into locomotive structures. Todd's images resist movement by portraying a singular pose. But they achieve this by using people paid to be constantly on the go – dancers – and whose bodies show their career choice in every sculpted muscle.

TODD'S PREOCCUPATION WITH other people's obsessions is clearest in her urge to photograph what she calls 'ethical minorities'. This started with a series on vegans, made in 2014: a minority she herself belongs to. Initially, she'd thought about hamming it up – her vegans were going to be in 'long robes, with bare feet, standing amongst overflowing sacks of grain and desiccated foliage'. Instead, she opted to show her subjects as she found them.

The results, superficially, are awful; the studio set-ups are clumsy, and there's nothing compelling, sexy or upsetting about them at all, except for an image of a man in his fifties dressed in head-to-toe Lycra.

When Todd sees my reaction, she laughs. 'He's my favourite,' she says. 'He insisted on wearing his cycling gear. Those are the gay vegans. Those are the mother and daughter vegans. Those two are a bit more glamorous – they're the beauty queen vegans. I knew I had to have a dreadlocked vegan too. In that one, the lab fucked up and exposed part of her head, but I'm keeping it like that. And that's me in my Farmers tracksuit pants.'

Todd's self-portrait as a vegan is arguably the closest we've ever been to seeing the real her. Except that its shocking plainness is just as unsettling as the more obviously staged self-portraits she pumped out earlier in her career. She has variously been an anorexic, a greasy harpist, a little-known socialite called Sandra West who was buried in her favourite powder-blue Ferrari, and a teary, plump Christina Onassis.

'I have a need to be these obscure, peripheral figures from history,' she explains. 'With Christina Onassis, I noticed that she always had a tormented expression, and I wanted to replicate it. With Sandra West, at the time, I didn't know what she looked like. But I didn't get it too wrong. I eventually saw a picture of her and she had pretty similar hair. I've always had a perverse need to explore the grotesque, and the changing of appearance. I think that stems from my childhood acting career.'

One of her most intriguing moves in this regard has been her recent co-opting of the Gilbert Melrose archive. Melrose was Todd's second cousin,

Gilbert Melrose
Fawn Interior, c. 1990

a photography enthusiast who ran a shop in a small New Zealand town for forty-six years, where he provided equipment and processing, and documentation of local events with prints available for purchase. When Melrose passed away, Todd inherited his personal archive. Her response was not just to organise it but to use it within her own practice, reproducing his images under the moniker 'Gilbert Melrose'.

As well as his commercial work, Melrose made thousands of photographs for himself, leaving behind, in Todd's description to the writer Megan Dunn, 'an obsessive archive of many thousands of negatives, mostly of tractors and farm machinery, landscapes, sunsets, hot air balloons, steam locomotives, tourist attractions, farm animals, and anything Christmas'. He also made dozens of portraits of his sister Joan, from whom he was inseparable; they lived together their entire lives, until Joan passed away in her sixties.

Todd's appropriation and reprinting of Melrose's work is built around his relationship with his sibling and his compulsive need to document his world. Todd channels him posthumously, walking a fine line between unsettling us and making us laugh at rural, conservative, mid-century New Zealand – a life of farming and Sunday roasts and a handful of community gatherings each year.

And how easy it is to laugh. Some of the first Melrose images Todd reproduced were photographs he took at a children's fancy-dress party. Just a few examples include: a kid in blackface so deep and thorough it looks like a *Texas Chainsaw Massacre* mask, standing with a chunky Tinker Bell and a boy in a bear suit holding something that looks, inexplicably, like a dildo; horror-tropey twins; a poor little bloke who obviously asked to be Noddy, wearing a dunce cap and high-waisted shorts; and a chubby baby wearing rabbit ears that make him look more like Nosferatu's unholy offspring than the Easter Bunny.

But Todd's interest in using Melrose's archive isn't for the easy gags. It's because the connections with her own images are so eerie. Melrose

Gilbert Melrose
Waikato Portrait 140, 1957

Cousin Diptych, 1989 / 2014

photographed people in costumes, children projecting a passive-aggressive sexuality, women with borderline mental states, and his sister, with whom he seemed, from the images, to have a tense, confusing fascination. Todd's longstanding exploration of monstrosity had found an inadvertent doppel-ganger in Melrose's more ingenuous mindset.

It seems inevitable to think here of Diane Arbus, whose enormous archive of images of freaks, outsiders, sexual deviants and the disabled was one of the most important and contentious photographic projects of America's twentieth century. Writing in the 1970s, Susan Sontag famously stated of Arbus that:

> [Her] work does not invite viewers to identify with the pariahs and miserable-looking people she photographed. Humanity is not 'one.'. . .
>
> The most striking aspect of Arbus's work is that she seems to have enrolled in one of art photography's most vigorous enterprises – concentrating on victims, on the unfortunate – but without the compassionate purpose that such a project is expected to serve. Her work shows people who are pathetic, pitiable, as well as repulsive, but it does not arouse any compassionate feelings.

Sontag's interpretation goes against the prevailing empathic wind, ensuring that the major questions about Arbus's practice are blown back onto its audience. If the images aren't sympathetic in motivation, what does it mean for us to look at them? What does it mean for us to laugh at, or take pity on, or be repulsed by her subjects? How would we react differently if the subjects themselves, rather than their images, were immediately in front of us? In Sontag's framework, Arbus's work is as much a question of form as content – a challenge to us to reconcile the strangeness of the people we're looking at with the power the medium grants us to assume superiority over them.

There is, though, an enormous difference between Arbus and Todd. Whereas Arbus's view of the twisted and deformed is essentially a

Vegan Portrait 11, 2013

documentary project that looks from the outside in, much of Todd's work is a psycho-sexual form of self-portraiture. She is the monster living inside her own labyrinth. Melrose's archive is unquestionably a form of self-portraiture too: this is Gilbert's universe, with himself and Joan at its centre. And as with Todd's, there seems something at the heart of it that remains unspoken, unreleased.

In a 2014 show at Peter McLeavey Gallery, Todd dialled up the erotic drama, offering a dual-portrait of herself and Gilbert, loaded with potential clues to the formation of their respective sexual identities. She presented one of Melrose's photographs of his sister Joan atop a horse, in which rider and animal are shown side-on: a wall of flesh in a Waikato field. Alongside this was a pair of images from her own teenage years – reprinted snaps she and a cousin took of each other on a family holiday. The photographs record the two young women tarted up for a night out on the pull – short dresses, heavy make-up, mousse-hard hair. All that mattered to them was the shared costuming ritual. Neither girl got drunk or laid that night; they never left the motel.

'Yes, 1989, in our bogan finery,' Todd recalls. 'We were staying in Kerikeri, and we didn't have anywhere to go. I've always wanted to show it as a diptych. We're both wearing black, against this peach interior. To me, they've always worked as a pair. There's a vernacular quality that's totally removed from what I'm known for. I'm starting to be more interested in images that aren't slick and perfect. These are raw.'

Todd is a master of untrustworthiness. Even writing this, I'm not a hundred per cent sure the Melrose archive isn't some brilliant, elaborate falsehood, another form of her signature masquerade. What interests me most here is that, rather than the schlock horror she made her name with, she has moved on to examining the horrors of familial connections, their impact on how we form our identities as sexual, adult beings and what happens when those connections are severed. When Joan died, she tells me, Gilbert collapsed at the funeral, falling apart like he'd lost his lifelong lover.

When I push Todd about her relationship with Melrose's photographs, she gives me a typical response – not so much evasive as sidelong, loaded with an implicit *something*.

'I know Gilbert would be a little bewildered by this art world attention,' she says, 'because he probably wouldn't consider what I'm reprinting to be his best work. But I think at the same time he'd be extraordinarily proud that his work is being seen and talked about. It's his obsessiveness that I find interesting. It resonates with my own. To be a good artist you have to be obsessive. It has to go beyond something you enjoy. You have to be consumed by it.'

The growth of the predominantly white suburbs of the North Shore is one aspect of Auckland's mid- to late twentieth-century expansion. In South and West Auckland you find another example – enormous Pasifika communities that have famously made Auckland one of the world's most populous Polynesian cities.

In July 2012, 'Home AKL', an exhibition that looked at three generations of Pacific artists who call Auckland home, opened at the Auckland Art Gallery (AAG). It did what it said on the tin, addressing all the themes you'd expect: diaspora, disconnection, celebration of homeland, the slippages that occur as one culture collides with another. There were plenty of exciting moments in it, too: the paintings of Teuane Tibbo, for example, and new work from young artists who have graduated from Auckland's art schools over the past ten years, including Siliga David Setoga and Leilani Kake.

Two young artists of Pacific descent who weren't included were Kalisolaite 'Uhila and Luke Willis Thompson. This was despite the fact that both, at the time, were Auckland-based and had recent projects that examined how we might understand place, home and Pacific identity in Auckland. At Pakuranga's Te Tuhi Centre for the Arts, 'Uhila had presented *Mo'ui tukuhausia*, in which he lived homeless around the gallery for a fortnight. Thompson, meanwhile, had shown *inthisholeonthisislandwhereiam* at his dealer gallery, Hopkinson Cundy.

These works were considered so significant that they were shortlisted for the 2014 Walters Prize, which Thompson eventually won. The contrast between these projects and what was in the AAG show was clear. 'Home AKL' made Pasifika art visible and confronted Pacific stereotypes. But it was,

Luke Willis Thompson
inthisholeonthisislandwhereiam, 2014

ultimately, a show about belonging. It seemed, to me, like it was missing a genuinely critical reflection on the contemporary economic and cultural contradictions for Pasifika communities in Auckland.

Thompson and 'Uhila, by contrast, weren't asking questions about belonging. Instead, they were presenting quietly confrontational views of what the inter-related issues of race, class and poverty look like in New Zealand's biggest city.

THE FIRST THING visitors to the 'Walters Prize 2014' encounter is a long, empty corridor. It changes the orientation of the AAG's top floor completely. Instead of its usual open space, a solid wall runs just behind its problematic pillars: structural devices that have become an architectural nightmare for the artists and curators who use the space. It's the first time they've been highlighted – they're more 'there' than ever – and negated simultaneously: hemmed in, with no real power to mess things up, as they often do.

Halfway down the corridor, low on the wall, is a text naming the artist and the work. It also contains an invitation:

> Luke Willis Thompson
> *inthisholeonthisislandwhereiam*
> Please ask a nearby guide to view the work
> The duration is approximately 50 minutes

You turn, and see the gallery attendant. You ask her whether you can view the work. It involves a taxi ride. You're in luck; the taxi has just returned from its previous run. She presses the call button for the service lift: one of those giant elevators that art galleries have behind the scenes – gaping mouths designed to swallow up enormous artworks and spit them out, unscuffed, on other levels.

The lift drops through the building's guts and hits the bottom with a softened thud. The doors open, and the attendant leads you to the vehicle entrance. A taxi is waiting. The driver leans against it. He smiles. There's nothing corporate about him or his wheels; it's a bog-standard, discount ride. You climb in, he slides into the driver's seat and the car eases away.

The exit from the central city is coy; a circuitous route that, if you were picking up the tab, would have you shuffling before you finally leaned forward and said something. But given you're not paying, and you don't know where you're going anyway, you sit back and watch Auckland go past at odd angles. You end up on the motorway, which is when your heart starts to beat a little faster. Now, you can't ask him to pull over. But the car is off just as quickly as it was on.

It slices through a group of small units in Epsom, pops out on the other side, and pulls into a villa's driveway. It's a bit run-down, but by no means derelict; it could do with a paint, some rotten boards need replacing, and some of the gutters need repair. On the veranda is a single, dirty sock.

Another attendant unlocks the front door, and tells you not to open any closed doors while you're inside. You step into a hallway and instantly recognise the wet smell of old Auckland houses; the childhood sense that nothing was ever quite dry. In a bathroom – the first room you poke around in – there's water on the floor, and a damp shirt hanging from the shower's curtain rail.

In the living room is a big dining table, flecked with paint. You find ordinary things on the mantelpiece – trinkets, family photos. There's also a big stack of funeral programmes; stored-up remnants of other people's passing. You carry on into the kitchen, and hit another smell from your past: a combination of cooking, cat food and residual damp. Next to the kitchen in a kind of lean-to is a worn mattress that makes you feel asthmatic just looking at it. Before you head back into the dining room, something catches your eye. On the wall, tucked in a corner, is a single image: a photograph of a toi moko – a tattooed and preserved Māori head – floating on a dark ground.

Kalisolaite 'Uhila
Mo'ui tukuhausia, 2014

It is a house filled with stagnant traces: the odour of damp stillness; the bed's phantom impressions; the funeral programmes; the severed head. There are also toothbrushes everywhere – used ones in the bathroom and in the hallway too, resting in a Christmas-themed TV tray. There are bits of clothing all over the place – hanging over towel rails, over the backs of chairs.

Someone is here, in some form. But no one's going to pop out and yell 'Boo!' This isn't a ghost train. It's the house Thompson grew up in, the house his mother still lives in, and lived in for the duration of the Walters Prize, hence the instructions not to enter any rooms that aren't already open.

It is, presumably, a tremendous imposition on her daily life to have people tromping through her house for several months, peering around it and trying to figure out how much of what they're encountering is staged, and how much of it is 'real'. But in trying to deduce this difference, the audience misses what this thing really is. Whether or not Thompson has staged certain elements – the photograph of the toi moko for instance, or the fact, which gradually dawns on you, that the artist is in many of the family photographs on the mantelpiece – doesn't matter. Because, in a sense, the entire thing is staged, from the moment you enter the AAG's corridor and read his invitation. What Thompson has created is a real fiction – a space and an experience that exists as literal form and that inserts us as its interloper *and* its protagonist. It's a play without a director, or at least a play with a director who enjoys sitting back and watching the actors figure things out for themselves.

We could spend forever trying to figure out what Thompson's work is about – or, to take his title, what hole he's dropped us down. We could read it in terms of growing inequality in Auckland. We could take that further in terms of his Fijian roots, and the way people from Pasifika communities are being forced out of neighbourhoods they've long lived in because of gentrification, whether by private landlords or the government selling off state houses to cash in on rising property values.

Or, we could read it as a straight-up power play – not just in his willingness to mess with us, but with his mother too.

But what this actually is, is the ultimate found object: a space and a framework so loaded with meaning that Thompson has decided the lightest of touches can have the most profoundly destabilising effect. We hate not being told what to do. Thompson's ambivalence towards us isn't an abdication of artistic responsibility. It's a confrontational stance.

BACK AT THE AAG, you see homeless people, three or four of them, through its shining windows, sleeping with their heads bowed and covered on the steps that border Albert Park. One of them, you assume, is Kalisolaite 'Uhila. Instead of sleeping rough for a fortnight, as he did at Te Tuhi, for the Walters he is living homeless in Auckland's CBD for three months – the full, wintry extent of the exhibition's duration.

There are traces of him around the gallery. Outside the café there are clothes hanging to dry. There's a shopping trolley filled with scrounged survival material – plastic bottles, food, shopping bags. Upstairs in the exhibition itself, there is more evidence of 'Uhila: a sleeping mat rolled up – although this isn't where he sleeps – and, on the walls, scrawled messages and statements about the work from 'Uhila himself, and from gallery visitors.

Scott Hamilton and Nina Tonga have written intelligent responses to 'Uhila's action, informed by a far deeper understanding of Tongan culture than I possess. They draw parallels with the figure of the haua: an outsider or wanderer, and an outcast from Tongan society. As Hamilton points out, there is a clear religious aspect to the haua, who embodies the Christian idea of self-sacrifice and the idea that Christ himself was homeless. It's a compelling argument for a New Zealand context. Our colonial and cultural past is similarly littered with self-styled wanderers: Rua Kenana, James K Baxter and Colin McCahon who, just before the opening of a major exhibition in Sydney, lost himself in the city's botanic gardens and was found confused and disoriented the next day.

'Uhila, like them, is hard to spot. It's a rare thing to see him on the back steps. But then, he may not be one of the hunched men. And that's his point, or one of them. Despite Auckland's alleged liveability, the city has recently seen a huge rise in homelessness. The truth is 'Uhila – a solidly built Tongan guy in his early thirties – is the new everyman: Auckland poverty given physical form. There are rumoured sightings of him on Ponsonby Road, by Victoria Park, outside the City Mission. For a few months, he is Auckland's UFO – a thing of wonder and spectacle as much as a young man putting into play conditions that carry the very real possibility of his own disappearance.

THOMPSON'S AND 'UHILA'S works were never intended to be shown side by side. They were thrown together by the circumstances of the Walters Prize, because the 2014 judges considered them each to have been such outstanding contributions to New Zealand art. We could, therefore, see their selection as arising from an implicit need not just to examine the conditions of contemporary art, but the contemporary conditions in which we live.

The artists orchestrated encounters that don't just explore what home is but what home does, forcing us to examine the intimacy of domestic space. Home is a way of being as well as a physical structure. It shapes everything we understand about inside and outside – architecturally *and* existentially. Home is where we eat and sleep and worship and read and talk and fuck and ultimately become ourselves.

Both works were the culminations of promising early careers. In 2011, 'Uhila had lived for several days alongside a piglet called 'Colonist' in Aotea Square. In *Stowaway*, performed in Wellington in 2012, he lived in a cargo container for four days and nights, a reference to the hidden journey his uncle took from Tonga to New Zealand. Meanwhile Thompson, in *Untitled*, 2012, had acquired and presented three roller doors from an Auckland

garage. The doors had been tagged by the teenager Pihema Cameron. When the owner saw the boy doing it, he chased him down the road and killed him.

The great cleverness of *inthisholeonthisislandwhereiam* and *Moʻui tukuhausia* is how they tap into ideas of violence, wandering, control and loneliness while also occupying a threshold of invisibility. The works were two extraordinarily subtle takes on the potential of performance art, in which the artists themselves were almost always absent – and yet the intensity and vulnerability of their actions meant that they, and their family relationships, were placed at real risk.

What Thompson and ʻUhila showed is that objects, spaces and bodies contribute evenly to an experience of a world inflected with trauma and pain and death, but also beauty and poetry and intimacy. And they did it with remarkable specificity, moving us through a city we thought we knew and thought we belonged to, tearing it open to show us what's really inside.

Old Plant New Smoke, 2015

Death in Palmerston North

'It accumulates into itself, as the thing that needs to be considered. I don't
want to create a series of roads to an end-point that becomes a statement
about painting. I keep finding new ways to think: "That's what it is!"
or "That's what it is!" Maybe everything else up to then I've got wrong.
I'm compelled to paint. I'm searching for paintings all the time.'

Across the dining table, Shane Cotton leans back. He's a big presence.
He has his daughters' names on his forearms, floating inside tribal arm
tattoos. He has also recently grown a beard, which, flecked with grey, fills him
out and makes him look like the bikers he spends much of his spare time with.

We've been talking for well over an hour at the table. Behind him, on the
wall, is one of his paintings – a diptych first shown in 2003 at City Gallery
Wellington, in an exhibition that changed everything for him. The text on it
reads 'KIA WHAI KIKO RANGI': words from the Book of Genesis in the Māori
Bible. The silhouette of a severed Māori head – a toi moko like the one on
Thompson's mother's wall – is painted in a neon-blue camouflage and floats
against a black ground. Under it is a spraypainted white line. Below that are
the words 'TA KAUERE', the name of a Northland taniwha, spelt out in Gothic
text. A single tūī emerges out of a target.

I ask Cotton about the decision to use the camo-pattern.

He pauses. 'It was a way to deal with a flat shape,' he says.

It's a typically deadpan answer. Cotton has a disconcertingly matter-of-
fact way of talking about his practice. Only now, as he enters his fifties, are a

lot of people – myself included – starting to understand the full complexity of who he is and what he does. I used to think it was easy to write him off, that he was an art market darling who made safe New Zealand paintings. But an important exhibition called 'The Hanging Sky', and a book of the same title containing excellent essays by Justin Paton, Robert Leonard and Geraldine Kirrihi Barlow, prompted me to look again. Being with Cotton and his work isn't as easy as I once thought.

COTTON HAS LIVED in Palmerston North for more than twenty years. His studio is a big warehouse with good natural light and a propensity to flood. There are stacks of magazines everywhere – plenty of *Artforum*s, but just as many biker mags (Cotton is a keen Harley-Davidson rider). There's a drum kit in one corner. A television mounted on a wall regularly streams American baseball games while he's painting.

All of this is fairly atypical for an artist's studio, but the strangest part of his set-up is that he works solo. Painters with Cotton's status often have at least one assistant, there to stretch and gesso canvases, get paints mixed and ready, and so on. But he does everything himself. In an age in which artists' studios often look like high-end architectural offices, Cotton's is a solitary man-cave.

When we meet, he has just sent off a large body of work to Hong Kong for his first solo show in Asia. Despite the shipment, the studio is fuller than I've ever seen it. He's in a productive phase, and new paintings are flowing freely. Many are continuations of what he's just packed up and shipped out; hints of grey cloudscapes with large diamond forms at their hearts. Inside the diamonds are abstractions that hark back to British painters like Ben Nicholson. One of the largest paintings in the studio, *Blank Geometry*, is a canvas on which smoke is delicately spraypainted. Over the top of that is a classic Cotton bird, stretched and warped. Beneath the bird is a painted

stick: an everyday chunk of wood you'd pick up and drag through the sand at the beach. In the top right corner is a single strip of red paint, meticulously masked, popping against the smoky ground.

There are also several boxes cantilevered to the wall on which Cotton has painted flat squares of colour: reds, blacks. At the moment, he's trying to combine them with small canvases, some of which have severed heads painted at their centre.

It's a weird mish-mash of stuff. But then Cotton's paintings – at least the ones he's made since his 2003 retrospective at City Gallery Wellington – are always weird. For more than a decade now, he has been on a search for new form, undoing his own practice in an attempt to find images and ideas. The search has been as wide as it has been erratic: immense, complicated canvases; delicate works on paper; 'target' etchings printed in a kibbutz; baseball bats painted as they turn on a wood lathe. He is a constant tinkerer – overpainting, cutting things up and reassembling them if they're not working, hauling paintings back into the studio even if they've been away and finished for months.

The smoke, the boxes, the bands of colour, and even that stick, are just the latest forms to emerge from that process. Most will eventually be discarded, but some will enter his idiosyncratic vocabulary – a world within a world of stormy skies, gang patches, Gothic text, warped birds and floating heads.

IN THE EARLY 1990s, New Zealand art entered a new phase with the emergence of a young group of Māori artists who began to tackle our colonial histories with barbed wit and stinging critique. Their work embodied a new national attention to bicultural issues (the Treaty of Waitangi – New Zealand's foundational agreement between Māori and the British Crown – had turned 150 in 1990), and tapped into the international rise of postcolonial theory.

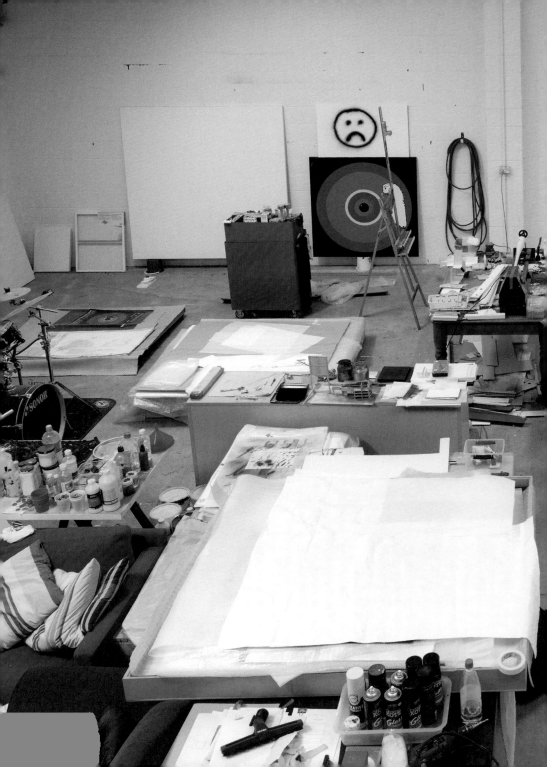

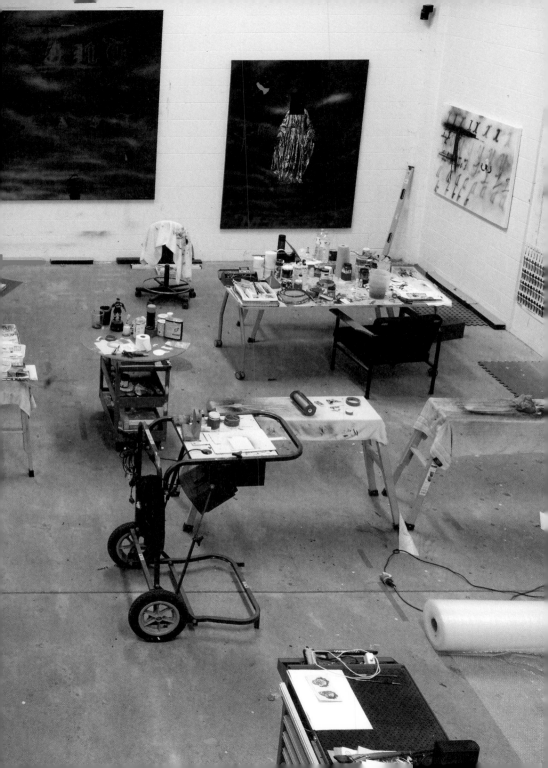

Cotton was a key figure of that moment. He developed a signature 'sepia' tone in his paintings, which provided the ground for a range of forms he appropriated from the period that straddled the signing of the Treaty. He used flags, symbols associated with Māori resistance and religious movements, ships, wooden buildings, waka, ceramic urns and potplants. Te Kooti's Ringatū churches – Rongopai in particular – were sources of fascination for him, discovered through Roger Neich's seminal book *Painted Histories*. New Zealand's colonial history was pervasive; Cotton's paintings belonged here, and nowhere else.

They also shot him to local prominence. He was the most easily absorbable Māori artist of his generation; his paintings were polemic, to a point, but never confrontational in the way Peter Robinson's swastika works or Lisa Reihana's video *Wog Features* were, nor as ironic or playful as Michael Parekowhai's sculptures. He became, by his own admission, the unwitting poster boy for a watered-down conversation about biculturalism.

The first big test of Cotton's cultural status came in 2003, with that early career retrospective at City Gallery. The show confirmed his ascendance into New Zealand art's pantheon, but it was also his first attempt to slip the bicultural net. Leonard describes the show succinctly:

> Downstairs, curator Lara Strongman assembled a tight, greatest-hits selection of Cotton's works from the previous decade. Upstairs, Cotton presented a cycle of seven large diptychs that were wildly new in imagery and treatment. The show felt like two shows in counterpoint, as if two artists were being presented: downstairs, the Cotton the gallery and 'the culture' expected, even demanded; and upstairs, the Cotton Cotton wanted.

The shift implied here was Cotton's abandonment of the sepia ground and the colonial imagery. Instead, the grounds of his new paintings were mainly black and flat with birds, heads and targets painted on them – developments that had their roots in his earlier self-created gang patches.

'I was initially drawn to gang regalia because of the aesthetic,' he explains. 'But I was also interested in how gangs are disconnected from things. They make up stuff for survival, be it good or bad. I grew up in Upper Hutt, where you'd see gangs regularly – the Mongrel Mob, Sinn Fein, Highway 61, white gangs, Māori gangs, mixed-race gangs. These are people who are disenfranchised but, on the other hand, who don't want anything from society. I've always found that interesting, particularly for young Māori men who feel this need to connect. It's a really strong outward expression of wanting to be considered.'

In *Patched: The History of Gangs in New Zealand*, sociologist Jarrod Gilbert explains that early gang culture here was a result of two major influences. First, the American biker group Hells Angels established a chapter in Auckland in the early 1960s. Second, the rapid urbanisation of Māori and Pasifika people in the 1950s and 1960s led to a loss of traditional tribal structures. For many young men, the gang arose as a solution to the need for a collective identity and also as a bulwark against the racial discrimination experienced in New Zealand's cities, not least from the police. Violence and transgression were, for gangs like the Mongrel Mob, ways of life. Gilbert recounts many horrific examples of the gangs' active willingness to overstep societal boundaries, from random attacks and public brawling to murder and rape.

This history is implicit in Cotton's paintings. But for him, the patches have other cultural resonances.

'They also come out of carving,' he explains, 'and the prominence of the eye in the manaia. And although I didn't think consciously about Ralph [Hotere]'s circle works at the time, that's in there too. Basically, I had this idea that the painting should have a big eye that looks back at you. I also liked the idea of taking the patch – something that has connotations of that which is bad, that which is violent, that which is disgusting to mainstream society – and letting it sit above a Christian text. That, for me, was it in a nutshell; not necessarily trying to be good, but trying to be faithful.'

Oblique Narrative, 2015

Cotton has faced consistent questions throughout his career about faith, about whether his work is an attempt to make sense of his own convictions. It's something I've never been quite sure about when looking at his paintings – whether they're a form of cultural pastiche, or statements about a private belief.

'I get it from all angles,' he says. '"What's your take on Christianity? Do you have a belief system?" But really, I see my paintings as observations. If I go to a meeting house in the North, I don't see any art but I hear a lot of words connected to Anglicanism. I hear them, and I'm going, What's happened? Can these different systems exist in the same space? People find ways of dealing with it, and things become very unusual. Like the way rituals are performed: all this heavy Christian laying on of hands and then, whoa, Rangi's still up there, and Papa's still down there, and then, wait a minute, there's God again, popping in and out of the space.'

With the black ground, his use of language, and his borrowings from Māori culture and myth, Cotton has also been subject to comparisons with the painter who casts the longest shadow across New Zealand art history, Colin McCahon. Cotton, though, sees a clear distinction.

'McCahon had questions about his own faith. I've never wanted to ask those questions in paint. I wasn't brought up a Christian, but I was surrounded by family who were. There was a huge expectation that having belief and living a life through The Word would deliver something. But it didn't. If anything, it just blanked everything out, made everything black. There were shadows everywhere. And all you had were words. Well, what fucking good are words? For me, their good is that they can become images in my paintings. Painting's the religion. Painting's the thing.'

It's an interesting idea; that in our contemporary world a medium like paint might take the place of faith. It's also not an entirely new one, and seems to sit easily in places with violent, colonial foundations.

HOUSTON IS A massive city in the southeastern corner of Texas. Not far from the Gulf of Mexico and just a few hours from New Orleans, it's in hurricane territory; a subtropical, sticky city.

By the time I arrive, Houston's curtains are drawn. I'd spent three hours at LAX on the tarmac after a twelve-hour flight from Auckland, because there was something wrong with the plane. I'm tired and in an obscenely bad mood. A chatty Eritrean taxi driver, training during the day to become an oil-rig engineer, drives me to where I'm staying: a tidy home near Rice University, owned by an amateur painter and a bail bondsman. They've stayed up waiting, even though it's well past midnight, to give me a Texan welcome. They show me my room, and I fall into the bed.

I'm mainly in Houston to give a talk at Rice about Yvonne Todd's take on suburbia. It feels like the right topic in the right place; Houston is a prime example of America's twenty-first-century suburban expansion. It's fast closing in on Chicago as the country's third largest city, and much of that is due to middle-class spread. But I'm also here to look at art, because Houston is a tremendous place to see twentieth-century painting.

That's because of one woman: Dominique de Menil, who transformed art patronage in Texas. Dominique and her husband John had moved from Europe to escape World War II, and, using the vast Schlumberger oil fortune as their platform (Dominique was its heiress), began to think about how collecting and commissioning contemporary art might renew our connection with the spiritual in a postwar, post-Holocaust world.

The de Menils' drive to help artists examine the intersections between the religious, the political and the unconscious became a vital force in mid-century American art. In 1964, they commissioned the painter and fellow European émigré Mark Rothko to create a massive suite of paintings for a non-denominational chapel in Houston.

The chapel itself is an almost empty octagonal space. The only furnishings are a few wooden benches and some kneeling cushions. The floor is asphalt, the walls grey gypsum. Soft natural light slips through a suspended

Interior view of the Rothko Chapel, Houston, Texas

ceiling; lights installed but not on. A passing cloud can change the entire room. It is dead silent but for the distant hum of the air-conditioning system.

As you enter, you're confronted first with a massive triptych – a wall of purple-black light. The paintings are far bigger than you, and the closer you get, the further you tumble into their surfaces. Their insistent darkness pushes back. There's a jetlagged shimmer at their edges, where the shadows and the wall meet.

On the three other main axes are more classical Rothko paintings; his signature floating rectangles, delicately bouncing between dark shades. But it's the four individual panels in the corners that are most surprising. Ripples in them look like storm clouds. As the light shifts, phantom presences start to appear. There are ghosts and there are voids and there are clouds and there are skies.

They are not about the afterlife either. They are about the immensity of what we're capable of doing: that we might make something like this, just to be with it. The Rothko Chapel isn't about projecting into the future or remembering a traumatic past. It's about absolute presence. It's the point at which a painting stops being a painting and becomes something else; a transition between states.

I grew up without religion. But I did grow up looking at McCahon's paintings and, later, Cotton's. And in the Rothko Chapel I start to understand what the sacred in their work might actually be; a space where events and histories and traumas and loves and bright points of light stop forming a line in your past and become a constellation instead: one that doesn't have a start or finish, but forms a constant picture of where you are right now.

FOR COTTON, FAITH and the sacred emerge in the moment of colonial collision, which his paintings both describe and become. Most recently, this has manifested itself in his visceral, even orgiastic, preoccupation with a single

form: toi moko – those severed and preserved Māori heads. He has returned to them again and again.

This has been difficult to make sense of. In Houston, though, I find myself thinking about his heads a lot. Houston is a city built on the dual forces of faith and violence. Founded in the nineteenth century, it was named after the man who first won Texas from Mexico and later made sure it became part of the United States.

The Texas Revolution is an essential building block in America's mythology: the battle of the Alamo, Davy Crockett, and all manner of other convenient half-truths that lie at the core of American frontiersmanship and masculinity. It was also an essential forerunner to the ecological and indigenous destruction that occurred as the South and West were conquered by guns, the telegraph and rail, which, as Rebecca Solnit so beautifully points out in *River of Shadows: Eadweard Muybridge and the Technological Wild West*, gave America a unified, bordered sense of itself – a sense built on blood and death and sand.

Cormac McCarthy turned this time and space into hell in his 1985 novel *Blood Meridian*. In it, Texas and the Mexican border form a godless, heathen purgatory through which the Glanton gang (based on real-life mercenaries of the late 1840s) roam – paid by the scalp – looking for Apaches to kill. A couple of decades before these mercenaries crisscrossed the Texas desert searching out scalps, Māori chiefs fighting in New Zealand's intertribal Musket Wars – which started in Cotton's tribal homeland of Northland – were engaged in a similarly gruesome project: trading severed and preserved heads with Europeans for guns.

Traditionally in Māori culture, toi moko were objects of great reverence. European collectors and museums were keen to get their hands on examples of this 'primitive' art form. As Leonard points out, several canny chiefs recognised this as a market opportunity, tattooing slaves and trading the results for firearms. Rather than being sacred, these 'mokomōkai' became kitsch, and even, in Leonard's framework, vampiric: objects for a market

and evidence of a culture knowingly consuming its bodies and traditions – products not of arcane tradition but of modernity.

Horatio Gordon Robley was a major collector of toi moko and mokomōkai in the late nineteenth century. He was the ultimate collector-soldier, having become fascinated with Māori culture while serving in the New Zealand Wars of the 1860s. Robley is perhaps best known for being the subject of one of the most troubling photographs in New Zealand's colonial history: an image of him, with his head collection. In it, he sits casually, one leg crossed over the other, holding a patu, staring contemplatively into the middle distance. His head collection seems to float behind him, half a dozen drifting far enough apart to create a kind of gruesome aura.

The photograph – rather than the heads themselves – has been essential to Cotton's work, acting as both a plague and a productive force for years.

'I wanted to see whether I could take a heavily laden image from our history and say something different with it,' he explains. 'I never wanted to take a side with the heads, and I didn't want to get too close to them. I was interested in how history had digested them. A lot of people know a little bit about the trade; it's something Māori have been tagged with – the idea of the cannibal, that sort of stuff. But the tradition of removing the head from the body is an art form. It's a peculiar form of art, but nonetheless it's a form of art. I think they're really about what it means to have and hold on to a memory or retain a likeness, which is also what painting was historically about. So I thought I'd start painting them and see what happened.'

This idea that the heads preserve a likeness is intimately connected to Robley's own interest in collecting them. His primary purpose wasn't to surround himself with gore, but to understand and document the practice of moko. As well as collecting the heads, he wrote a famous book that analyses Māori tattoo, and which, much like Charles Goldie's paintings, was intended to capture an important aspect of Māori culture before it disappeared.

This points to one of the great tensions of colonialism – the close connections between knowledge, death and erasure. The wiping out of Māori

customs was seen as an inevitable consequence of the drive towards modernity. But, as we know, traditional Māori – and more broadly, Polynesian – culture never died out. It also had an enormous impact on the development of European modernism. Gauguin, Matisse and Picasso were forever changed by their encounters with artifacts from the South Pacific and other so-called 'primitive' cultures. The intersection between colonialism, violence and museology, then, was an essential force in the birth of twentieth-century art.

In 1984, New York's Museum of Modern Art sought to understand this influence. Curated by William Rubin and Kirk Varnedoe, '"Primitivism" in Twentieth Century Art: Affinity of the Tribal and the Modern' juxtaposed the great masterworks of the early 1900s with the ethnological objects that had such a profound effect on their makers. While noble in intent, the exhibition copped enormous flak for its perceived cultural hierarchy, placing Western painting at its apex and the ethnological forms as its source material. Starting with a seminal critique by Thomas McEvilley in *Artforum*, the exhibition became a cornerstone of postcolonial debate.

At exactly the same time, an enormous exhibition of Māori art, 'Te Maori', was on display at New York's Metropolitan Museum of Art. For Māori artists – and Cotton's generation in particular – 'Te Maori' was as much a crucial turning point as Rubin and Varnedoe's exhibition. Yes, it presented Māori art on an international stage. But at what cost, as art historians such as Rangihiroa Panoho have examined, to how we understood the contemporary versus the classical? Like Rubin's exhibition, 'Te Maori' established hierarchies, with carving clearly at the top. It also seems an interesting coincidence that Robley's heads were right there, in the same city, at the same time – in storage at the American Museum of Natural History. Robley had sold them to the museum in the early 1900s, having first offered them to the New Zealand government. They weren't returned to New Zealand until late 2014.

This confluence of events in New York is emblematic of the complexities of representing colonised cultures, particularly in an age when those former

colonial powers have started to acknowledge the massive detrimental impact their imperial ambitions had.

Cotton's use of the Robley heads is part of this picture. He has clearly benefited from the shift that emerged in the wake of the '"Primitivism"' and 'Te Maori' exhibitions. His career, and his cultural reception, has been built on his status as a Māori artist. Implied in this is the sense that he has access to certain knowledge that his Pākehā contemporaries don't. For Cotton, though, that jacket has never been an easy fit. Like his imagined gang patches, there is nothing reverential, spiritual or particularly unique in his relationships with the heads. Painting them is simply an act of re-presentation: a way to keep them in play as the disruptive residue of our violent history, still alive, staring back at us.

IN LATE 2012, the largest survey of Cotton's work since the 2003 retrospective opened at Brisbane's Institute of Modern Art (IMA). Titled 'The Hanging Sky' and curated by Paton, it was a Christchurch Art Gallery exhibition derailed by the earthquakes. Leonard was the director of the IMA at the time, and picked up the show.

As its title suggests, the exhibition was built around a defining formal shift in Cotton's practice: the use, as backdrops for his paintings, of stormy, spraypainted skyscapes. Cotton's skies are generic; they don't belong to a single place or time, and certainly not to the Land of the Long White Cloud. Initially, they were a way for him to rebuild spatial depth after working for so long with flat black grounds. They also became spaces where physics doesn't matter and where forms can tilt and tumble and warp, unburdened by gravity.

Cotton's shift into the clouds was a prolific one. 'The Hanging Sky' showed the full gamut of his output during this period, from the very good to the downright infuriating. *Outlook (Blue)*, 2007, for example, is a relatively

Easy Forever, Forever Easy, 2010

early sky work in which Cotton laid down markers for what was to follow. At its centre is a head, shown frontally, its dried lips curling back to reveal dead teeth. In the centre of its forehead is a single red dot (in later paintings, this dot grows into circles that obscure entire faces). Around it, humming-birds dive through the sky at wild angles. The head itself is decorated with foliage, as though being revered in some ancient ritual, or as if the birds are turning it into a nest.

There were also works like *Easy Forever, Forever Easy*, 2010, in which too much of Cotton's inner biker emerges. The silhouette of a bogan Madonna hovers against a craggy rockface with red wings springing from it. At the wing's tips are vulture's heads, turned down like the handlebars of a chopper motorcycle. Swallows dive in and out of the scene, while at the bottom two rivulets of red paint run upwards, like blood going against the tide. And above it all, in spraypainted Gothic letters, are the words 'Easy Rider'.

It's cheesy, and over-the-top, and kind of gross. But writing this, there's the same nagging doubt I had when I first saw it: that it might actually be a great painting; that I'm just missing something; that perhaps its excesses are well-laid traps.

The pervasive inconsistency in his work and the uncertain effect it had on me was the moment I became convinced there was more to Cotton than I'd given him credit for. Time and again in 'The Hanging Sky' I was knocked off-centre: amazed, angered, annoyed, won over. The question of how much Cotton was in control of this diminished the longer I was with the work, replaced instead by a cumulative feeling of nervous energy: not in the sense that Cotton was unsure of what he was up to, but that he was moving around in an attempt to get to the heart of something embedded in the conversations *between* his forms – the skies, the birds, the heads, the words.

In one room there was a long line of slick, proto-modernist targets, which Cotton had printed in Israel. He had then painted small heads on them,

along with small bands of colour: delicate interventions that combined the traumas of colonialism with the purity of modernist form.

In another space, he displayed a line of painted baseball bats. Worked on a lathe and painted with rings of colour before other images were added to their curved surfaces, these had always been confusing objects in Cotton's oeuvre. In 'The Hanging Sky', they started to make sense. When I asked Cotton about them months later, he talked about their latent violence: the sense that they could inflict terrible damage while being objects of profound beauty, similar to the way we view and understand taiaha.

It was, however, hard to escape those skies. Cotton is clear that they're a formal device and bucks strongly against my suggestion that they might have anything to do with faith. But he is equally surprised that he has rarely been called on the fact that they borrow so directly from the American painter Ed Ruscha (though Paton has drawn attention to this) – who, time and again, has painted words or hard-edged forms like buildings and gas stations against big skies.

Ruscha is an important member of a generation of Los Angeles-based artists who shifted some of America's art discourse away from New York in the 1960s. As the critic Dave Hickey explains of this West Coast move:

> The ocean and the desert are always there: their atmospheres assure us that we live in the shimmering midst of a 'full world.'
>
> The easy Euclidean distinctions that constitute the very stuff of American artistic identity dissolve. Life blurs between our bodies and our minds, our bodies and the world, between sight and touch, earth and sky, land and sea, large and small, near and far. Existing on a daily basis in a comfortable, breezy relationship with the natural climate and feeling oneself 'at one' with the world, the traditional Northern European distinction between the spaces we call negative and those we call positive evaporates – this occludes the glamour of that 'world elsewhere'; it dims the past and dissolves the future in the bright mystery of the here and now.

Hickey's explanation, though thoroughly LA-centric, nonetheless resonates with other Pacific cultures. Central to what he describes is the relationship between light and the sky, and their combined consequences for the way we see and react to objects in space. The quote also contains an unintentionally perfect summation of Cotton's sky visions: 'Life blurs between our bodies and our minds, our bodies and the world, between sight and touch, earth and sky, land and sea, large and small, near and far.' In Cotton's sky paintings, objects can appear at any size: a sparrow can be huge or distort so that it stretches across the sky; a head can be tiny; concentric circles that once might have been Mongrel Mob patches can consume the universe. We can't – and shouldn't – separate them out from each other or try to read them as individual symbols or markers because they only exist as a singular whole – not on, but in, their skies. They rely on each other completely.

Cotton's early works were cartographic; they mapped a cultural and social terrain. They were more informational than experiential, an extension of what was basically a literary discussion of New Zealand's colonial legacies. By contrast, his sky paintings and everything since have functioned first and foremost as images. Maps rely on keys and our ability to understand scale, to read them in a singular way. Images, Leonard suggests when discussing Cotton's surreal turn, privilege slippage and misbehaviour: the spaces between forms, as Cotton's paintings show, are where new connections are drawn, and where meanings can be simultaneously made and undermined.

IN THE FINAL room of 'The Hanging Sky' was a huge, multi-panel work, 'The Haymaker Series, I–V', 2012. When viewed as a single work, it's one of the largest paintings Cotton has ever made – each of the five panels is 2.2 metres tall and 1.8 metres long. It is, as its title suggests, Cotton throwing everything he's got at us.

The first panel gives the series its title. It is dominated by a representation of a carving by a great 'Māori modernist', Arnold Manaaki Wilson. Skewered on Wilson's sculpture are various objects: a bird, a lump of rock that looks like an asteroid, blue and red balls. In the top left corner is the thing Cotton has been avoiding for so long: a landscape, framed in the sky. Along the bottom is a band of targets, now so far removed from gang patches they look more like an homage to Cotton's deceased contemporary, Julian Dashper.

In the next panel, *Diamonds and Circles*, Cotton tears open the sky with a giant diamond void. Inside are its mechanical guts: wheels and cogs and circles, some of which turn into eyes that stare back at us. The hint of a mountain range pushes its way up into the picture and a potplant rests on a table, both of which hark all the way back to where he started.

Next is *See.r*. On a plinth is an amorphous sculpture, a bit like a Barbara Hepworth or a Henry Moore. There is also the first appearance of a head, floating, almost completely obscured by a cream-coloured dot and a blue band of colour. The rest of the panel is dominated by two frames: in one, Cook's *Endeavour* is trapped inside a thick black border. Above that, a thinner frame of blue and pink bands provides an outline for nothingness – just the empty sky beyond.

Coloured Dirt Dreaming makes up for the lack of heads in other panels. There are eighteen in all, arranged in a grid, floating like they do in the original Robley photograph. Cotton has blocked out their facial features with coloured dots, which fix them to the sky. Driftwood flies between them. In the bottom right are two more birds, skewered, as they are in *Haymaker*, on pedestals – frozen forever.

Finally, there is *Staging Post*, in which Cotton's desire to have a painting stare back at us is taken to an almost ridiculous extreme. The panel is dominated by a giant eye, secured on a pedestal. If we were in any doubt this is a manaia, the stylised three fingers in the top left corner confirm it. But there's also a lumpy cartoonishness to the form, reminiscent, as Paton points out,

of Philip Guston – an effect augmented by the fact it almost looks as though the manaia is smoking. There's also a fawn, in tribute to Michael Parekowhai, a piece of Peter Robinson chain, and a bizarre, organic form stuck to the pedestal-tree, which could be an ear or some other orifice. There's a head here too, only this time Cotton has reduced it to flat bands of old-school Apple Mac colours.

'Haymaker' is as sobering and confusing as it is ambitious. As Paton writes: 'What rises from the work . . . is a feeling of serious play and wilful impurity, as Cotton steals back from himself images that were frequently burgled from others in the first place.' He goes on to describe Cotton as a magpie, implying that he's someone who spots shiny things in the culture, snatches them, and builds up a collection that makes sense to him, even if others initially fail to see the logic. But 'Haymaker' also seems to signal the end of something. It is Cotton's work entering its own event horizon – a painting in which he replays New Zealand's origins over and again: the moment in which two cultures crashed into each other, and everything we know was created.

IN LATE AUGUST 2015, Cotton and I catch up one more time in Palmerston North. He's just back from the US, where he's been riding motorbikes across country. He's still jetlagged. There's no point in us going to the studio, because there's nothing there, so mainly we sit and talk about the trip, and his plans for his next body of paintings.

'I'm trying to press on with how to get disparate things to relate to one another within the painted space,' he says. 'Things that are out of sequence or out of step with one another but somehow in the painting find a way to be together. Not necessarily in a comfortable way, more a sense of grappling with each other. I also want to try to make an image that endures somehow. Something that I wouldn't see anywhere else.'

The Haymaker Series I–V, 2012

Quite what those paintings will be made up of is hard to pin down. He talks about his attraction to the 'epic' quality of hard-edged abstraction, but knows he can never do that just on its own – that an abstraction always needs to come into a conversation with something more organic, like a head. He also mentions that he's thinking about returning to one of his earliest motifs, Victorian potplants, which he sees as an 'enduring form from New Zealand colonialism that I didn't quite deal with fully in the past'.

I ask him to talk more about his travels through the States.

'When I was away,' he says, 'all I saw was big skies. When you're travelling along, you see these derelict signs beside the road, which often have holes in them. And when you look through the holes, you see a bit of that big sky. I like the idea that a painting might reflect that. It's a play on the idea of signs, and that in those gaps there could be images. This has a lot to do with understanding the importance of narrative in paintings, of telling or grappling with a story. I'm not interested in the stories themselves, but in the idea of stories as a way to convey information.'

So you're interested in the sign of a story, rather than the story itself? I ask.

'Yeah. I have the feeling that we're very disconnected from stories, particularly myths, as the continuity between us and them is chopped away or eroded. So what fills that void?'

It's a telling summation of the way he thinks. Cotton's entire career has been driven by this attempt to fill a void. But this isn't about his own disconnection from his Māori origins. Rather, it's that the picture plane is the void, and disconnection is his defining subject. The heads, the gang patches, the lifting of symbols from Ringatū churches – all of them are tied by Cotton's ability to see alienation and then apply his own alienating force to it. He makes us fall through fractured historical space, each juxtaposition and layer causing yet another break in the story.

'When I was riding, we went through Navajo country,' he continues. 'We stopped at a couple of places. I could relate it to a lot of the problems

Māori have here. It was a very similar vibe. But the difference was it was heavy with sadness. You could almost touch it. We'd stop at these places and they'd have their little stalls set up, selling their bits and pieces. But there was something not right about it. It's all done out of survival, but it seemed to me that something was not connected there at all. It was exactly like when I was in Israel.'

There is no question that Cotton is drawn, constantly, to the visual consequences of colonialism, wherever he goes. But he is also adamant that his desire to paint such things isn't about a particular ethical position.

'No. Because a lot of it I'm confused by. I get tongue-tied when I try to describe it. But I know what I see. I always felt, right from art school, it was really important to be an observer; that the observation of things was important. The treatment of the heads is the same. It's a slice of observed history, repackaged. But it's not a moral position. It's not about that for me. I've always stood on the outside of things. It's the way I've always been.'

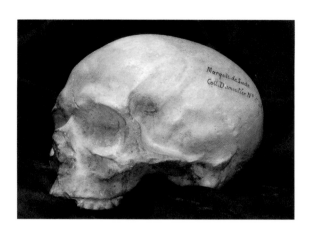

Moonlight de Sade, 2010

What might we learn from a head? Robley's collection of toi moko and
mokomōkai was, in his thinking, essential to the forces of preservation
and ethnographic scholarship. It was just one part of a wider colonial
preoccupation with the cranial, and with what the structure of our skulls
might reveal about our differences. Phrenology was, in the late eighteenth
and nineteenth centuries, widely practised and widely accepted as an
attempt to understand how the physiology of the head might correlate to the
interior life of the mind.

It is, of course, quack science; dangerous bunkum that became a crucial
tool in European imperialism, used to demonstrate the supposed inferiority
of colonised people and, therefore, the inherent intellectual superiority of the
colonisers. One of the major practitioners of this was Pierre-Marie-Alexandre
Dumoutier, who accompanied Jules Dumont D'Urville on his voyages to the
Pacific in the late 1830s. A committed phrenologist, he made dozens of life
casts of the indigenous peoples he encountered throughout Melanesia and
Polynesia, including in New Zealand.

Some of his life casts were taken from Fiona Pardington's Ngāi Tahu
ancestors. Much has been written about Pardington's discovery of
Dumoutier's casts in Parisian museums. Her large-scale photographs of
these casts have been shown extensively, including at the 2010 Biennale of
Sydney, and a lavish book is dedicated to them.

They are tremendous images. But at Pardington's survey exhibition,
'A Beautiful Hesitation' at City Gallery Wellington, curated by Aaron
Lister, they weren't my primary interest. Instead, I became fixated on a
related image: a cast of a skull, which is in the Flaubert Museum in Rouen.

81

Dumoutier's name is written on its chalky surface, along with the moniker of the person it allegedly came from. It is, apparently, a cast made from the skull of the Marquis de Sade.

The photograph has all the lushness we've come to expect of Pardington's work, the skull-cast filling most of the frame against a dark, velvety ground. It is also a rampant art cliché: a clunky *memento mori*. Pardington can at times be heavy on the symbolism, even, as some of her recent still-lifes have shown, heavy-handed. At face value, this looks like one of those occasions. But the more time I spend with the photograph, the more I realise her treatment of Sade's skull is different. It is in fact a vital connecting image within her practice, which has helped me to understand the overall significance of her thirty-year body of work.

I HAVE A PENGUIN Deluxe copy of Sade's *Philosophy in the Boudoir*. On its cover is a Manga-like illustration of a couple on a chaise longue; he with a hand up her skirt and his vampiric mouth (toothy, a red tongue emerging) poised near her neck; she with legs wide and an ecstatic, flushed face. On the back cover, her entire body has turned scarlet, his vampire-mouth buried firmly between her legs, an open book cast aside on the floor.

Inside the back cover is the rear end of a horse – for reasons that become apparent to readers brave enough to stick with the book. Inside the front is the following excerpt:

To the Libertines

Voluptuaries of all ages and sexes – it is to you alone that I offer this work. Nourish yourselves on its principles: they foster your passions; and these passions, with which cold and shabby moralists try to intimidate you, are simply the means used by nature to help human beings attain nature's goals. Listen solely to those delicious passions; their source is the only one that will lead you to happiness.

> Lubricious women: may the voluptuous Madame de Saint-Ange serve as your ideal; take her example and despise everything that flouts the divine laws of pleasure, to which she was fettered an entire lifetime.

Written as a series of dialogues, *Philosophy* centres on the defilement of a fifteen-year-old virgin by a pair of aristocratic libertines. As the teenager starts to embrace her corruption vociferously, other characters join in the fun; men with huge cocks who shoot absurd amounts of sperm, the female corrupter's (similarly hung) handsome brother, and eventually the teenager's own mother, who becomes the subject of the entire group's sexual violence.

The mechanical couplings, triplings and quadruplings are ridiculous. In between their debaucheries, the characters offer up philosophical ruminations about republicanism, the state of contemporary France, and its contradictory morality. The entire book is a bounce between humping and pontificating, giving it its timeless title.

It's easy to see why a phrenologist like Dumoutier would prize Sade's skull-cast; no doubt he believed the exterior shell held clues as to the neural location of Sade's comical, violent perversions. Even now, there's every reason to be fascinated with it; not because its shape and form might reveal something about the mind it contained but rather because it is a nagging reminder of the space between Sade's imagination and his raw physicality. Here we have a trace of the man, and not just any trace, but the casing for the brain that produced his fantasies.

Pardington's treatment of the skull-cast goes to the heart of how we understand Sade and feel about his writing. Everything he wrote was just words on a page, dreamed up by a hardcore pornographer. Yet we often read his imagined corruptions as real, in part because we know in retrospect that he lived plenty of what he wrote. We even use his name for an entire sub-category of sexual practice.

This space between the description and the act – between reading about sexual power and actually exercising it – is what makes Sade such a vital

literary figure; the progenitor of a tradition that takes in DH Lawrence, Henry Miller, Georges Bataille, Anaïs Nin, Pauline Reage and Bret Easton Ellis, to name a few. In each and every case, there has been a furore about where the line between pornography and art is: the former gratuitous and socially damaging, the latter essential to the advancement of culture. Time has almost always come out on the authors' sides, proving that there is always a threshold – a teetering space where the violence of language can have a revelatory impact on how we understand the potential of our bodies in relation to each other.

Photography has suffered just as much at the hands of moralists. Robert Mapplethorpe's explicit photographs of BDSM and other sex acts became a touchstone of the art versus pornography debate in America. So did Larry Clark's early photographic series 'Tulsa' and 'Teenage Lust', which showed stark, often terrifying images of teenagers engaged in sex, shooting up and playing with guns (later, he would make *Kids*, a brutal coming-of-age AIDS-era film). Diane Arbus too, as discussed in the chapter on Yvonne Todd, has been accused of violence and cruelty towards the unfortunates she photographs.

Pardington has regularly worked in this space. In early works like *Choker*, 1993, for example, we see bruising around a woman's neck but have no way of knowing whether the injury is the result of a consensual encounter – the image's ambiguous title alluding to both a tight-fitting necklace and a person who may have caused the bruising. In her series 'One Night of Love' from the 1990s, Pardington rephotographed pornographic proofsheets from mid-century England – dozens of vaguely unhappy-looking girls with their tits out, captured by the camera a second time with all the imperfections, scribbles and scratches of the original proofs made visible. In 'The Medical Suite', 1994, Pardington raided old medical textbooks and rephotographed images of bodies in various states of distress, distortion and poxiness. It is precisely in this Sadeian space, between the description and the act, that Pardington's work gains its electric physicality.

In recent years, Pardington has shifted her focus to museum collections. It's tempting to see this work as somehow more earnest and worthy than the earlier sexual images, but it is driven by the same logic. There are her photographs of heitiki, which, in Māori culture, have their own life force, their own mauri – objects worn on the body that are also bodies in themselves, now separated by museum glass from human skin. There are her photographs of hallucinogenic mushrooms in museum display cases, their psychotropic effects denied by the fact that they're actually stand-ins for the real, mind-altering fungi. And there are her heads: likenesses of her ancestors rendered in plaster for the cool contemplation of European men who believed the shape of a skull could reveal everything they needed to know about the complexities contained inside it.

Museum classification and sexual power are about desire for the Other and our urge to conquer – to take our pleasure from them while also making them known, exposed and controllable. It's also easy to take a moral high ground and emphasise the negative impact classification or sexual control can have on those subjugated or sublimated by them. But is it so simple?

It's Pardington's ability to keep us one step removed that I find most compelling in her work: her photos of photos, the bruises around a neck rather than the bruising act itself; fake mushrooms; life casts rather than actual human remains. In keeping us at arm's length, she raises, rather than reduces, the stakes for our voyeurism and consequent desire by forcing us to confront the fact, and the act, of looking. In doing this, she shows us that we are equally complicit in her power play over her subjects; a willing partner in her ambiguous cruelties.

Sade's skull, then, is more than a curiosity. It's a key that unlocks the uncomfortable truths at the heart of Pardington's practice. It's also a glimpse at immortality, at the mind of a man whose demand that we stay connected to our physicality changed the way we think about sex forever. I'd love nothing more than to hold it. Instead, I'll have to satisfy myself with Pardington's photograph of its double, inscribed with another man's name.

Billy Apple with B.E.A Flight over East Berlin, 1961

Live Forever

In Manassas, Virginia, a 126,000 square foot building houses one of the world's largest collections of genetic material. According to the American Type Culture Collection's (ATCC) website, its mission is to serve

> U.S. and international researchers by characterizing cell lines, bacteria, viruses, fungi and protozoa; developing and evaluating assays and techniques for validating research resources; and preserving and distributing biological materials to global public, private industry, and government research and scientific communities.

Among its 3400 cell lines, 18,000 bacteria strains, 3000 human and animal viruses and eight million cloned genes – all stored alive, ready to be deployed in the wars against illness, ageing and disease – are a handful of living cells, constantly multiplying, from New Zealand. They belong to the artist Billy Apple.

For more than fifty years Apple has been one of the most inventive practitioners of art in the age of mechanical reproduction, using everything from bronze editions and photography to Xeroxes and printed receipts. Now, biotechnology presents him with the possibility that he could reproduce himself. Theoretically, all it would take is for one zealous collector in the future to decide he or she wants an edition of 'Billy Apples' and the artist, as one of his recent canvases declared, will live forever.

Immortality also seems the perfect coda to a career that started, on a cold London day, with the disappearance of a twenty-six-year-old New Zealander called Barrie Bates.

APPLE IS ONE OF New Zealand's most divisive cultural figures. I'm an absolute believer in his work. I think it's a travesty he's never received the highest accolades this country has to offer its artists. Apple has never been a finalist for the Walters Prize. Nor has he been given the opportunity to represent the country at Venice. Overseas, he is recognised as one of the most important artists New Zealand has ever produced. He has, however, had to wait for this. It wasn't until a major retrospective in Rotterdam in 2009 that influential figures in the international art world reawakened to his work. Since then, the attention has been consistent.

But many people here still think he's a charlatan. The man obsessed with his own name. The man who gets other people to pay his bills, who outsources everything, who collects grand prix motorbikes and makes work out of gold. The man who has made himself a trademark. The law firm MinterEllisonRuddWatts has canvases in its offices stating the amount of credit extended to Apple over recent years. It's a lot: the process of becoming a registered trademark has clearly been a long, expensive and litigious one.

In March 2015, the line between his supporters and detractors was put to the test by his retrospective, 'Billy Apple®: The Artist Has to Live Like Everybody Else', at the Auckland Art Gallery (AAG). Its curator, the Wellington-based art historian Christina Barton, described it as 'an extended self-portrait, of a man and an entity called "Billy Apple" negotiating and interrogating his relationships both with himself and with the world around him'. With around 200 works, it was the largest solo exhibition the AAG had presented in years.

When I caught up with Apple a month before the show opened he was flat out, not just preparing for the retrospective but trying to keep on top of all the other projects he had on the go. Exhibitions in Mexico City and London. A launch of his apple cider with Saatchi & Saatchi. An attempt to find the exact centre of Zealandia – the vast underwater continent our lumpy islands sit at the top of. And *The Immortalisation of Billy Apple®*.

Everything Apple does depends on his ability to find, and work with, collaborators at the top of their respective fields: scientists, signwriters, apple breeders, coffee blenders, art dealers, curators, photographers, printers, mechanics and so on. His partner Mary Morrison is a crucial member of the team – the person who answers the emails, co-ordinates the dates, checks things over. She's an ex-critical-care nurse and artist who looked after Apple following a hernia operation in 1998, and they've been inseparable ever since.

Everything Apple does is about himself. 'To understand the art,' Morrison says, 'you have to understand the man. You have to understand that it's per-sonality driven. And Billy doesn't have an average persona. People say his work is simple, but it's not. It's pared back, and pared back, and pared back until he can cut away no more. That's when he's got to the purity of the point.'

The fact that his work is primarily motivated by subtraction rather than addition – by taking things away rather than building things up – is also what makes Apple the perfect candidate for emperor's new clothes attacks; the suspicion some people have that there may not be anything there at all. For me, though, this is the compelling anxiety at the heart of his practice: the desire to assert his presence in the world forcefully, everywhere and in every form – as art, as design, as commodity, as brand – alongside a deep, simulta-neous need to disappear from that world. It's a contradiction that gives his work its complex humanity. And it's what keeps me coming back to it, again and again.

IN 1959 BARRIE BATES, a young graphic designer, left New Zealand to take up a place at the Royal College of Art in London. Once there, he found himself part of a remarkable student intake; among his classmates were David Hockney, Derek Boshier, Allen Jones, RB Kitaj and Pauline Boty. Collectively, they would go on to spearhead British pop.

Bates and Hockney became particularly close. They were mirrors of each other: Hockney the boy from Bradford; Bates the lad from the colonies. One gay, the other straight. And both ferociously determined.

'Both of us wanted to work hard,' Apple says. 'Not just fuck off to the pub. We'd often work at nighttime. We'd hide out and they'd shut the place down, and when things were quiet, we'd come out and go into the print department, or we'd go to the supply place, climb the wall and steal a roll of canvas. Whatever had to be done.'

At Apple's home, we look through a pile of photographs of Bates and Hockney. There are several of them together at an amusement park. It's the summer of 1961. The pair had travelled to New York on a student charter flight. Apple tells me they stayed in the city separately – Bates in Manhattan with a filmmaker and jazz reviewer called John Craddock; Hockney with another of their classmates out on Long Island. Bates was working in the city; having become obsessed with American advertising, he'd landed a month's work experience with one of his Madison Avenue heroes, Herb Lubalin. But he and Hockney still managed to find time to meet regularly, including, as the photographs show, at Coney Island.

I look at four images from the day, arranged in a grid. In the first, Bates and Hockney are overlooking the amusement park, each wearing a badge. Bates's says 'I Like Girls', Hockney's 'I Like Boys'. Hockney hams it up for the camera, biting his finger. In the next image, Bates watches his friend munch a corncob. In the third, the pair sit shirtless on the beach, shades on, as Hockney sucks a cigar. Finally, they stand with a sign that reads 'Hot Dog on a Stick; Elvis on a Stick'. Bates assiduously takes notes. Hockney, with that cigar again, looks less impressed.

Surely, I ask, the pair knew exactly what they were doing, walking around a tough New York neighbourhood with Hockney openly declaring his homosexuality, munching or sucking anything phallic he could find? They were asking for trouble. Apple shrugs. 'We didn't think about it. The buttons just declared what we liked. We met up, sat on the beach. It was a day out.'

Come on, I say. Apple pauses. Then the conversation takes a turn.

'I read Bates's Royal College dissertation and his manifesto,' Morrison says. 'I got to the end of the manifesto, and it seemed really sexually ambivalent. I said to Billy, were you bisexual? Then I waited for a minute and thought, No, you're too scared to be bisexual.'

She and I laugh. Apple grins, just. 'So I asked him who wrote them,' she continues.

'Ann Quin,' Apple says. 'She was a good writer.'

Quin was an experimental novelist in 1960s Britain, associated with BS Johnson. In 1961, according to Apple, she also became a secretary at the painting school at the Royal College.

'We had a relationship,' Apple says. 'She researched and wrote my thesis for me, as a conversation between Vincent van Gogh and [the proto-pop American artist] Larry Rivers at the Five Spot Jazz Club. It was called *Pop Corn*. In those days, they handed out topics for people's dissertations. If you're in the graphic design school, they give you van Gogh because they think you're a bit fucking stupid. So I did it the way I'd do any business. You get the best writer around and away you go. She ghosted the whole bloody thing. But boy, did she piece it together.'

Apple takes credit for the title, a play on Rivers' early pop works and van Gogh's cornfield paintings. But when he says Quin pieced it together, he means it. Almost the entire thesis is made up of found material – fragments from art magazine interviews with Rivers spliced together with quotes from the letters between van Gogh and his brother Theo, synthesised by Quin into a seamless conversation.

Bates and Quin were together for close to a year. 'She was a pretty wild person,' Apple says. 'If she wanted a pee, she'd just stop in the middle of Kensington and go between two cars. She was uninhibited like that. But she really was a very good writer.' Just over a decade later, Quin brought her own story to a terrible end. 'You know that classic Reggie Perrin series, where he walks into the water?' Apple asks. 'She did the same thing at Brighton Beach. And never came out.'

It's intriguing to me that Apple should choose a popular culture reference to describe the drowning of his ex-lover. Over the coming weeks, as I reflect on it, the relationship with Quin becomes more than a passing curiosity. Apple tells me that not only did she write Bates's thesis and manifesto, she would often write his correspondence. He was outsourcing, like he always did. Except this time, he was outsourcing his personality.

In 1964, Quin published her debut novel, *Berg*, still regarded as her most important book. It opens with this:

A man called Berg, who changed his name to Greb, came to a seaside town intending to kill his father . . .

The book unfolds as a frenetic three-way horror show in a Brighton boarding house between Berg/Greb, his unsuspecting drunkard of a father and their mutual lover. Given what happened to Bates in late 1962, I can't help wondering if the Berg/Greb reflection – a man assuming his mirror identity – is connected to Apple's own history, to shared conversations between lovers about identity and personal reinvention.

With all the hot dogs, the cigars, Quin's lack of inhibition, and the discussion of Bates's orientation, I ask Apple the obvious question about his friendship with Hockney. No, he tells me, it never became sexual. Even if it had, what seems more important is that Bates, a colonial outsider, was being drawn into complex relationships in London with other people from the edges: Hockney the Northerner, who was openly gay; Quin, from a

Billy Apple with <u>Neon Floor #1</u>, 1969

working-class family, who was clearly 'different'. All three, it seems, were trying to find their own reflections.

Around this time, Bates also took a trip into Tito's Yugoslavia. His mother was a Croatian New Zealander, and he travelled to connect with her relatives – not at her request, but under his own steam. Once there, he felt the relatives were passing him on quickly: from Rijeka to Zagreb, then Sarajevo and finally Split. He wasn't sure whether they were afraid Communist informants would see them associating with a Brit, or that they just didn't want him there.

I've never heard Apple talk about the trip before. He leaves us for a second, and comes back with a file. Inside it is every passport he has ever had. He picks out the oldest one and, with a magnifying glass, scans for the Yugoslav stamps: 'Here they are,' he says. '16 to 22 April 1962.'

It was the last meaningful attempt Bates made to connect with his familial past. Seven months later, to the day, he would cease to exist.

ON 22 NOVEMBER 1962, Bates's search for an identity ended for good. In the London loft of his friend Richard Smith, he bleached his hair and eyebrows with Lady Clairol Instant Crème Whip and disappeared forever. In his place stood Billy Apple; a living, breathing 'brand'. It happened in a flash and was, I think, one of the most radical moments in 1960s art. Pop art was about breaking down the line between art and life, but the emergence of Apple was of a different order. It was the difference between illustrating that dissolution and actually *becoming* it – and not just being it temporarily but living with the decision for good.

The conventional wisdom about Apple's name change is that he was putting everything he'd learned from the advertising world into practice. Looking at a lot of the work he has done since – particularly from the 1980s on, where we see the brand producing products and eventually being

trademarked – this makes sense. Apple himself has always been happy to support this view. He explained it to me for an interview in *frieze* in 2012:

> Advertising had a language that art didn't have at the time, which gave it structure. It taught me that I could call myself an art director, and assemble a team of specialists to produce the work. The brand was also a way to get away from the New Zealand connection. Suddenly, you're from nowhere, you're brand-new. I became British – I was created there in 1962. I could say: 'Billy Apple was born in London', and a lie detector wouldn't twitch.

But after hearing about Quin, thinking about his relationship with Hockney and learning of the Yugoslavia trip, the advertising explanation no longer seems sufficient. Barton, too, has long been attempting to make sense of the name change, framing it as a subtle battle with ideas about subjectivity rather than a straightforward appropriation of advertising techniques. Acknowledging the complexity of that eponymous event, as Barton does, is also, I think, the key to understanding the complexity of everything Apple did after that.

A brand is a corporate concept, sure, but it is also a permanent mark on the body. In that moment of transformation, Apple branded himself as deeply as a third-degree burn. Morrison describes it as 'a psychic severance'. Bates was wiped off the human map. For a long time, even his relatives had no idea where he'd gone. He didn't return to New Zealand until 1975, and then only for a few months.

Ask Apple about the name change, and he'll tell you exactly what he wore in his first days in possession of his new identity: natural-coloured Levi's, white Keds, an off-white Burberry raincoat. But it's extraordinarily hard to draw him on its psychological impact.

'I could have just done a show called "Billy Apple – End of Story",' he says. 'But there was no turning back. It was a fresh start. I hadn't seen my family since 1959, and nobody made long-distance calls in those days. They had the

Metropolitan Police looking for me in 1963. The cops came around to find where I was, to make sure I was still alive or whatever.

'Hans Ulrich Obrist wanted me to talk about my epiphanies. I told him the name change was the epiphany. But how many more do you want me to have? You don't want too many epiphanies. They get in the way. There was only one. After that, everything went towards supporting it.'

What Billy Apple recognised, once he became Billy Apple, was that his job from that point on wasn't to impose his inner life on the outer world. After all, he no longer had a personal history to draw upon. It was to show how the outer world imposed itself on him. While many of his contemporaries back in New Zealand were bemoaning the tyranny of distance, Apple was unpacking the full force of two interconnected burdens – the self and the body – in an age when technology and consumer comforts promised to release us from the limitations of both.

I'VE KNOWN APPLE for almost fifteen years. In 2002, I wrote about his work *Severe Tropical Storm 9301 Irma*, which he presented at the Waikato Museum of Art and History in Hamilton. The piece arose from a freight ship journey Apple had taken from New Zealand to Osaka in 1993, when the ship narrowly missed being engulfed in a tropical storm. Apple took nautical and meteorological data from the incident and turned it into an installation, with sound arranged by the composer Jonathan Besser.

It had all the hallmarks of Apple's work: technical precision, talented collaborators, reducing lived experience to pure information. But underpinning the installation, it seemed to me, was something else: fear. For all its programmatic attention to the data, this was a work about a man confronting the possibility he might never make it back to port.

A couple of weeks after the article came out, my phone rang. I choked when I heard the voice on the other end, and waited for the full treatment;

I'd heard how prickly Apple could be. But he'd liked what I'd written.
He even wanted to work together on something. We decided to restage
a work he'd originally made in New York in 1969, called *Four Spotlights*,
at Hamilton's Ramp Gallery, in 2003. That's exactly what it was – four of
the gallery's spotlights, mounted on tracks in a perfect square, pointing
straight down at the floor. The rest of the gallery was empty.

Not long before it was due to open, I picked Apple up from the railway
station and took him to the gallery. He'd given me clear instructions before
he arrived – the space needed to be spotless – and my intern and I had
polished the floor and repainted the gallery, twice.

'What's that?' he said, pointing to a paint drip. 'And this?' Some of the
things he pointed out, no one else would have noticed. But, at twenty-four
and keen to work with him, I didn't argue. I took him to his hotel, went back,
and we started again.

Years later, in 2009, Apple carried out another gallery 'Subtraction'
at one of Europe's leading contemporary art spaces, Rotterdam's Witte
de With. The work was called *Revealed/Concealed*, part of which was
the removal of a staff kitchen – an awkward internal room that had been
messing up the gallery's white cube for years.

As viewers entered the gallery, they were confronted with a floating wall,
which had the following text on it, using Apple's red and black brand colours
and Futura font:

REVEALED/CONCEALED

Billy Apple® requested on 20 January 2009 that Witte de With Center for
Contemporary Art take the following actions in the second floor gallery prior to
25 June 2009

1. Cover the windows by building a wall that runs the full length of the
 southern side of the gallery

2. Remove the two internal rooms that function as kitchen and storage within the gallery space
3. Uncover the windows at the east end of the gallery and the windows of the freight door at the west end

On the opposite side of the wall was a floorplan of the space, with Apple's changes highlighted in red.

'They took all the switches off the walls, replaced fittings, all the lights were methodically cleaned,' he says. 'I had people cleaning windows that hadn't been cleaned for years, because they'd been covered up. It was incredible.'

He even had a gallery assistant scrubbing a fire hose with a tiny brush. Why bother? I ask.

'We were revealing the long view. At that point, it has to become *hyper*. You don't go in and redecorate or overpaint. You detail it back. It's like a restoration. It becomes brand new. That's what you're looking for.'

Revealed/Concealed was part of a retrospective, at that point Apple's most high-profile European exhibition since his ill-fated 1974 survey at London's Serpentine Gallery, which was shut down by the Metropolitan Police.

Apple had left London in 1964 and moved to New York. The Serpentine exhibition, called 'From Barrie Bates to Billy Apple', was his big return, a chance to show the British everything he'd achieved in a decade living in the world's most exciting art city.

During the early 1970s, his work had become increasingly concerned with the documentation of his daily activities: cleaning windows, collecting pieces of broken glass from the streets and so on. The most corporeal example was a work in which he kept tissues from his nosebleeds, excretory and masturbatory wipings: paper, in other words, with blood, shit or semen on it. Some of this was included in the Serpentine show.

There were public complaints, and the exhibition was shut down. It eventually reopened, though not before Apple had removed the offending

Billy Apple removing Body Activities, 1970–73

work. The whole experience had a devastating effect on him. It was also as good as things got for a long time: throughout the late 1970s and 1980s he struggled to find institutional traction in the US or Europe, eventually turning his attention back to New Zealand.

That this latest retrospective was happening in the Netherlands was the unusual result of Apple's rediscovery by the international art community. One of the world's most influential curators, Nicolaus Schafhausen, came through New Zealand in late 2006. Having been tipped off by the conceptual artist Lawrence Weiner, Schafhausen returned in 2008, visiting Apple's warehouse with the intention of choosing work for a full survey in Europe. (Schafhausen also played a crucial role in launching Simon Denny's European career, by suggesting that Denny study at Frankfurt's Städelschule.)

It's easy to assume that the art world's globalisation is about finding the next big thing: discovering talented kids straight out of art school and turning them into superstars. Apple is the other side of the coin, in that, as well as chasing newness, there is a strong drive to fill in the gaps left by conventional art history. Apple is a prime candidate for this. He has undeniable New York pedigree. He is still in possession of much of his pop and conceptual work. And, now in his eighties, he's entering the final years of his career.

Morrison argues that it was Apple's consistent innovation that caused him to fall off the art historical radar. 'They're realising Billy got there before everybody else,' she says. 'He was always a step ahead. But that was the problem: he was a step ahead.'

But what, exactly, put Apple ahead of his peers? And what makes him such an outsider to art history, while also being such an influential figure in contemporary New Zealand art?

In other words, in the grand scheme of things, how much does he actually matter?

If being first, as Morrison suggests, does mean something, then Apple counts for a lot. After becoming Billy Apple in London and moving to

New York in 1964, he was included, that year, alongside Andy Warhol, Roy Lichtenstein, Jasper Johns and other young luminaries in 'American Supermarket', a seminal pop exhibition that literally took the form of a shop (Warhol's *Brillo Boxes*, Apple's bronze fruit for sale, and so on).

He was an early user of neon. But by the time it started taking off as a medium in the New York art world, he'd moved on, befriending a physicist doing research into lasers (the pair once shot a laser at the moon, from Apple's studio window, just to see if they could hit it from Manhattan). And instead of working with silkscreens like so many of his pop peers, Apple turned to a new reproductive technology – xerography – working closely with its corporate inventor, Xerox.

In 1969, he changed tack. Instead of continuing to make objects, he opened one of New York's first experimental art spaces and started to record the banalities of daily life – like the bodily functions that got his Serpentine show shut down. Around this time, he also started to think about how he could intervene directly in museums and galleries, before the art world had labelled such work 'institutional critique'. The 'Transactions' – oversize receipts recording the details of their exchange – were an extension of this, examining the relationship between the art market's backroom machinations and the artist's very real financial need 'to live like everybody else' (a phrase developed in conjunction with the critic, poet and longtime Apple collaborator Wystan Curnow, which subsequently became Apple's defining mantra).

Many of his contemporaries from 'American Supermarket' – Warhol, Lichtenstein, Johns – went on to stardom. He didn't. 'That hurt a bit,' he says. 'I used to get very envious. I learned not to be jealous though. It used to fucking hurt when the Whitney wouldn't consider my projects. The best thing I ever did was open my space at West 23rd Street. There was no one to ask. You could just get on with things.'

Now, things are changing. At the same time as his AAG retrospective, Apple was in 'International Pop', a historical survey at the Walker Art

Center in Minneapolis – one of America's major contemporary institutions. His London dealer, The Mayor Gallery, has been getting his work into collections like the National Galleries of Scotland and Tate Britain, while his Auckland dealer, Starkwhite, is making inroads in Asia. In 2009, Schafhausen gave him that big survey in Rotterdam (losing a kitchen in the process). In 2012, *frieze* published my long interview with him. The world cares about Apple now in a way it hasn't since the early 1960s. The question is how long that will go on for. Apple is hoping it will last forever.

'WE'RE REALLY OBSESSED with this machine, our body. And the machine creates the illusion of consciousness, of a soul and a self, all that stuff. So what happens if you take a bit of it out and give it away?'

Craig Hilton is a biogeneticist and the man behind *The Immortalisation of Billy Apple®*. Getting Apple's cells into ATCC's collection was Hilton's first step. Since then, he has also had Apple's DNA sequenced; a process that gives a full picture of his vulnerabilities – the little flaws, tics and hereditary trapdoors that leave him open to certain illnesses and diseases. A map, in other words, of the most likely ways Apple will die. This is more than an art world gimmick. It's real science. Apple's cells are being used for actual research.

Hilton's credentials are world class; after a PhD from Otago University, he worked at Harvard Medical School. He's also an artist, with a Master of Fine Arts from Auckland University. 'I'd like art to do something that science hasn't done, or maybe doesn't have the nerve to do,' he explains. 'And when I was thinking about a project that would have both real art and science value, Billy's practice fit perfectly. Normally, for ethics approval, you have to make sure the people are anonymous. But the whole point is that it's Billy; they're called Billy Apple® cells. So Billy signing away his privacy was a kind of ethical backdoor.'

Apple agreed to be part of the project almost immediately. His freely available cells and his medical information, are, in the WebMD age, biological weapons in the fight for accuracy and transparency. We live in an internet culture of paranoid self-diagnosis but few of us really want to know if we're going to get Parkinson's or Alzheimer's. Then there is the moral conundrum of what this means for our children: do we really want them to grow up knowing all the hereditary horrors that flow through them? And, of course, there is the biggest ethical vortex of them all; the fact that one day, we could be cloned, with or without permission. It's the most complex identity project Apple has been involved in since the name change. It's also how the brand will outlast the body.

'Making the cells and the DNA sequencing available to everybody and anybody means they're effectively open-sourced,' Hilton says, 'which is what a lot of brands now do, not charging for their products – Google, Facebook and the rest.' Hilton also makes the point that as DNA sequencing becomes cheaper, big companies – life and medical insurers especially – are going to mine our genetic information for risks in much the same way they currently use our online activity to direct their marketing.

'We're all going to be in this situation soon. But Billy's doing it now. He's stepping into the future.'

IT'S THE FIRST Monday in March 2015, the first day of install, and the AAG's curator, Stephen Cleland, is showing me through the galleries earmarked for Apple's show. Half are freshly painted; the others are still building sites. There isn't much work in there yet except a few of the 'Transactions' – *I.O.U.*, *P.O.A.* and *Bartered* – leaning against walls. There is also a special incubator, along with a giant CO_2 bottle to run it. By the time the show opens, it will contain Apple's living cells.

The artist is leaning over a worktable with the exhibition designer, looking

Billy Apple in his warehouse, 2011, looking at a self-portrait from 1969

at floorplans. They're discussing sight lines. 'The long views are very impor-
tant on this thing,' I hear Apple say.

Even though each room deals with a separate theme, he is crystal-clear
about how he wants viewers to move between them, to see links between
works or experience shifts of conceptual register. Barton is a key voice in this
too; essential in using Apple's work to reshape how we might consider the
relationship between his art and life.

He's also adamant about the standards he expects. As we move through
the unfinished rooms, he points out things that need to be fixed: patches
that need more sanding, electrical plates that need to be moved, slight
bows in newly built walls that will need to be straightened before anything
can be hung.

He and the exhibition designer get into an intense conversation about
the exact shade of grey they'll paint a particular wall. Cleland takes me
down into storage, where Apple's works are racked up. Several 'From the
Collection' pieces are still wrapped, recently delivered by their owners.
Smack in the middle of the room is *Sold*: Apple's very first 'Transaction',
which Peter Webb exchanged in 1981 for $3000. The named purchaser is
The Future Group.

Over the coming days, as the works are brought up from storage, the
sight lines start to tell the story. Apple's neon signature. The self-portraits.
The bronze apples. Photographs of his laser installations. Xeroxes.
Documentation of his cleaning works and alterations to museums. His solid
gold apple. An entire room of 'From the Collection' pieces.

Taken in isolation, each work could seem cold, stark, ungenerous even.
Together, they are poignant. This is the significance of Barton's curation – the
subtle way it reveals the depth of Apple's continuing self-examination. 'As
much as there's an evacuation of personality in the production of a "brand",'
she says, 'there's also something else – something which might almost have a
tragic cast. The search for perfection, or a system on which to order one's life,
the disappearance of a "subject" and how that affects all his work.'

Aspects of The Immortalisation of Billy Apple® project, 2009–10

The neon signature asserts his existence in blazing red light. His 'From the Collection' works aren't just about pecuniary exchange, but are also records of a life. Amid the corporations and universities and well-known collectors are exchanges with his longtime signwriter Terry Maitland, a work belonging to Morrison and a number of smaller canvases that Apple gives to friends when they get married, or to friends' children.

There is also sadness. The 'Self-Elimination' portraits from 1969, for example, in which, across five canvases, Apple progressively disappears. There is a reference to the wipings that saw his big moment at the Serpentine shut down. There are surprises too: a room filled with shattered glass tubes and delicately knotted neon works from the 1960s (tributes to RD Laing), accompanied by a film of the neon knots that Apple made, with a soundtrack by Nam June Paik.

It's possible to walk in and see conceptual coldness. It's also possible to walk in and see shameless self-promotion (bags of Apple coffee, cans of Apple cider). And it's possible to see something desperate – a continuous and relentless urge to confirm one's presence in the world. But all of that is what makes Apple's practice so human, and humane. His entire body of work is pocked with flaws and disappointments and arrogance and occasional moments of brilliance, in exactly the same way our lives are. The difference is he's chosen to live his life in the public eye, as a kind of cipher for the second half of the twentieth century, exploring the massive technological shifts we've collectively experienced.

At each end of the exhibition, Barton has positioned a modest photograph. In the first room, a young man with newly blonded hair sees himself for the very first time in a small handheld mirror. It isn't a good photo, shot from a low angle so that an overhead lamp blows the light out and gives him a blurry, auratic glow. In the exhibition's final room, a man in his seventies peers through a microscope. He's looking at his own cells, just extracted, splitting and renewing, ready to go out into the world to find new homes, new hosts. Destined, unlike the body they came from, to be immortal.

IN MY LAST MEETING with him, Apple tells me about one of his earliest visual memories. As a young boy, he visits his Croatian grandparents in Mt Albert. It's sometime in the mid-1940s. They give him a jigsaw to complete, sent, Apple assumes, from relatives in Yugoslavia. As the pieces come together, a gathering of young, hopeful people begins to emerge. Many are wearing tan uniforms. There are flags and banners everywhere: black, white, red. It's his first remembered encounter with graphic design: Nazism, the twentieth century's most defining and horrific exercise in cultural branding.

On the night his retrospective opens, white banners with a black logo surround the AAG, fluttering in the March breeze.

'I'm becoming quietly excited about it now,' he tells me. 'It's a bit like getting one's affairs in order. Even though "Billy Apple" the brand is fifty-two years of age, I'm living in a seventy-nine-year-old body, and it's hard. The mind's quicker than the body. But the comforting thing is that, with the cells out there, there really isn't an end for me. There's no final date. Can you name any other artist in the world who's done that? Nobody.'

American Night, 2014

Steve Carr

<u>Transpiration</u>

In the end, Apple's immortality will probably be tied less to the future lives of his cells than to his legacy for New Zealand art. His influence in the local context is profound, particularly his mixing of pop with hardcore conceptualism. And, yes, narcissism, too – not in the pejorative sense, but in the sense of holding a mirror up to oneself in the hope that the face staring back might also reflect wider questions within the culture.

One of the clearest inheritors of this is Steve Carr, an artist who has consistently explored the connections between pop culture, art history and the transformation of self. Carr's *Transpiration*, 2014, was the culmination of a residency at the Dunedin Public Art Gallery (DPAG). In it, huge carnations hover in half-dozen clusters on the wall. They start their lives looking like balls of cotton rags – white, bunchy, frayed. Colour then gathers at their fringes and grows into a slow leach that turns them yellow, or pink, or blue. The flowers' inner folds wobble slightly. There's a more general sway at their outer limits – a kind of peripheral rocking. Single petals peel away, minuscule movements that turn into sublime shocks when you manage to catch one at the edges of your vision.

For all that, there's still the sense that maybe nothing is happening. While I'm there, a young woman walks into the flower-filled room and is convinced she's seeing a frozen image. When she sees a petal move, she wonders aloud whether the flowers are changing colour before her eyes. She pauses, before announcing that it's all a ruse.

There's nothing special about Carr's flowers, which are just shop-bought blooms. The process being witnessed is pretty basic too: the carnations are sitting in unseen pots of coloured water, sucking it up through their stems.

It's a primary school magic trick, a way to teach kids about natural science as well as a cheap device florists use to stain their stock. Carr has shot the process over twenty-four hours with a time-lapse camera, then stitched it together into a loop of around fifteen minutes, which runs forwards and back so that we witness the flowers' inhalation and exhalation as a constant, tidal pulse.

The banality of the work's origins is transformed by the weight of art history. Although the flowers aren't painted, they're thick with paint. Their ragged edges are like the final drags of a brush before it breaks from the surface. The white on black is as stark and luminescent as Manet (one of the greatest flower painters), or Chardin, or even Velázquez. Carr's carnations are also a clear nod to Andy Warhol's *Flowers* and to Jean Cocteau's film *Testament of Orpheus*, where flowers become essential, surrealist symbols at the end of the film. From Cocteau to Warhol to Carr; a lineage that reaches through classroom science experiments and impressionism, all the way back to seventeenth-century still-lifes. Except that Carr's flowers are never still.

WE'RE USED TO thinking about cinema as a photographic medium. But conceptually and behaviourally, it shares a great deal with painting, in that both are concerned with the relationships between images and the passing of time. In painting, this is subtle and easy to miss because at first glance, its objects are static things: stillnesses, hanging on walls. Nothing moves. And yet a painting's surface is also an indexical record of the time it took to be made, every mark and stroke the trace of a body moving through space.

Cinema has a similar ability to defeat the laws of time and space. It can collapse whole lives into minutes, carry us across the world in the flash between frames, and slow time down to fix our attention on the quiet, unseen forces underpinning daily experience.

As well as being filmmakers, Warhol and Cocteau were painters. Many of cinema's greatest directors are, or were. David Lynch is another. Perhaps that's why he is also present in Carr's installation. The experience of watching *Transpiration* at the DPAG was punctuated every fifteen minutes by the bright chirps of a mechanical bird, coming from a television screen in one corner. On the screen was a companion work, *American Night*, 2014. In it, a little bird perches on a fake branch, against a background of spring blossom. It's an obvious set-up, and an incongruous letdown after the magic of Carr's giant floral illusion. But the two works are actually showing the same thing. As the screen's artificial day disappears into false night, it becomes clear that, here too, we're witnessing a twenty-four-hour cycle shrunk to a handful of minutes. As the sun comes up, the bird lets off its frenetic tweet. Just like *Transpiration*, Carr is riffing here on one of the great final scenes of modern film; instead of *Testament of Orpheus*, this time it is *Blue Velvet*, when a fake bird closes out Lynch's dreamscape.

In the time it takes us to watch the bird's daily cycle, everything is new, different and somewhere else: the flowers' blues are white and whites are pink and some yellows have turned so bright they're almost phosphorescent green. It's the strongest evidence yet of Carr's ever-increasing ability to control, and reinvent, the interaction between painting's history, film's materiality and cinematic time.

It's also a reminder that Carr's videos are about screens, in the same way that paintings are about screens: material things that act as images, as windows and as defeaters of sensible time. Like great painting, *Transpiration* is about what happens to our experience of the space *around* the work – just like the young woman who swore she'd seen a mirage.

THE FIRST TIME the art world really noticed Carr was in 2001, when he presented the video *Air Guitar* as part of his final student exhibition at Elam

Transpiration, 2014

School of Fine Arts. In it, Carr acts out a stadium-rock fantasy, miming a classic track from Joe Satriani's album *Surfing with the Alien*. Things develop as one would expect in any teenage boy's bedroom, until Carr dials the hubris up to ten. As a smoke machine shrouds him in a starstruck fog, he grows in confidence and strut, letting off a couple of Pete Townshend-style windmills before returning to his phantom solo.

As funny as it is, Carr's silent performance homes us in on a second layer of teenage male fantasy – all the bucking, thrusting and straining make it clear that this is, more than anything else, a wank video. Watching Carr pound away at his absent axe becomes ridiculous and awkward; he turns us into his mum, walking in at the worst possible moment.

This wilfully untoward sexuality didn't pass in a hurry. In 2002, he made *Pillow Fight*, in which he and a group of teenage girls have a pyjama party and smash each other around, sending clouds of feathers into the air. Not long after this came *Dive Pool*: a film shot underwater of Carr in a scuba mask, watching bikini-clad women swim past him while he sucks in oxygen – evenly, mechanically – from the tank on his back.

Ostensibly, there was nothing wrong with these acts, except of course, that *everything* was wrong with them. Carr used plausible deniability to infect childish activities with an implicit sexuality. For some critics, this tipped past the early humour of *Air Guitar* and into a more corrupt space. Rather than backing down, Carr made one of his funniest films in response: *Tiger Girls*, 2004, in which he sits in a spa pool filled with attractive young women and does absolutely nothing except drain several bottles of Tiger Beer.

THERE'S NO QUESTION that Carr's early games, performances and gags were adolescent, narcissistic and self-obsessed. But they were also important steps in his attempt to master a more archetypal condition: Carr is, above all else, a trickster.

In his book *Trickster Makes This World*, Lewis Hyde shows us that the trickster is, in every culture in which it appears, a force for change. Central to this is the power to step across the thresholds between gods and men and life and death, unencumbered or deliberately negligent of the rules that dictate behaviour in each. The trickster is also responsible for the forces that keep us rooted in our own mortality; most notably, our desires – our need to eat, to drink, to fight, to love, to fuck and so on. The trickster's troublemaking reminds us that we're only flesh and bone, and that our bodies are both contingent on, and vulnerable to, our appetites. Little wonder, then, that Carr's early works were full of booze and sex.

By 2009, Carr himself had largely disappeared from his films. Instead he began to focus on the close interconnectedness of his core mercurial forces – sex, mischief, humour and magical transformation. This came to a head in one of his finest and most painterly works, his 16-millimetre film *Burn Out*, 2009. On an early West Auckland morning, a young man in a black car does exactly what the title suggests. But rather than the jump-cuts and heavy-metal typical of YouTube videos of burnouts, Carr's event is shot at distance against lush Henderson bush, with no sound. There's a rough, transformative physicality to the action: rubber turning into smoke for no good reason other than for its beautiful grandeur. It is, in many ways, *Air Guitar* redux: smoke, circles, humour, solitary romance, hopeless bogan endeavour. Except what we're witnessing this time isn't a fantasy or a jack-off but a tangible transformation (rubber combusting into smoke).

This is a vital shift: because with *Burn Out* and everything since, Carr, instead of using himself, now uses matter undergoing extreme change to lead us across thresholds.

Nowhere is this clearer than in *Screen Shots*, 2011. Across nine monitors arranged in a three-by-three grid, we see the artist's hand slowly pricking paint-filled balloons against a coloured background. As the pin slips in and each balloon peels back, there's a brief and wondrous moment in which the paint holds its shape and wobbles in mid-air before coming apart.

Once again, Carr transforms a childish pleasure (blowing up a paint bomb) into something erotic and sublime.

The explosions are filmed using a Phantom camera, capable of shooting high-definition footage at more than 5400 frames per second. It's designed to show us things our eyes weren't meant to see. Carr doesn't use the Phantom to get off on its technological capabilities, but rather to create an image of total bodily empathy. His balloons, and the paint they contain, hang like organs and burst with human release. To over-emphasise this, they're presented on 32-inch screens, which provide a 1:1 scale between the artist/magician's hand and our own. Carr can't resist a dig at painting's history here either, crashing the absurdity of abstract expressionism's drippy masculinity into its fussy, industrial cousin – the pristine minimalist grid.

In *Dead Time*, 2012, Carr used the Phantom to mine even deeper into art history. Seven screens hang, like still-life paintings, in a row. On each, a single apple is suspended from a string against a black ground. The inspiration for his composition is obvious and unhidden: the paintings of the Spanish master Juan Sánchez Cotán. Each apple is just different enough for us to realise that it isn't the same image repeated seven times. Then we're forced to wait, and wait. But for those patient enough, the payoff arrives – a William Tell succession of explosions as each apple is obliterated, one after the other, by a single bullet that traces visibly across the screens. By stretching an event that lasts a few seconds to several minutes, Carr allows us to witness not just action, but complete, painterly disintegration. The last flecks of apple flesh look like stars spread across black space – a Big Bang that tricks us into thinking, just for a moment, that we're staring into the heart of the universe.

Transpiration, then, is more than a one-off victory over time and space; it's the culmination of an intense period of magical experimentation. Carr's carnations are the sorts of things a clown might use to squirt you in the eye. But they're also paintings, bodies, organs demanding slow release and things experiencing their own death, over and again.

The great sophistication of Carr's recent works lies in his recognition that the forces of material transformation he's so interested in – combustion, explosion, degradation, disintegration, transpiration – are, like cinema and painting, entirely contingent on time, and that the tools of his trade give him the ability not only to witness temporal change, but completely alter our experience of it. In doing this, Carr allows us to breathe underwater, see the universe in a shattered apple and disappear with him into clouds of smoke.

Gravitas Lite, 2012

Scattered Pieces

The first time I met Peter Robinson, he made me sing Sam Cooke's 'Chain Gang' with a group of strangers. Robinson handed out sheets of A4 with the lyrics printed on them, hit play on his iPhone, and after a few tinny opening bars, set us to work. We mumbled along and avoided each other's eyes, while he took the lead.

This happened in June 2012 on Cockatoo Island, in the middle of Sydney's harbour. Robinson was part of that year's Biennale of Sydney, his contribution a work called *Gravitas Lite*: a massive installation of polystyrene plinths and chains of varying sizes, which wrapped around and through the island's defunct machinery.

As well as being a home of Sydney's Biennale, Cockatoo is one of the city's most haunted sites. In its early days it had been a prison – a place where inmates cracked rocks from the sandstone cliffs, material that helped build Sydney's signature stone buildings. Later, it was a shipbuilding yard. 'Chain Gang', then, was Robinson's waiata for his installation and for the place: a musical parallel for the material transformation he'd performed in turning a space of forced labour into a Lilliput of restraint and entanglement. Cooke's tribute to the toughness of prison life during America's civil rights era had found another life half a world, and half a century, away.

Most of my fellow mumblers were Robinson's patrons, a group of New Zealanders who'd helped fund his massive installation. They shuffled off quickly after the song was done.

'That seemed to go pretty well, didn't it?' Robinson asked me.

I muttered something in reply. In Robinson's world, everything is a question. Everything is always something else. And everything is about hard work.

ROBINSON'S STUDIO is in a 1970s office block in central Auckland, which he's about to be kicked out of because the building is being converted into luxury apartments – another victim of Auckland's gentrification. Although he shares the space with a few other artists, he takes up the most real estate, working out his large-scale installations and scatter pieces on its concrete floor.

Robinson himself is a big guy too: six foot, with a white-streaked mop of black hair. There's a shambling delicacy to him. Catch him when he doesn't know you're watching and he'll be stooped with a kind of depressive thoughtfulness. But once he starts moving his materials around, any physical clumsiness disappears. He is capable of shifting a single metal rod or lifting the edge of a piece of felt, and making the entire room change.

He's also his own harshest critic; when we meet, he's going through a kind of existential crisis.

'I want to change some stuff, rethink things,' he says. 'Do a lot of reading. I might go underground for a while. I'm trying to work out where I'm going, what I'm doing, what things could be. I'm starting to lose faith in what I do a bit. Which is probably a good moment. It's not a very comfortable moment. I'll either regroup and charge straight back into it or it'll be a change of direction.'

I ask him what he's losing faith in.

'It might be the process. Sitting around playing with material, kicking it around. It's not just the work, it's the whole enterprise of being an artist: spending so much energy, so much money on production, with very little

return. I'm a reasonably lucky artist, but I've just spent so much over so many years, and I'm really going backwards rather than forwards, financially. I need to think about that. It's probably a strange way to have this conversation. But it's a reality.'

It's easy to look at Robinson's recent career – shows in Istanbul, Sydney, Melbourne, Paris, Jakarta, feted by major curators and included in prestigious biennales around the world – and assume he's living his dream. But it's a tough grind, especially for an artist for whom political questions have always been essential. He now finds himself part of an art world system whose own political and economic motivations – not to mention questions of social and cultural equality – are increasingly hard to negotiate.

'We get caught in wanting to resist that system,' Robinson says, 'but at the same time wanting to be successful within it. It's connected to capitalism, and the split that it causes within the subject. That's interesting in terms of how to perform as an artist. That's not something my work really examines at the moment, and probably can never do on its current course.'

Robinson and I have planned to meet at Artspace on K Road, where he has a solo exhibition. But at the last minute he changes the appointment to his studio, because there's something new he wants to show me. When I arrive, the space is rammed full of stuff, like he's pulled everything he's made in the past few years out of storage and thrown it together. Felt is the dominant material: coloured squares on the floor; circles that slump where the floor and walls meet; poles wrapped in it; different coloured squares arranged in grids or stacks; tiny discs like washers; linear pieces that, from a distance, look more like drawings on the floor or the wall; and the sheets they've all been cut from – squares of fabric that might otherwise have ended up in the bin.

As well as felt, there are bent and malformed steel pipes, either industrial grey or neon-gold. Coke cans hang from thin wire or lie crushed on the floor. Finished bog rolls are propped among traditional Māori gourds. Tiny pinched pieces of aluminium pipe are scattered on the floor, like miniature versions of Warhol's *Clouds*. And everywhere, there are little figurines and

statues: kitschy geishas, samurai warriors, coconut heads, African fertility sculptures, dinky Aborigines leaning on didgeridoos. There's a gold Buddha and a Pinocchio with his nose half-extended. There's even a perfect little wharenui perched on the edge of a black felt square, like it's about to tumble into a sinkhole.

'I haven't quite come to terms with them yet,' he says of the figurines. 'They've been in my work before. They go back to what I was doing around the turn of the century. But the polemic isn't as nasty as it was in those days. They shift the scale of things. They also set up the idea of being lost in language. A sculptural language is a language on its own terms. We recognise it as such, but we can't understand it as we usually understand language. Here, that's exploded. It's as though these figures are trying to make their way through a code. But the code is scrambled in some way, and their gazes seem to be lost in something. The colour of them also seems to key into the colour of the felt. There's a relationship – a vividness.'

It's impossible to take it all in at once. It's also a welcome shift from what I'd seen as a certain politeness emerging in his recent work. Since abandoning polystyrene after the Sydney project, Robinson has used felt again and again. In it, he'd found a material with amazing optical effects – something that slips between object and image and between flatness and form, so that as we enter his installations, we feel as though we're entering a picture and a sculpture. At the same time, the felt experiments had started to feel like formal exercises, like Robinson was developing a visual vocabulary with no obvious grist or politic – just a satisfaction with its own cleverness.

Robinson has also taken the step of letting audiences interact directly with the installations, as a way of democratising making, of breaking down relational hierarchies between artist and viewer. The most substantial example of this was his contribution to the 2013 Auckland Triennial. In the Auckland Art Gallery's mezzanine, he lined up dozens of coloured felt rods, each one around 2 metres long. A team of volunteers picked these up and carried them through the city to the Auckland War Memorial Museum

(more on this project soon). Later that year, at The Dowse Art Museum, he let people build their own rods from small discs of felt scattered across the floor. And at Centre Georges Pompidou in Paris and Artspace in Auckland, audiences were given permission to rearrange his forms in whatever configurations they liked.

It's a perfectly noble and inclusive act, but one fraught with risk. In the hands of amateur enthusiasts, Robinson's subtle, delicate arrangements are easily turned into stick figures, smiley faces and emojis.

'I'm surprised with what people do,' he says. 'I really do feel like a viewer of the audience's work. There are so many things I'd never have done myself – the way people have tied things for example, or gone around the rules. I was also surprised at how free they were – they weren't intimidated by the role or the space whatsoever.

'In some instances [at Artspace], I found myself being disappointed by the results because they didn't subscribe to my preconception of how things should look, which was as an all-over composition in the space. They became more territorial and isolated as gestures. Then I realised there was something interesting in that. So I learned a lot about my sense of trying to be open but actually being very controlling, or having a propensity to be very controlling.'

Which is all good and well. But it doesn't change my feeling that Robinson is a sculptor who *should* take control, *should* dictate terms to us forcefully, just as he'd done in Sydney. That's why his latest jumble was such a relief. It had a bossiness. It seemed to me that with it, he was back to his best – in a space where his formal games and his deeply felt politics become inextricably tangled with each other.

ON THANKSGIVING NIGHT at the Lost Horse Saloon, beer is a dollar and a turkey dinner costs whatever you want to pay. An absurdly good-looking Texan barman, tall and blond with a tattoo crawling up his neck, looks at me

127

like I'm an idiot when I ask him to repeat the price. 'It's Thursday,' he says, like that explains everything. He pulls the beer. When I ask him about food, he points to the smoking lounge at the back of the room.

On the other side of the smokers' door, a black woman in her fifties stands beside a makeshift buffet. She smiles, and assembles an enormous plate of food for me: biscuits and mashed potato and gravy and turkey thigh. I ask her how much I owe, and she points at a jar filled with scrunched dollar bills. I put some notes in it and carry my plate back into the bar, sit down, and watch two girls as pretty as the barman shoot pool, lining up trick shots against a wall covered in animal skulls. The towering proprietor, wearing an eye-patch and a Stetson, moves through the room chatting to patrons and pauses, long enough to give me a nod.

I'd set out from El Paso a few hours earlier, on a 300-kilometre trip south-east along the Mexican border. As I turned off the interstate, the sun started its slide behind the mountains. Lucky Luke outcrops of prehistoric rock turned into cartoon silhouettes as the sky glowed red, then orange, then purple. Each time the colour shifted the hills scooping up the light were surrounded by a slightly different haze, a kind of graded blue fog; colours I'd never seen before, and yet the entire horizon was lit up with them as though, here, they were the only logical possibility – the only way the world could be.

Up ahead, I saw a low, flat building, standing alone at the edge of the road. I pulled up opposite. It was, of all desert possibilities, a Prada showroom: a bizarre thing in a bizarre place, hunkering on the side of US90 and showing signs of its age; windows grimy, awnings torn. As the last of the light faded, bulbs inside illuminated stiletto-lined shelves – weird late capitalist relics inside a structure well on its way to ruin; another scar in a landscape full of beauty and glory and death and art.

The sky fades to black. I get back in the car and drive to the city limit of Marfa, Texas, and realise I'm completely alone and nothing is open, until I see a neon-red sign flashing 'BEER' from the far end of town and go in, hoping I'll maybe find something to eat and drink.

MARFA IS A DREAM. It is also a place of pilgrimage; an art world rite of passage. Despite being in the middle of nowhere, the town and its surrounds are full of contemporary art. The Prada showroom, for example, is a permanent artwork by the Scandinavian duo Elmgreen and Dragset, made in 2005.

Their project is certainly a draw, but art worlders mainly come to Marfa because of one man: Donald Judd. Judd was arguably minimalism's greatest hero, his cantilevered rectangular boxes among postwar art's most defining forms. He was also an art critic. In the endless hours he spent during the 1960s and early '70s looking at and making art in New York's stark, well-lit galleries, he decided something wasn't right; that the experience of art was far more complicated than simply using your eyes to look at an object inside a neutral, and neutralising, white box. In Judd's view, it should be about the wholeness of an encounter, in which the surrounding context – the light, the architecture, the landscape – and the way it impacts our bodies is as important as the form itself.

He set out to prove his point. He hit the road and washed up in Marfa: the place where he would try to change everything.

Judd bought up properties all through the run-down town, driven by the idea that its buildings would eventually house massive installations by himself and his famous friends – Dan Flavin, John Chamberlain and others. With support from the Dia Art Foundation (which was set up by Philippa de Menil, the daughter of John and Dominique), he eventually turned his focus to an ex-military barracks on Marfa's outskirts, which is now called the Chinati Foundation; a massive complex only accessible to the public on an official tour.

I arrive early and walk through the one project by Judd that is open all the time: *15 untitled works in concrete*, built between 1980 and 1984 – a kilometre of concrete boxes set out in a field of wheat-coloured grass. What matters isn't so much the boxes' solidity as the spaces they articulate, and not even the spaces inside them, but the space you're standing in just beyond their limits. As you walk the kilometre, you notice everything but the boxes

Donald Judd
100 untitled works in mill aluminum, 1982–86

themselves; the dry morning light casting shadows harder than the concrete; the crickets and giant ants at your feet; the piles of dirt thrown up by moles or whatever their desert equivalents are. Judd's boxes suspend you in a confrontation with the edges of yourself.

As soon as the Foundation opens, I join a tour group and the day unfolds slowly. It's like a retreat: a semi-slumberous movement through the heat and the dust. It's silent. You are constantly aware of your own breath. Your guide only speaks when she absolutely needs to. The rest of the time, you're left to deal with the facts of the things in front of you. Facts like Judd's *100 untitled works in mill aluminum*, 1982–86, inside two former artillery sheds. At first the steel boxes seem uniform – identical units in neat rows. But each is subtly different from the rest, their internal spaces carved up in different ways. Over time, some of them have moved as the desert's heat and cold makes their metal ping and contract. Some, our guide tells us, have wandered well away from their original marks. Massive windows flood the room with constantly shifting lines of Texan light. In the distance, you can make out Judd's concrete boxes, resting in their field of gold.

You move on to text works by Carl Andre: sheets of typewriter paper on which the artist has tapped out words not just for their meaning but for their shape – units of sculpture as well as speech. You journey on into Ilya Kabakov's imagined communist classrooms, ruined simulations of the schools he was educated in behind the Iron Curtain. You stand in front of John Wesley's strange, sexy, figurative paintings. And you move around Roni Horn's long cones made from copper, which, when you stand in just the right spot, disappear into flat discs of light.

But the most important thing, by far, are Dan Flavin's works. Collectively, they constitute an enormous installation, filling a long run of soldiers' barracks. In each, Flavin's intervention is near identical. At the end of each room's length are passages, with soft glows emanating from behind them. You round the corner and encounter fluorescent tubes slicing on the diagonal – as though saw-teeth have bitten through space with coloured

light. The barracks are horseshoe shaped: a small section of building connecting two long spaces. Flavin has set out complementary colours within each, so that the diffused glow from one backgrounds the sharp specificity of the other: glacial blue lines against butter yellow, pink against martian green.

They are the same colours, I realise, that I saw the evening before in the sky.

When the tour is done, I get back in the car and head into Marfa for dinner. It is Friday now, the night after Thanksgiving, and more things are open. I choose another bar, a big barn of a place, wondering if maybe there'll be some live music later. Instead, there's a big screen on the stage, playing a film. I have walked into a *Big Lebowski* marathon. I order a beer and a sandwich from the bartender, and ask how long the movie has been running.

'This is like the eighth fucking time,' she says. Then she kicks out a smart-arse local loaded up on too many White Russians. It's been a long day.

Marfa, for someone like me, is a sacred place. It's about what's possible in the relationships between objects, space and the sky. In that, I decide, there's something extraordinarily optimistic. It's also a seductive mix of Americana, minimalist sculpture and rampant, knowing hipsterism (no one puts the Coen brothers' masterpiece on repeat in the middle of the desert without a decent dose of self-awareness). Marfa is a place that shouldn't exist. But it does, because of the transformative force of one man, with a plan to change how we think and feel about art, and the world, and our place in relation to both.

'TO ME, THERE ARE two kinds of formalism,' Robinson says. 'One that's completely empty and just a sign of itself, and one that's rich and subtle and speaks of meta-languages. I think [my work] is the latter rather than the former. Like where one element doesn't stand by itself, but stands in relation to another element. Then there starts to be a sort of code intrinsic

Dan Flavin
Untitled (Marfa project), 1996

to the work, rather than it needing an extrinsic relation. There seems to me something really important about making work where the audience doesn't have to know anything prior to walking into it, and being able to make some connections with it, and within it.'

Robinson is describing his own work, but he is also, by extension, describing minimalism, and Marfa minimalism in particular. Robinson was the New Zealand artist I thought most about in Marfa, because of his constant exploration of the interconnections between formalism, materiality, space and the moment of encounter.

'There's a kind of spiritualism there too,' he says of Marfa, 'which I guess is connected to the idea of the pilgrimage. But it's not just that. When you're with those aluminium boxes, you really do become highly conscious of yourself in relation to the environment. It's not just an idea; you actually feel it somehow . . . Labour and minimalism's blue-collar aspect are also important: the notion that they're trying to destabilise the hierarchy between the viewer and the artist. I think my work is also dealing with the problematics of that.'

He's cautious though – as he so often is – of drawing a direct line between Marfa and the issues in his own practice.

'My work isn't about minimalism, but feeds from it; it takes away this veil from it and tries to recover something. For me, minimalism is the source in terms of its socialist agenda, its non-hierarchical politic . . . I'm really interested in the potential of abstraction to have this sort of politic, but for it not to be served up to you on a plate.'

This explanation opens up new possibilities for understanding Robinson's recent work. On the face of things, his career looks like it has been split into distinct parts: the proto-minimalist phase he's just been describing, and the bicultural period that preceded it, for which he is still best known. But they are actually closely linked.

Robinson identifies with Ngāi Tahu; a tribal connection that has been an essential part of his life and work. But his affiliation also embodies a

queasiness in New Zealand's bicultural consciousness: namely, how Māori do you have to be to be Māori? And what criteria do we use to decide? Robinson is, famously, just 3.125 per cent – or one-thirty-second – Māori. Much of his early work dealt with this absurdity: not of his own identification, but the comical trauma at the heart of cultural definition – the idea that bloodlines are how we define our ability to speak for particular groups.

Robinson's 'percentage paintings' – crudely scrawled works that stated his family's Māori bloodline and its dilution all the way down to his own single-digit number – launched his career. It was whakapapa rendered as stark, biological fact. The paintings also included grungy korus and spirals, and stick-figure planes that doubled as waka. But it was the numbers, above all else, that people focused on.

In this, as Robinson well knew, there was the whiff of eugenics. He didn't shy away from such associations. In 1998, he hit the headlines with his 'swastika' works, which, using the same crude drawing technique, offered up the Nazi symbol accompanied by the words: 'Pakeha Have Rights Too!' It caused a media storm, in part because Jenny Harper, then in Victoria University's art history department, had one hanging in her office.

By this time, Robinson was starting to gain significant international attention. After his works were included in the 'Cultural Safety' exhibition, which travelled to Germany in 1995, he was awarded a residency in Aachen. He was also the first recipient of Creative New Zealand's Berlin residency programme in 2000. He remained in the German capital for several years after that, a period that coincided with substantial shifts in his work – in particular, a move away from obvious Māori content. This had an instant effect on his reception.

'When I stopped making work that dealt with biculturalism and post-colonial discourse, the international invitations stopped too,' he says. 'I'd realised that the basis of my invitations was the content of my work, but for me that work had run its course. I'm pleased I made that decision; there was a danger of continuing with it, just so the invitations continued. But they

Ruses & Legacies, 2013

wouldn't have continued for much longer, because that kind of thing [major postcolonial exhibitions] ran its course as well.'

He was also selected at this time, alongside Jacqueline Fraser, to be New Zealand's co-representative for the country's first exhibition at the Venice Biennale, in 2001. Robinson's contribution, an installation titled *Divine Comedy*, was built around binary numbers. He'd created prints that were effectively code – grids of ones and zeroes that were based on existentialist texts: lines from Sartre about nothingness transformed into a visual language of numbers, the patterning of which referenced minimalism's seriality as well as the abstract 'nothingness' of op art and New Zealand's own version of it – Gordon Walters' koru paintings.

When read as letters rather than digits, Robinson's ones and zeroes spelled 'IO'. In some Māori creation traditions, Io is the supreme being – the generative force that shaped the world. This Māori reading was reinforced by Robinson's choice to restrict his palette to black, white and red – and of course, what we knew of his practice up to that point. There were also strangely (for him) slick sculptures; hanging spheres that sprang warty, cellular versions of themselves.

Up until recently, I have always seen *Divine Comedy* as a transitional outlier within Robinson's practice. I now understand that it was in fact a crucial turning point: a moment that linked his bicultural politics with an increasingly sophisticated understanding of minimalism and its complex art-political legacies. This was the productive moment in which the building blocks of the next fifteen years' worth of Robinson's work were laid.

Fast forward to now, and Robinson is one of the go-to guys when international curators turn their attention to New Zealand and Australia. This isn't because they always expect him to represent an Australasian or Māori position per se, but because his inclusion in their line-ups offers the possibility of expanded conversation – an extension of a curatorial theme into this corner of the world. In other words, his presence at biennales tends to shrink conceptual and geographical distances rather than accentuate them.

Partly that's because his current work is so malleable, conceptually and literally. There is its internationally and intentionally readable play on minimalist histories, its on-trend scatterings and its inclusive sociality. His installations can also expand or compress as needs dictate. He has even perfected a method of shipping entire exhibitions in suitcases – a helpful side-benefit of his shift into lightweight felt.

These are the sorts of pragmatic details artists now have to think about. Though inclusion in biennales carries a lot of kudos, it usually doesn't, at an individual level, come with much cash. It's often up to the artists to find the funds. Robinson, then, has become a kind of freelance contractor in the biennale economy; someone who can be inserted into a given situation and bend his work to curatorial conditions on the ground. This status also underpins much of his current self-doubt, as he begins to examine the kinds of returns he, and the broader art world he's a part of, gets from making such large financial and emotional investments in these events.

Sydney in 2012 is a good example. Robinson's *Gravitas Lite* was one of the most critically acclaimed works in a biennale which, titled 'all our relations', expressed a universalising urge to capture the essence of the human condition. As curator Catherine de Zegher stated: '"all our relations" concerns a global movement of art and thought that has been under the radar and now emerges as radical and dynamic, bringing forward significant change. From the collaborations and juxtapositions emerge powerful and wholly new ideas, a truly global proposal of what art is and what it does in society.'

It was a woolly proposition that didn't work. The 2012 Biennale of Sydney was quiet, confusing and far too gentle to enact the radical social change its curators aspired to. It was, however, typical of a growing number of biennales, particularly since the GFC, that have sought to position art as a remedy to global ills. Which is a tough thing to do, for a form of exhibition that is itself a product of exactly the systems it is trying to critique. It's in this biennale context that the relationships in Robinson's installations between minimalism, capitalism and labour come into sharpest focus.

WHEN THE CURATOR Fulya Erdemci came up with her concept for the 2013 Istanbul Biennial, titled 'Mom, Am I Barbarian?', she had no way of anticipating how political events in the city would force her into an extremely difficult position.

Erdemci had stated that her exhibition, the line-up for which included Robinson, would explore the relationship between public space and art as a political forum, and that consequently, it would explode out of traditional gallery spaces and into the city's defining gathering points. It was due to open in September. But at the end of May, a small protest against the planned razing of Gezi Park to make way for a shopping mall and luxury apartments tipped into one of the defining global-political moments of that year.

The Turkish authorities broke up the protest with tear gas and by burning protesters' tents. The Arab Spring had already proved how quickly such incidents could snowball, and so it was that a small demonstration against property development quickly turned into a massive occupation of Taksim Square, with large protests in other parts of Turkey. A standoff over gentrification and the commercialisation of urban space came to symbolise the frustration of a generation of young Turks living under the increasingly repressive Recep Tayyip Erdoğan regime.

'When we made a site visit [before the exhibition], there were things in the air,' Robinson recalls. 'We were taken to the outskirts of Istanbul where they were shifting people from ghettoes, for want of a better word, in the city's inner suburbs out to new projects. Gezi Park hadn't become a centre of dissension and debate by that point. But when we were there for the biennial, they'd sealed it off. When you walked down the main street, there were busloads of policemen, and in Taksim Square there was a very heavy police presence. There was always something in the air, a sort of menacing state police presence that was unfamiliar.'

For Robinson, Istanbul 2013 was an important moment not just for the rumblings outside, but because it was where he made one of his first large-scale 'scatter' pieces using felt. A work that he had conceived as a

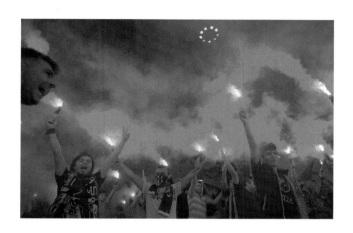

Uriel Sinai
Unrest Continues in Turkey with Anti Government Protests, 2013

total environment, in which a vocabulary of repeated forms might develop conversations between themselves and with viewers, was recast by political events beyond his control.

In his work, *Ruses & Legacies*, clear Perspex cubes – which played on the minimalist boxes of Judd and Robert Morris – provided a rhythmic anchor, either on their own or stacked inside each other like Russian dolls. These were doubled by similarly proportioned cubes made from thin bands of wood, which became open voids through which other materials spilled. Felt (a material also used extensively by Morris) was present in myriad shapes and forms: small squares like dice cast across the floor; flat discs; tubes that vaguely resembled uncut liquorice allsorts; or stacks that looked like carpet tiles waiting to be laid.

Some of the arrangements of different-sized discs on the floor harked back to the bubble sculptures in his 2001 Venice Biennale installation. He also used the same black, white and red colour scheme. It was clear that he was circling back to something, or at the very least trying to resolve questions he'd kicked open – about the relations between minimalism, abstraction and biculturalism – more than ten years earlier in Venice.

For a lot of visitors, however, these subtle references would have been drowned out by the events outside. Many commentators assumed Erdemci and her team would treat the political crisis in Turkey as a boon – a reinforcement of her biennial's central objective. But instead of participating in the revolution on the streets, Erdemci pulled her exhibition and artists inside. As Sam Thorne wrote in *frieze*:

> plans to utilize public spaces were dropped, with organizers arguing that this would have required collaborating with the same authorities who were busy crushing other forms of expression across Turkey. Erdemci, for her part, became convinced that not realizing projects in public spaces was 'a more powerful statement than having them materialize under such conditions'. . . . The exact nature of Erdemci's pre-Gezi planned interventions and commissions remain murky.

> What is clear, though, is that the biennial retreated. Rather than taking place in the public sphere, it withdrew . . .

Erdemci was criticised for the decision, not least because some of the buildings the biennial withdrew to were galleries funded by Turkey's corporate giants. This wasn't the first year the biennial had been criticised for this; it had long been sponsored by Turkey's largest business, Koç Holding, who also produce military vehicles and ships used by the Turkish government (although Koç's relationship with Erdoğan's Islamist government is far from straightforward).

But it's unfair to dismiss Erdemci's exhibition. One of its many strengths was that it served up one of the most important political artworks of recent years: Hito Steyerl's *Is the Museum a Battlefield?*, which was made specifically for Istanbul in 2013. *Is the Museum a Battlefield?* takes as its starting point the extrajudicial execution of one of Steyerl's friends, a member of the Kurdistan Workers' Party, in 1998. Structured as an extended lecture, complete with slides, Steyerl traces the trajectory of a bullet found on the battlefield where her friend was apparently killed all the way back to its corporate roots. From there, she examines the close interconnection between arms-producing corporations, the art world and new museum architecture. Persuasive, at times funny, and infused with a fierce polemical energy, in the context of Erdemci's biennial it was an incredibly potent work – a mirror to the events and debates unfolding around it. It turned the walls of Istanbul's galleries into permeable membranes through which money, death, militarisation, protest and contemporary artmaking all became part of the same ambivalent flow.

Istanbul 2013, emblematised by Steyerl's breakthrough work, came to stand for the contemporary art world's defining tension; its increasing reliance on private money generated from business and political practices that many artists find troubling, and, often, obscene. Such dilemmas are now commonplace, given that countries in the former Soviet Union, China and the Gulf states are starting to dish up major opportunities for

contemporary artists. Which is not to say that more traditional Western sources are necessarily better; it's just that the question of art money's cleanliness has become a globally pervasive one.

Thorne concluded his excellent review of Erdemci's biennial with a cautionary note:

> The contingency of the biennial form has, in the more Utopian moments, been thought to be its strength. Rather than a slow-moving museum, a biennial can be flexible and responsive – to time and to place. 'Mom, Am I Barbarian?' was shaped by both an awareness of the urgent obligation to respond and the knowledge that any response would be inadequate. It felt trapped. But this provided an interesting case for the biennial in the 21st century. When a cultural institution is so thoroughly enmeshed with private interests, the same interests that are transforming the fabric of the metropolis, how is it possible to stand outside?

In other words, according to Thorne, this wasn't just a Turkish problem. It was something all of us who ply our trade as cultural labourers on the international art circuit needed to face up to.

JUST BEFORE THE Gezi protests hit the world headlines, Robinson had been in another major art event, this time in his hometown. The 5th Auckland Triennial in 2013 had been much anticipated, in part because the Auckland Art Gallery (AAG) had turned to one of the world's most prominent curators, Hou Hanru, to direct its flagship contemporary art event.

Hou called his Triennial 'If you were to live here . . .'. It was a ponderous title for an exhibition that 'invited artists to respond to the diverse cultural, social, architectural and urban characteristics of Auckland'. Hou suggested that:

144

A triennial is a space for producing new aesthetic forms and social spaces. . . . It is not only an occasion to see art, but an interaction between artists, people and the city to envisage possible futures.

This evocation of the relationships between civic space, the citizenry and socially oriented artworks was near identical to Erdemci's semi-aborted ideals a few months later, and not so different to the curatorial rhetoric surrounding the 2012 Biennale of Sydney. And so it was that Robinson found himself, once again, at the service of an attempt to use art to change how we think about public space.

Robinson's response to Hou's brief was *If You Were To Work Here: The Mood in the Museum.* At the AAG, 240 rods covered in felt were arranged in a grid on the gallery's mezzanine floor. Instead of black, white and red, Robinson opted this time for a colour scheme of red, green, yellow and blue – a reference to the four 'humours' in Hippocratic medicine.

An army of volunteers collected the sticks – one each, carried vertically, leaning against their shoulders like rifles or flags – and formed a procession that moved through the CBD, past Auckland University and through the Auckland Domain, to the city's other major collecting institution, the Auckland War Memorial Museum. There, the marchers were given a formal Māori welcome before they crossed the museum's threshold and, as per Robinson's instructions, leaned the sticks against the classical columns and walls of the museum's Grand Foyer.

From that moment on, the museum's staff took over the project, choosing sticks that reflected their mood on any given day and placing them somewhere within the building. Slowly, Robinson's felt sticks colonised the space: entering vitrines, climbing up walls, leaning against plaster casts of ancient Greek sculptures and standing next to some of the most valuable Pacific taonga in the world.

If You Were To Work Here is a quietly important work, not just within Robinson's own practice but within recent New Zealand art. As with his

If You Were To Work Here: The Mood in the Museum, 2013

chains in Sydney, it said some sharp things about the relationships between cultural labour and cultural institutions. The procession had moved from Auckland's newest museological space – the extension of the AAG – to its oldest; the museum's Grand Foyer, which was built in the nineteenth-century image of its parent institutions such as the British Museum. The procession itself relied entirely on volunteers participating for no financial compensation. Then there was the subjugation of Robinson's own controlling impulses to the emotional states of the museum's paid workers. The irony of this, of course, was that as they embraced the project, his own presence throughout the building grew.

These socialised moments were punctuated by formal stillnesses, in which Robinson's sticks became line drawings in space: the grid of them on the floor before they were collected; their poise when leaning against the museum's fluted columns; and the sharp incisions they made throughout the building over time. Their status as weapons couldn't be overlooked either; the Auckland Museum is built as much on rifles and taiaha as it is on classical principles of science and collection. It is an institution where the nineteenth-century Land Wars between Māori and Pākehā, and Gallipoli in World War I, don't compete for attention but co-exist on a hill that is a strategic and spiritual site for local Māori tribes, and that has long been central Auckland's biggest green space.

WHEN I CATCH UP with Robinson just before Christmas 2015, the developers have finally booted him out of his studio so they can get on with the luxury renovation. He has moved into a space at Elam School of Fine Arts, which is empty while the students are on summer break.

When I arrive, the floor is covered in pink and brown felt. It's a redux of the piece he made for the Pompidou, because there's talk the Paris institution might tour it, including to Istanbul. The original work had been made

in blue felt, but the floors at one of the proposed future venues is black. Robinson is trying to figure out if the new colours will pop more effectively against the darker ground.

As we talk, he moves through the space, tying strips of felt. This time, they come together as a kind of waist-level web. It occasionally traps me, so that I have to duck under the threads and find a clear space, before he quietly pens me in again. Not that I think this is his agenda; in some ways, he seems oblivious to my presence. He's far more focused on figuring out how to make the felt float. At the same time he is chattier, more relaxed and more forthcoming than he has been in our seven or eight previous meetings; as though the fact his hands are busy is helping his mental wheels turn too.

'Feel free to move stuff around,' he says to me.

I half-heartedly shuffle a few little discs on the floor. I'm more interested in watching him, seeing how his subtle rearrangements alter the environment and his thought processes.

Robinson is not long back from Indonesia, where he participated in the Jakarta Biennale curated by Charles Esche. Robinson had met Esche when he'd been brought to Auckland to judge the Walters Prize, which he gave to Luke Willis Thompson. My previous meeting with Robinson had been a couple of months before he left for Jakarta. At that point, he'd been at his most sceptical. With his studio packed into cardboard boxes, waiting for the moving truck to arrive, he'd expressed all his doubts about his involvement in biennales and the economics of the art world. Which is why I'm surprised to find him so positive about Jakarta.

'There was a great feeling about it,' he says. 'It was a really special biennale.'

He hands me his phone and goes back to his hammering and tying. I flick through the photos of what he made in Jakarta. For the first time, he had built an arena, a knee-high wall that marked out a square to work within. Inside it, I saw several people – Indonesians mainly – crouching, moving

If You Were To Work Here: The Mood in the Museum, 2013

black pieces of felt around the floor, creating pictograms. I flick on and see details of what they've made. Some of them are extraordinary.

'Really amazing, eh?' Robinson says. 'From highly interesting abstraction to figuration. With Paris [the Pompidou] and Auckland [Artspace], I was trying to veer people away from figuration. This time there was no guidance at all, apart from a few rules: take your shoes off, don't tie the material, don't ruin it for others. I don't know if it was that particular culture or just letting it be more free, but it worked in a much better way.'

It's clearly, from a formal perspective, the best iteration of the project to date. But it is also the most knotty and complex. The arena, as a defined field, also seems to double as a zone for behavioural observation, like a kind of pseudo-anthropological study.

'It also just functioned really well as a place to hang out,' Robinson says. 'It was very relaxed. But, yeah, it's interesting how that structure completely shifts it. I think it makes it a better work.'

This takes us back to the conversation about the role of labour in his work; his desire to dissolve hierarchies between artist and viewer. As he observes himself, this utopian ideal inevitably hits roadbumps when put into practice.

'It's all very well to try to be non-hierarchical. But the problem is the people I work with generally have less knowledge about artmaking than I do. So what does that do in relation to me as an expert in the field?'

Most of his collaborators, as he implicitly points out here, haven't been to Marfa, or Istanbul, or Venice, or Sydney, or Paris, and probably never will. Most of them don't know about the complex debates about the tension between minimalism's blue-collar ideals and its complicity with late capitalism. Robinson's giving away of control, then, isn't a straightforward, democratising act. It's also a critical examination of the power dynamics of knowledge acquisition, of putting people to work, of who can speak about what and for whom. They're exactly the same questions he was posing with his percentage works in the 1990s.

'I think the politic in my work is still here,' he says. 'But it's much more subtle, and actually more sophisticated. When I made the work for the Dowse Museum and titled it *Tribe Subtribe*, that's linked into it. But again, I'm trying to keep it at arm's length because I think it makes the readings of things too easy.'

Over the course of our conversation, he has managed to turn the entire room into a hovering felt grid; a floating structure that acts as a perimeter for the miniature, abstract dramas playing out on the floor below it. Everywhere I look, there are chains and cages, circles and rectangles, loops and lines. Ones and zeroes.

He pauses when I point this out.

'Yeah. I seem to be making universes again, don't I?'

Within, my thoughts are vainly thrusting outwards.
Spread out now is my view of the hill,
Whilst inwardly, I long for the man she now possesses.
Recalling, dear one, the days when we too were alone.

In *I Like America and America Likes Me*, 1974, the German artist Joseph Beuys spent three days in a New York gallery with a live coyote.

The coyote is an important animal in Native American mythology: a complex, half-human figure who, in many traditional stories, fulfils the role of the trickster and shapeshifter. He is an essential archetype. Beuys' co-existence with the animal was in part a political comment about the detrimental impact of American modernity on its native landscapes, cultures and fauna. But it was also his attempt to enter a transformational state. This was a trope that often appeared in his work: for Beuys, ritual enactment and changing form were cathartic processes for postwar German society.

Over the past forty years, plenty of artists have taken on Beuys at his own game, but not many have managed to absorb and critique the legacy of *I Like America* quite so intelligently as Shannon Te Ao, in his work *two shoots that stretch far out*, 2013–14.

In five successive videos – short films, really – the structure is almost always the same. A young man in black jeans and a T-shirt moves barefoot through a barn that could just as easily be a colonial school hall or church; worn floorboards, tongue-and-groove panelling. The light is dead flat. The only sound is the man's voice. He's Māori, and wears a wedding ring.

153

<u>two shoots that stretch far out</u>, 2013–14

In each film, animals accompany him: a silent donkey; a swan; a wallaby; rabbits; a rabble of chickens and geese. The duration of their time together is determined by how long it takes him to recite a poem – anywhere between two and three minutes, depending on the pace of his delivery. When he's finished, the camera is too: a black screen, a brief nothingness, and then, a few seconds later, there he is, speaking his poem to the next set of creatures.

The young man is Te Ao, and the work is a portrait of him undergoing a profound transformation as he recites the same text, again and again:

It was then we lover-like oft our limbs entwined.
This is but an elusive memory for you,
For assuredly, you have utterly forsaken me.
The wretchedness of a husband shared.

Te Ao's poem is a stripped-down English translation of a waiata from the Ngāti Porou tribe on New Zealand's East Coast, about a woman sidelined by her husband, who has to watch and suffer silently as he takes a second wife. The woman's pain at having to share her man is immense. But as sad as her plight is, we're left with a raft of questions. Are we simply listening to Te Ao recite something he's moved by? Or is he channelling the voice of the woman? If he is, who is she? And what does that turn him into? And just as crucially: who is Te Ao, as the performer, sharing the text with? The animals, or us?

TE AO FIRST presented *two shoots* at the 2014 Biennale of Sydney (two years after Robinson had shown his massive chains). It was a perfect fit with the exhibition's vision: curated by the Australian Juliana Engberg and titled 'You Imagine What You Desire', the biennale privileged the mythic, the archetypal and the erotic.

It also very nearly didn't happen. During the preparations for the biennale, it emerged that one of its main sponsors, Transfield, was involved in the administration of Australia's offshore detention centres for asylum seekers on Manus Island and Nauru. As the exhibition approached, riots at the Manus facility led to the death of a young Iranian, Reza Barati.

Almost half of the ninety-six artists selected for the exhibition, including Te Ao, signed an open letter calling for the biennale board to sever its ties with Transfield. The problem was that Transfield's chairman, Luca Belgiorno-Nettis, was also the chairman of the biennale board. The initial response was dismissive, but as the pressure mounted and an artist boycott was called for, the board relented: Belgiorno-Nettis stepped down and the biennale cut its links with Transfield.

On one level, this was a victory for the power of protest. But the action inadvertently oversimplified the same issue I reflected on in the previous chapter: art money's relative cleanliness. The targeting of Transfield was a response to an immediate humanitarian issue – the Australian government's horrible treatment of asylum seekers. But Transfield is just one of many global businesses who support contemporary art while making money from practices many artists object to – Koç's production of military vehicles being another. As a result, the boycott call presented the danger of biting, and biting inconsistently, the invisible hand that feeds the whole system. This left many of the artists in a terrible quandary. In the end, a handful pulled out of the biennale, while the vast majority stayed in.

Engberg openly stated that the artists were welcome to respond to these issues within their work. Te Ao – the only New Zealander included that year – made a quiet gesture towards this, by including a wall text alongside *two shoots* from the writer Murdoch Stephens, based on the UN's 1951 Convention Relating to the Status of Refugees. But he left the video itself untouched.

This was a good move, because he didn't need to do anything to the work; it had already hit a sweet spot between postcolonialism, contemporary politics and myth. All of the animals Te Ao encounters in the videos are

introduced species. This, combined with the story of the unhappy marriage, could easily be read as a metaphor for the meeting of two cultures (the Māori man and the foreign animals), and extrapolated out from there as a kind of eco-colonial message about New Zealand's past. In the immediate context of the biennale's ructions and fallouts, it was also just as feasible to draw a parallel between the introduced animals and the plight of the people imprisoned on Nauru and Manus.

In a biennale that so wilfully cultivated a sense of the collective mythic, it was also important to see Te Ao's work as part of a classical conversation about transformation and shapeshifting. There is, for example, a lot of Leda in Te Ao's encounter with a swan, particularly given his poem's emphasis on the broken sanctity of a marriage. In the original myth, Zeus, in the form of a swan, is the aggressor, raping Leda on a day that she had already slept with her husband. In Te Ao's version, the swan is perfectly still: the passive victim of *his* encirclement. All we see of the artist as he paces around the bird is his dark clothing and bare feet. His jeans are turned up, just enough to stop them catching under his heels. This small gesture reveals tattoos: pīpīwharauroa, or shining cuckoos, with their wings spread; the migratory birds that, in some Māori traditions, may have guided the first people to Aotearoa.

It seems likely that Te Ao knows exactly what he's doing here, circling a swan with winged feet. One of Zeus' sons was Hermes: the product of yet another of the god's violent sexual conquests. Identified by his winged sandals, Hermes was both a messenger and a trickster, capable of crossing thresholds, changing form and accessing the afterlife. Maia, Hermes' mother, is also one of the Pleiades – the constellation whose appearance signals, for Māori, the start of Matariki – the New Year.

Te Ao's encounter with a donkey plays similar mythical games. In classical mythology, the donkey is often associated with Dionysus; another of Zeus' half-human offspring. He is also deeply connected to Western understandings of the line between eroticism and death, and to the transformative force of sexual release. As the camera pans, Te Ao is the first thing we see.

We watch him with his eyes downcast, as if he is reading the waiata from a sheet in his lap. The camera keeps moving and the shaggy face of the donkey comes into view, in profile, inches from Te Ao's own. Undisturbed by the animal's proximity, he keeps reading. The animal doesn't seem bothered either, his sidelong eye trained on the camera. About two-thirds through the recitation, the donkey passes his muzzle over Te Ao's shoulder. On the way back, he gives the artist a bump – a rare moment of physical contact in the cycle between Te Ao and the animals.

Two shoots is about a waiata. But it is also about crossing oceans, crossing genders, crossing between times, between the dead and the living, between the animal and the human, and between the earth and the stars. Te Ao, fixed in human form, nonetheless embodies mercurial energy throughout. It is a performance framed by lost physical love – the shattering trauma of having to forego the moment when our bodies merge with the person we most desire.

It would have been easy for Te Ao to take on the role of shaman, hamming up his own indigeneity as a critique of Beuys' attempt to become the dark Other. But he paces around this cliché as delicately as he does the sleeping swan. Just like Beuys, he co-habits the space with his animals. But rather than wrapping himself in props in pursuit of a mystical truth, he turns the room into a world of overlapping physical and phantasmagorical presences: the animals; what those animals symbolise archetypally and ecologically; Te Ao himself; the poem; and his voice, channelling that of a woman – a heartbroken ghost filled with lilting scorn.

Beuys referenced colonial history. Te Ao's work, by contrast, enacts it. *Two shoots* is immensely sophisticated: a series of videos in which the minimal information provided – a man, a room, a poem, an animal – explodes with excessive force. Te Ao, understanding the stereotypes and clichés of indigenous spirituality, anchors his work in something more difficult to absorb or categorise: the disruption of the shapeshifter, who in evading capture, picks us up in a moment of contemporary, migratory tension and carries us on a remarkable journey through time and colonial space.

159

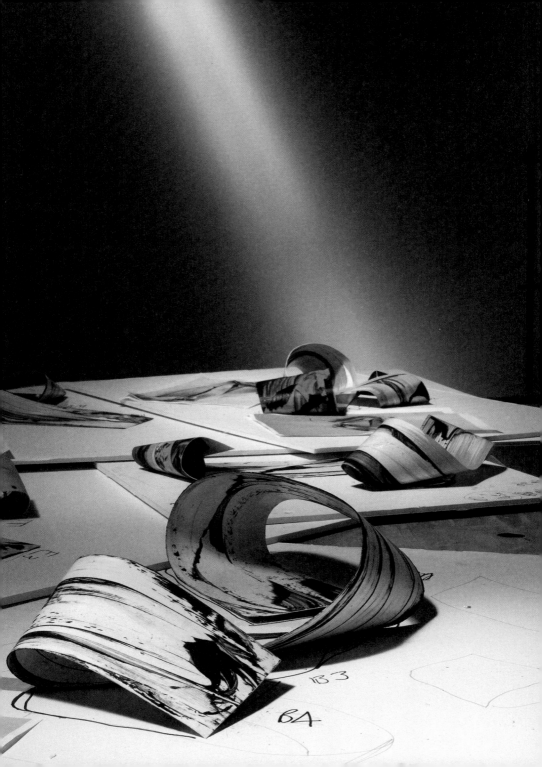

Parallel Worlds

'It's a sense of the aggression, the anger, the hope, the resistance, combined with everything I see, and everything that represents those things back to me. It's a translation point where I can communicate all of that to another . . . actually, no, sometimes I don't give a shit about anyone else. It's so *I* can see it. And I suppose I always have the vague hope that if I can, there might be a handful of others who do too.'

From Judy Millar's house, you can see the curve of the earth. White's Beach seems miles below; you can just make out people walking their dogs and scrawling marks in the sand. The house perches on stilts, flexible enough that it doesn't blow over in the regular Tasman storms the Waitākere Ranges spare the rest of Auckland from. Out here, way down the Anawhata road, there is nothing between the house and Australia, except a wall of churning ocean.

Sitting here, looking at the view I lived with for three months, I've just asked Millar what she's searching for when she paints. 'An image that is how I really see the world, and experience it,' she continues. 'An image that's able to actually carry the way I feel and exist and see and am, and to offer all of that as an available form.'

Millar is tall and thin, in her late fifties, with grey-blonde hair that just reaches her shoulders and seems permanently blasted by salt and wind. Since 2002, I've done at least a couple of studio visits with her a year, either in Auckland or Berlin. Every one of them has been as though the conversation

from the last meeting never stopped, even if months have gone by. Millar speaks with an intense energy, and has a remarkable ability to draw tangential connections. In one recent conversation, we covered 1968 student protests, Catholicism, quantum physics, surrealism and whether Lorde is a better artist than Simon Denny – all before we got anywhere near talking about her work.

Millar had to wait until her forties to get much international traction, but is now one of New Zealand's most successful artists. These days, she splits her time between the Anawhata house and central Berlin, where she and her partner, the German painter Katharina Grosse, have converted an old grocery store, just on the eastern side of where the Wall once ran, into their home.

Millar's German move wasn't just for a change of scene; it was the result of her work undergoing a major overhaul. In the 1990s, she'd been making solid, formalist paintings and showing them with her longtime dealer, Gow Langsford Gallery. But around 2001, she changed everything. It was a simple move that had massive consequences: she put a canvas on the floor, took her (extremely corrective) glasses off, and pushed paint around with her bare hands. The results veered between the extraordinarily beautiful and the downright ugly. For Millar, the difference didn't matter. Far more important was that she was finding new ways to imagine, and realise, pictorial space.

The ambiguity of these works came from their strange push-and-pull between figure and ground; it was impossible to know whether her gestures sat on top of the colour field she'd laid down or behind it. Later, she started 'drawing' more consciously – slicing into her swishy marks with rags and squeegees to create defined, although still largely non-figurative, forms.

After toiling for over twenty years, things started to take off. European dealers and curators became interested, so she started to spend more time in Berlin. This had an obvious impact on her work.

'It's gained a toughness,' she says. 'I get the train in Berlin, and a lot of people who get the train there are not doing so well. They're still struggling

with the transition from socialism to capitalism. Then there are the dog people [young homeless people or squatters who keep mongrel dogs]. And the city has a pretty bad heroin problem. When you're meeting that on a daily basis, things have to change. Like those super-saturated colour paintings at Gow Langsford ['Proof of Heaven,' shown in early 2015] – they were made in Berlin. I don't know that I would ever have used those colours here. It was almost a therapy; a way to address or escape what I saw on the train that morning.'

Her other escape is Anawhata. She has occasionally contemplated severing her ties with New Zealand. The loss of both her parents in a short space of time gave her even more reason to go and never come back. But it's her house, more than anything else, that keeps her returning.

Millar started building it in 1984. A couple of years earlier, she'd sold her first café, called Domino's, for a profit, and had used the money to buy a west coast scrag of bush that sloped so steeply it was pretty much uninhabitable.

'Domino's was designed to be a collective,' she says. 'It was inspired by Gordon Matta-Clark's FOOD [an art-restaurant collective in 1970s New York]. We were all artists. None of us had any money, and we all had time, and we were all working in cafés for other people. So I just thought let's get together, combine our skills. I found the space and set it up, and then nobody wanted to be in a collective. They all wanted wages. So I became the boss. That was a huge disappointment to me. I understood a lot about human nature through that.'

It was also one of Auckland's first cafés to serve real coffee. 'We put espresso with vegetarian food. And it was super-cheap. It was a runaway success. We used to have queues around the block. I'd had ideas that I'd be spending the mornings in my studio, and then I'd go in there. But I never got to the studio, so after a year and a half, I sold.

'I went to New York for three months and blew a lot of the money. But I had enough left to buy the section. I'd been out to Anawhata with John Reynolds, because his parents have a place there. Something in my mind

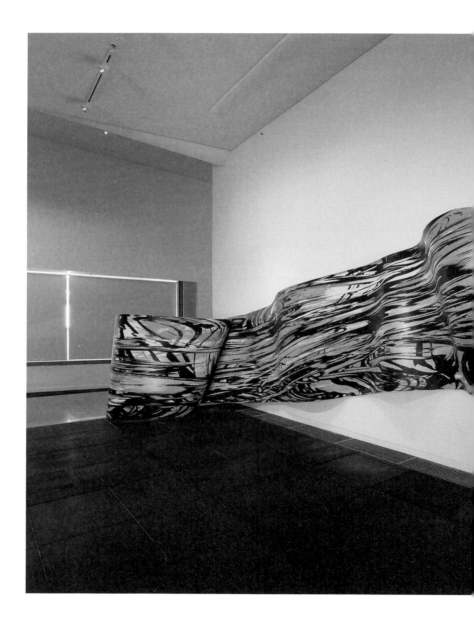

Space Work 7, 2014

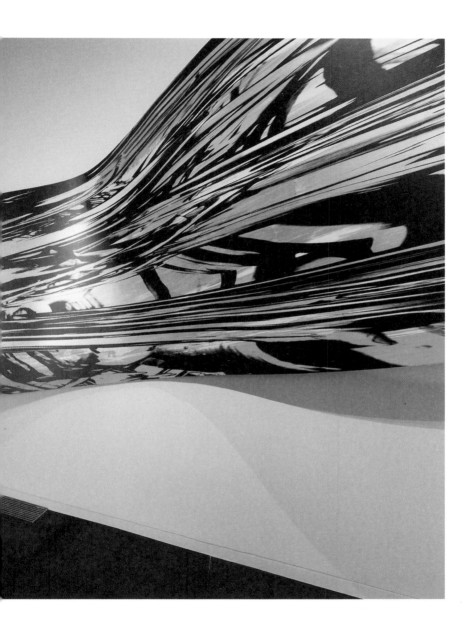

went: I need to be here. I was pretty . . . I don't know, I was going crazy. Out there something matched me. I thought, This is going to save me. I saw the storms and the wind and I knew it was going to sort me out. And it somehow did.'

Slowly, Millar cleared and flattened a building platform. The trouble was, she didn't have any money left to build the house. So she teamed up with a friend – a young Auckland architect named Richard Priest. 'We'd washed dishes together as students,' she explains. 'He was just out of architecture school, and it was pretty much his first building project.'

The house became as much an encapsulation of 1980s Auckland as Domino's was. While Millar was introducing espresso to Aucklanders, the city's old buildings were being demolished to make way for glass towers. 'Everything was being torn down, so I started to collect materials. It was always just a couple of crates of beer, swaps. As I found materials, Richard would redesign the house.'

Over the years, she has made a few additions. In the early 2000s, Priest designed a studio that lets light in through the roof instead of from the side facing the sea, so Millar isn't distracted by the view. It is a house on the edge of the world: off-grid and self-contained, and where, on a good day, you can watch the sun go down, literally; a single, smooth drop like a lozenge through treacle, somewhere beyond a horizon that isn't actually there.

MILLAR'S RECENT RECOGNITION has been two-paced: one thing in Europe, and something different in her home country. To put it another way, a lot of people in New Zealand don't get her work. And plenty said as much when she was New Zealand's surprise pick for the 2009 Venice Biennale.

'I wanted to do it because I had a project,' she says. 'I knew that I could use the situation and the resources to develop something I couldn't do otherwise. Even though the resources weren't enormous, they were far greater

than I'd had the opportunity to make use of before. For me that's still the best thing about Venice – that it gives artists the opportunity to do something they couldn't do anywhere else. It should be a dream project.'

In 2009, Millar's dream project faced an uphill challenge. Officially, New Zealand had skipped the previous biennale in 2007 because of the heat generated in response to et al's 2005 installation; a lambasting of the work by various public figures and the media, which resulted in the infamous 'Donkey in a Dunny' label for a work that was, I thought, the country's best presentation at Venice up to that point. Creative New Zealand bounced back and committed to the 2009 exhibition, and Millar was chosen. Things were a little confused, however, because Francis Upritchard – one of the other frontrunners – had also been given the nod. I'd always assumed this must have annoyed the hell out of Millar, but the opposite is true.

'It was a relief to have Francis there,' she says. 'It was an extremely difficult time to be doing Venice, because you knew if you messed up there would never be another New Zealand artist go. So there was an added responsibility that went way beyond your own work – a responsibility to perform and behave. Francis having to front that too took some pressure off.'

Upritchard's co-selection also told Millar a great deal about how she was viewed by some influencers in New Zealand. 'I knew I wasn't supported by a big group of people, which is why Francis was on board too. That was good to know, because then you go, "Okay, let me do it and show you".'

Millar's project, *Giraffe-Bottle-Gun*, in La Maddalena – a circular neo-classical church – was as much a breakthrough for her as the moment she put a canvas on the floor. It was the first of her large-scale painting installations. At the centre of the church, Millar and her team built a big, twisted form, like a scrolled piece of paper knocked just off its axis. It was wrapped in a vinyl print of Millar's brush and hand-marks, blown up as though they'd been made by a giant, or a celestial power. She also placed massive painting fragments around the room, the shapes of which gave the show its associative title.

Millar's marks, colours and shapes interacted oddly with the building itself and the paintings embedded within it; small moments such as when a pink swirl in her work jutted up against the pinkish wings of a painted angel on the wall. These resonances were easily missed but they were the key to the work's success: the sense that there was no real demarcation – temporal or physical – between Millar's painted universe and the one created hundreds of years earlier. What made this stranger still is that a couple of months out from the biennale's opening, when she'd already made most of the work, the venue she thought she was showing in was pulled. The team scrambled to find an alternative, and Maddalena was it.

'Sometimes I think I didn't have anything to do with that project,' she says. 'Like it was made for the site it ended up in, even though I didn't know where that was. I do think there was some kind of hand guiding it, which was quite beyond me. When I went into Maddalena with my tape measure to see if things fitted, six weeks out from having to install, wherever I put my tape it was the exact measure of the things I'd made. I started to think, There's something weird going on here. It was pretty weird being in Venice and wondering who was, or what was, going on. Maybe it's just like when you kick a ball, and it travels, and it lands somewhere else. I don't know.'

The Venice installation raised Millar's European profile substantially. Two years later, while Michael Parekowhai was New Zealand's official artist, she was also present as part of the group exhibition 'Personal Structures', alongside major figures in conceptual and performance art like Carl Andre, Lawrence Weiner and Marina Abramovic.

But in New Zealand, Millar is considered a painter and is rarely, if at all, discussed as a conceptual artist. This is not to say she doesn't have her fans; in fact, more and more collectors, critics and curators are starting to embrace her vision. But there is still a big difference between her reception here and in Europe. Much of this boils down to her intensely considered relationships with the respective art histories of each place. It is also

contingent on whether we accept that, in Millar's world, paint is the tool rather than the outcome – the means through which she makes a set of illusionistic, spatial and deeply political discoveries.

JUST NORTH OF Copenhagen, the sky and the sea are like two sheets of steel, flecked with wayward snow. Somewhere behind them is Sweden, but there's no chance of seeing it today: the snow has arrived late – only yesterday – and the January light has turned into a kind of blindness that probably won't lift until late March, maybe early April.

The road is clear of ice and traffic, and Torben's old hatchback makes good time. His English is rusty and my Danish is non-existent, but we muddle through the trip without too many crossed wires or awkward silences. He points out the Arne Jacobsen buildings along our route: a beautiful petrol station, a row of terraced houses overlooking the coast.

Torben is the father of a close friend from Detroit, the ceramicist Marie Hermann. I'd been staying at Millar and Grosse's house in Berlin, and decided to make the short trip to the Danish capital to see a couple of exhibitions. Marie had arranged for me to stay with her dad. When I got to his house, he greeted me warmly, and showed me where I could sleep – Marie's old bedroom, her teenage face on the wall, long before I knew her, kissing her near identical sister's cheek.

Torben now lives alone. His wife, Marie's mother, died suddenly a year earlier. The house and Torben are still adjusting to the new emptiness: not quite enough lights to counter the northern dark, the fridge near empty, a cask of red wine on the kitchen bench with a single drip, dried, just under its beak.

I had expected to just crash at his place and let him get on with his work (he is an architect, and was at that moment in the final stages of a small house), but he offered to drive me the following day to the Louisiana

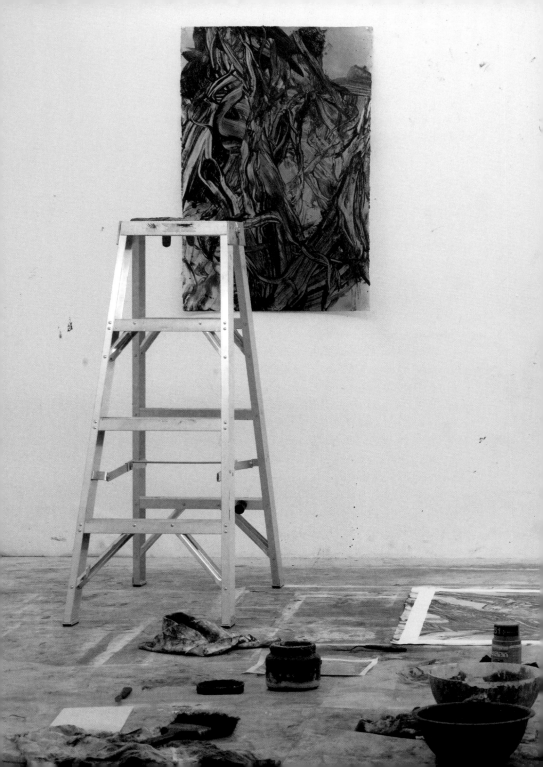

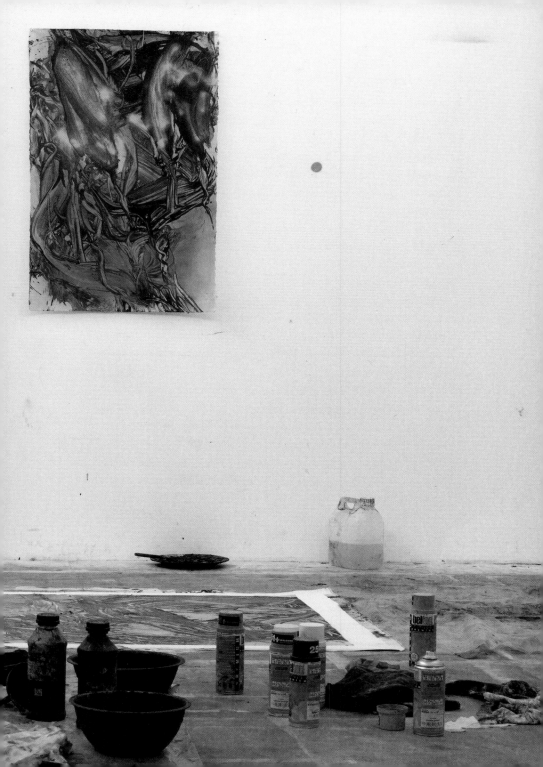

Museum of Modern Art, which is an hour or so out of the city. It was one of the main reasons I'd come to Copenhagen. I didn't take any time to accept.

After a couple of laps of the Louisiana's carpark we find a space, throw on our coats, and dash through skittish drops of ice towards the front doors. Torben knows the collection well, and leads me straight to what I want to see – a room of superb Giacometti sculptures and some great paintings by Per Kirkeby.

But, mainly, we're there to see an exhibition that pairs Denmark's best-known twentieth-century artist, Asger Jorn, with one of America's, Jackson Pollock.

A few years earlier, Millar had helped me to see Pollock in a new way when she described him as a 'weaver' of space. Her idea transforms Pollock's seemingly random drips into a self-conscious warp and weft structure, deliberately controlled to construct painted images – pictures with differentiated surfaces, figures and multiple zones of action. Most of the time, I find, her interpretation sticks.

Pollock's work is also a perfect example of the nagging importance of encounter. Everything we think we know about him – the drink, the unconscious splashing, the macho expressionism – is blown out of the water through the simple act of standing, for a long time, in front of his paintings. The longer you peer at his surfaces, the more you recognise their ambivalent depths. You start to see 'things': like Mark Rothko's Houston panels, forms emerge from the cumulative drips – not because your brain is tricking you but because they're actually there.

The pairing with Jorn makes these visions even clearer. Internationally, Jorn is less known than Pollock, but in Denmark he casts an enormous shadow. In a nation of five million people with cultural hang-ups about its size and status, there's a parallel to be drawn between Jorn and Colin McCahon. Jorn, like McCahon, was an unusual but brilliant painter in a small country who never fully found his global place. Like McCahon's paintings, Jorn's slipped between comfortable categories: between expressionist

abstraction and figuration, between proto-religious symbolism and sharp political commentary. In Danish painting, all roads lead back to Jorn, as they so often do in New Zealand to McCahon.

The exhibition makes clear that both Jorn and Pollock wanted to reinvent painting for a postwar world. Both privileged the mythic in the wake of World War II's carnage. Both were searching for a visual language that linked, as Millar describes it, 'their inner and outer worlds', and discovered the foundations for this in the same sources: Picasso and surrealism. Both had seen Picasso's *Guernica*: Jorn in Paris in 1937, Pollock in New York in 1939 – their respective encounters no doubt confirming their shared beliefs in painting's capacity to convey existential and literal horror.

Of course, there are plenty of differences between them too. Jorn believed fervently in art's duty to intervene in everyday life. He was a founding member of the Situationist International alongside Guy Debord, until they split because Debord didn't believe images could create meaningful cultural change (he believed painting, in particular, was too easily commodified by capitalist culture). Jorn didn't agree. Pollock, by contrast, was less concerned with the everyday, focusing instead on a more rarefied, formalist conversation about painting's social function.

Nonetheless, the connections between them are staggering. It is a remarkable exhibition that shows not only how two artists straddled World War II, but how painting on two continents traced interconnected paths in pursuit of a reconciliation between the interior lives of artists and the traumatised, technological world they occupied.

Afterwards, Torben and I sit down in the Louisiana's restaurant and share a heart-stoppingly expensive lunch of Scandinavian sandwiches and beer. Tiredness hits me in a wave. I've been on the road for almost five months – San Francisco, Detroit, Chicago, Pittsburgh, London, Sheffield, Berlin, Copenhagen. I'm ready to get on a plane home. Torben, reading my silence, offers to drive me to the local train station. We say our goodbyes, and I get on a train headed back into the city, just as the last of the weak light disappears.

Call Me Snake, 2015

'AT MY EXHIBITION opening in Zurich, a lot of artists were gathered in a huddle. I could see they were concerned about something, so I went over. One of them said: "He thinks these are surrealist." A friend, this curator from the Czech Republic, said: "Of course they're fucking surrealist!" When you look at the roots of all the painting I come from, the American School or whatever, it's all surrealism. It's the slippage between the unknown and known worlds, the way perception slides between those things. Which I think is also the basis of religion – this attempt to tie our crazy mental world and our crazy physical world.'

More than any other artist, Millar has made me believe that art history is useless as a fixed timeline, but hugely helpful as material: as a series of disparate nodes that, when brought together in new configurations, accumulates into a solid picture of experience. Surrealism is one of Millar's nodes. McCahon and Pollock are two more.

So is early Renaissance painting. In 1990, she was tired of the New Zealand art scene. She applied for a postgraduate scholarship from the Italian government to study the work of the artist Lucio Fontana and his fellow spatialists in Italy. What she didn't know was that the trip would shape the way she worked and lived for the next twenty-five years.

'The thing that I came back from Italy with most strongly was the way everything just grew out of the ground,' she says. 'The architecture, the art, the food, the people. And yet it wasn't materialistic – that was the strange thing. It seemed to come out of the earth, but it would gain this lightness. There's also an everyday theatre. You understand that you're there to perform, and not to be real. The way you show yourself – the daily *passeggiata* – where you all just get out and look at each other; it's the weirdest thing.'

She had also given up on painting before she left New Zealand. Italy brought her back, but it wasn't, as she'd anticipated, Fontana. 'It was the Assisi Chapel. It was Giotto. I saw him doing these massive storytelling exercises, and I thought there had to be a way to keep this going. It wasn't right that it had disappeared. Standing in front of those things, you're a

protagonist in his world, in that church. The painted people are as big as you are, you relate to them. You're just another figure in the scenario. It's bizarre. Then you see how they're made, how simple they are. They look like comics. Except they're seven hundred years old.'

To a certain extent, then, Millar's Venice installation was her coming full-circle. Twenty years after her encounter with Giotto, it was her chance to take on, if not him specifically, certainly the painting tradition he pioneered.

In a book published alongside *Giraffe-Bottle-Gun*, I wrote that:

> Italian religious painting sets up a particular type of interactive painterly theatre, which brings performance, illusion and material fact together with the purpose of the buildings it occupies. It creates a parallel cosmos real enough to seem continuous with the one we're in. This is heightened by the way it shows almost all suffering in bodily terms, playing on paint's ability to approximate human flesh. Consequently, we empathise with the bodies on display. We're also reminded of the smallness of our own worldly complaints.

Real enough, approximation. While everything I wrote felt true at the time, I was still drawing a relational hierarchy; still privileging our 'real' as more solid than the painting's 'real'. What I've since realised is that the space of painting exists just as much as the space we stand in when we look at it. If we accept that, then our sense of time also has to shift, because an encounter with a painting, whether it's seven hundred years or a day old, happens in a constant present tense. And when we stand in front of it, we are often occupying the space of its making; the productive zone where the artist once stood with his or her brush. Looking at painting is a potent example of embodied vision – an experience in which time, space, the boundaries between our own bodies and the ghosts who previously stood in the spot we now do, all collapse. This is crucial to understanding what Millar does and where it comes from. In her world, real and imagined space exist on the same continuum.

Once this realisation came for her in Italy, Millar was able to jump forward to another important moment in that nation's art history. Not to Fontana and the spatialists, but to the movement that immediately followed them – Arte Povera. Emerging in the mid- to late 1960s, Arte Povera was part of the wider global counterculture taking hold at that time. In a similar way to Jorn, its practitioners proposed a radical rethink of art's function within society, many of them believing in art's everyday potential – its ability to intervene directly in the social fabric. In her excellent book on the movement, Carolyn Christov-Bakargiev writes that Arte Povera artists were

> concerned with the point at which art and life, nature and culture, intersect. They attempted to create a subjective understanding of matter and space, allowing for an experience of 'primary' energy present in all aspects of life as lived directly and not mediated through representation, ideology or codified languages.

Arte Povera artists weren't beholden to a single medium, or a single political outcome for their work. They used everything from mirrors and dirt to consumables like food and coffee. They wanted to create total experiences – sound, smell, touch, sight. Christov-Bakargiev goes on to write that:

> The attempt to make art without the mediation of a codified language of representation reflected an ideal of 'authenticity' commonly held in the 1960s by that generation of 'rebels' who challenged what they perceived to be an oppressive economic and cultural system based on consumerism and tradition, devised to control rather than liberate. The protests of May 1968 throughout the Western world represented the culmination of these positions in a broadly social and political context Rejecting bourgeois values and post-industrial capitalism, as well as the rigours of traditional Marxism [the Arte Povera artists] anarchically embraced the powers of the imagination.

Millar describes Arte Povera as lurking between 'the physical, the meta-physical, and the political'. But what she identifies with most strongly is its desire to examine art's ability to disrupt the space where our bodies meet the world.

'I would describe that as the point of imagination,' she says. 'Where we meet reality – whatever that is. It's that crashing against, it's the point where imagination *has* to kick in, because it's only through imagination that we know anything.'

IT'S MARCH 2015, and Kyra and I decide to take James for his first camping trip, to Piha. Millar and Grosse walk down from Anawhata and meet us at the campground, just as we're setting up the tent.

'Jesus,' Millar says. 'Didn't you check the weather forecast?'

Kyra and I look at each other.

The five of us head down to the beach. Grosse wiggles an enormous clump of rubbery seaweed along the sand, so that it looks like a tangle of angry snakes. James chases her and grabs one of the tails. The whole bundle snaps out of her hand. He falls down laughing, and they start over again.

Millar and I trail behind. She asks me about the book. I shrug. The more I work on it, I say, the more I realise it's just a subset of something else, that chasing art is no different from people who travel to go hang-gliding, or to sleep with strangers, or to eat strange food. It's all the same thing.

She smiles. 'I was on a panel discussion last week about how we could get more people involved and interested in contemporary art. I started by saying that I didn't even know what an artist was.' She laughs. 'I could see I'd completely lost everyone.'

Kyra looks at the sky, then turns to Millar. 'Is that likely to turn into something?'

'Probably,' Millar says.

Proof of Heaven II, 2014

Seconds later, a wave crawls towards us: one of those Piha inch-deep creepers that refuse to stop. A wall of rain and wind hits us. We run up the beach. James runs too. I turn to check on him, and see that his feet are barely touching the ground; that he's only just heavy enough to have gravity on his side. His face turns from joy to a panicked grimace. I stop, line him up like a goalkeeper, and he slams into my chest. We spin together and race to the takeaway shop. When we get there he's soaked, and covered in sprays of black sand. He laughs, and asks for an ice cream.

THE FOLLOWING MORNING, after a wet, windy, sleepless night, the three of us drive back to the city. We stop in Titirangi where, at Te Uru Waitakere Contemporary Gallery, Millar has an exhibition called 'The Model World'.

In the first room, giant painted constructions fold through the space. None of them read as whole paintings. They are more like fragments of a single work, all with black-and-white surfaces that veer between cowhide patterns and blown-up Ben-Day dots. The longest fragment snakes along the floor, its centre hoisted by a strap tied to a plank of wood, the ends of which rest on stepladders.

In the back corner are two tall pieces of the sculpture-painting; conical twists, standing as a pair, inverting each other. In the foreground is a flat, folded white rectangle, attached to ropes and a pulley. I help James pull the rope and a world inside it splits open: stylised brushstrokes, popping up and waggling at him like underwater creatures.

A projector throws illuminated shadows around the room, the same cow-spots flipped on themselves – black now, on the white ground of the walls. The projection makes silhouettes of every movement in the space: James scurrying about; me lowering the pulley; the brushstrokes springing out then disappearing.

Upstairs, Millar has installed a bigger form: another ribbon-strip, this

time lifted into the air by several ropes, all wrapped around hooks on the walls. The ropes are attached to straps that seem to make the form bend and warp, as though, were it released from its restraints, it would flop passively on the floor. On one side are the same cow-dots, painted more roughly than downstairs. On its reverse, a fleshy pink.

The whole thing is playful, silly, low-budget. It's also like a stage-set, some avant-garde environment you might use for a new take on *Macbeth* or *Waiting for Godot*. I remember Millar, years earlier, talking to me about Bertolt Brecht, and I can't help wondering if he's back.

'You're forced to become the protagonist in the theatre,' Millar says, when I ask her about the exhibition. 'Then it becomes very unclear what is what. You've got the projection, yourself, the shadows, everything getting mixed up. People are very uncomfortable about it. They cling to the edges of the room. Children don't. But adults don't want to step in there.'

Millar has played these theatrical games plenty of times before. It started with Venice. But at Te Uru, something is different. In the past, she'd always tried to hide the structure, to create an immersive environment that seemed to defy its gravitational burdens – to emulate, perhaps, the 'lightness' that everything had for her in Italy. Here, she allows us not just to see all of its inner workings, but to play with them ourselves – the pulleys, the ropes, the ladders.

Rather than theatre specifically, Millar argues that 'The Model World' comes more from 'a place of intrigue with illusion and magic. And I'm still not sure they're different things. Is an illusion really magic, or is it something else? There's also the idea of having a trick explained to you while it's done, and it still not losing its power. In fact it gets *more* magical, because you still can't see exactly how it happens. So the work is really about our inability to see. You lift something up and it blocks as much as it reveals. Or you stand in it and you create a shadow, but you also block out a lot of other possibilities of seeing.

'Every person has a completely unique take on the world at any moment. This work makes that very obvious. As soon as someone else enters the space, you're suddenly aware of the dots falling on them, even though you're not aware of the dots falling on yourself. So there's that whole thing of the other person allowing you to see more, because it shows you how you're being seen. It's all that.' She pauses. 'It's Merleau-Ponty made live.'

I ask her about the pink on the form upstairs. 'I wanted it to be like the stomach of an animal,' she says, laughing. 'I wanted it to be very vulnerable somehow. It also has as many reversals as I could think of. It looks soft, as though the ropes are pulling it into shape, but it's hard. It's looks light, but it's heavy. Then it's got this animal, vulnerable thing about it, even though it's just a very formal form. I wanted to build as many of those instabilities into it as possible.'

Simultaneously with 'The Model World', Millar has a solo exhibition of paintings, called 'Proof of Heaven', at Gow Langsford Gallery in central Auckland. Along one wall is a series of dark, swirling works on paper. Large paintings fill the rest of the room. They're turbulent, gestural, brightly coloured. The way she's drawn them is less severe than a lot of recent work; fewer hard edges sliced by a squeegee or other sharp implement. We're back, mainly, with her hands. But she has created twisted forms too; grotesque, circular vortexes that drag us inside the paintings. Her colours are also more putrid; sickly yellows, and a purple streak that migrates across the paintings like a bruise.

They remind me of mannerism – that transitional period in Italian art in which the illusionistic achievements of the Renaissance had become so well absorbed that artists started to test their limits. It was the first time Italian art moved from a drive for optical perfection towards an understanding that images are slippery, multivalent things. The human body and its warping was at the heart of mannerism's troubling discovery that all art, no matter how illusionistic, is a kind of caricature.

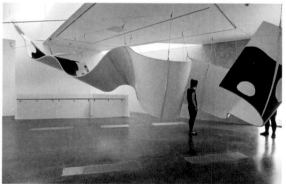

The Model World, 2015

Millar agrees with the mannerist reference, and laughs again. 'Simon [her studio assistant] said it's like looking at Old Masters while you're on mushrooms. There's a psychedelic aspect to them. I thought that would be a complete disaster. I was totally ready for that.'

It wasn't. The show was a sellout.

In both exhibitions, it occurs to me, there are links not just in terms of the theatrical and the caricature, but also in a kind of idealism. Psychedelia was a by-product of the same 1968 energy that motivated the Arte Povera artists to reconnect art with real experience. Millar's titles can't be ignored either: 'Proof of Heaven' and 'The Model World' are absurdly utopian.

'But isn't utopia a kind of theatre?' she says, hitting her rhetorical stride. 'Don't we just use it to play out our best fantasies? None of us really believe in it, do we? Just as I don't think anyone really believes in dystopia. The worst position was modernism, which was frightened of any kind of fantasy. It just wanted to be real, somehow. But what the fuck is real?'

We seem to be getting closer to the core of Millar's outlook: a deep, heart-felt political philosophy, best described as resistant optimism. Its location, for her, is always in the relationship between our innate physicality and our creativity: the desire to have our inner experience leave its tangible mark on the world in some way.

'I think it's absolutely crucial right now that humans open their imaginations,' she says. 'We've had them shut down.'

By what? I ask.

'By political strategies, educational strategies. Artistic strategies as well. We've been conned into thinking everything must have a use value. Artists took that up really strongly – whether that was a political use value, or some kind of commercial use value. Imagination began to be drained out of artistic practice in the latter part of the twentieth century . . . Where our humanity lies is in our poetic sensibilities, our ravings. As soon as the American avant-garde took over, art became increasingly materialistic. Not only

physically, but imaginatively and philosophically. It became "the stuff is the stuff", "it is what it is". But after that, we have to rekindle something.'

We're back where we started; the question of what Millar is searching for – what that 'something' is she's trying to 'rekindle' and comprehend.

'It's like prodding at something more than trying to understand it,' she says. 'Trying to make it come alive. I don't know that understanding has to play a big part in that. Which is why it's so weird that you would then want other people to understand it. But that's one of the paradoxes – that you want the other brain to see it more clearly than you can yourself.'

This image could be the solid we introduced earlier, or equally the plan of a library, the library. This image could be the solid we introduced earlier, or equally a means to work through something, a spatial condition, a scene from inside. This image could be the solid we introduced earlier, or equally a piece of furniture, a plan, a rival brain. And whether we think of this image as a solid made of objects, actions or gaps, a plan of a library or a fleshy substance — it is, clearly, part fixed structure, part leaky building. Gaps to be filled, holes from which things spill.* The holes — the gaps — leak and spill, disrupting the rhythm it wants to be, the score it wants to conduct.

This image shows us the spilling that interrupts the library both as a spatial construct and infrastructural code. An interruption that ensues as the library and its contents come into unmediated contact with their surroundings and whatever inhabits them: a gust of wind that moves swiftly, a drop of water that moves swiftly, walls that collapse suddenly.

A gust of wind that moves swiftly, a drop of water that moves swiftly, walls that collapse suddenly.

The interruption highlights the many standards that apply here. The way a library collects, what kinds of things are collected, how they are accessed and subsequently how they are shared. Or in other words, the uncomfortable thing, the strange thing, is that in order for a library to work — this specific language of conditioning a space

* Marina again: "Prior to typology, prior to expression, identification also means producing alterity; that which is seen most first of all be demarcated from the unseen, all of which is inconceivable in terms of the logic of that specific archive and the knowledge it is supposed to produce." Marina Vishmidt, "Redemption of Pose", in Let's Take Back Our Space, eds. Mike Sperlinger and Andrew Hunt (Southend-on-Sea: Focal Point Gallery, 2011).

Kulturforum, 12 October 1967 (aerial view). On the left side of Potsdamer Straße: Neue Nationalgalerie under construction, br. Matthäikirche and the Philharmonie. On the right side of Potsdamer Straße: the building site for the new library. The Landwehrkanal runs parallel to the lower edge of the image. The partially visible diagonal of the old Potsdamer Straße leads to Potsdamer Platz, of which only ruins remain. Behind Potsdamer Platz runs the Wall.

The weather, a building, 2012

The New Zealand artist Ruth Buchanan, like Millar, has made Berlin her
home for the past several years. Also like Millar, the particular conditions
and histories she has found there have had a big impact on her work. This is
clearest in her book *The weather, a building*. Ostensibly, it is about the two
forces, named in the title, that determine our relationships with space; how
we know the world, and how our world is shaped. While we tend to think of
them more as settings than characters in our daily dramas, Buchanan's book
looks at how these twin determinants of physical experience might become
protagonists, rather than backdrops, within a story.

The story she uses to demonstrate her idea is the movement of Berlin's
Staatsbibliothek – the State Library – from its original home on Unter den
Linden at the start of World War II through to its post-reunification split
identity – half on Unter den Linden in the old Soviet zone, the other half on
Potsdamer Straße, in the West. In between, it is shunted and pulled through
the German capital: a lumbering giant vulnerable to forces outside of its
control, both political and meteorological. It is stripped of its most precious
possessions, regains some, loses others forever. It lives and breathes and
suffers as much as the different generations of inhabitants whose lives were
determined, in twentieth-century Europe's most contested city, by those
same epic forces.

The conceptual foundation of Buchanan's book is a timeline that
recounts the library's history in stark terms. Here's a summary:

In August 1939, it is decided that many of the Prussian State Library's
treasures should be moved from its Unter den Linden home into a secure
bunker in the Ministry of Economics. This is just the first step in the

collection's dispersal. Over the next five years, almost all of the collection is sent somewhere else for safekeeping, mostly out of Berlin altogether. The building itself is heavily damaged by aerial bombardments. By the time the Red Army arrives, almost everything is gone.

With the war over, the status of the library's collection, and its location, become symptomatic of the unfolding drama in Berlin. The old Unter den Linden building is in the Soviet zone. Books that have spread through the Soviets' sphere of influence are brought back together and housed in it. Meanwhile, the Americans consolidate the books in their zone and establish a library in Marburg. The sum of Germany's knowledge, once held in a single space, becomes an early victim of the Cold War – split along geopolitical lines well before the city itself is divided by concrete.

In 1972, a storm destroys one of the West Germans' provisional storage depots: an enormous, air-supported dome sheltering 500,000 volumes from the collection, mostly periodicals. With the collection exposed to the elements, the decision is quickly made to move everything to the nearby Reichstag.

Eventually, the West German library comes to occupy its current site – a new building on Potsdamer Straße. But even here, nature won't leave the collection alone. The architect decides to include commissioned artworks and other decorative features in the building. One of them is a fountain. It's a problematic feature; its basins clog up, and readers complain about the constant sound of dripping water inside the building.

BUCHANAN'S BOOK, co-designed with the expatriate New Zealander David Bennewith, includes writing by Buchanan herself; a technical account of the rescue of the books from the damaged air dome, written by the man who oversaw their move into the Reichstag; and an essay by the artist Ian White, on allegory. It also includes archival photographs, such

A drop of water that moves swiftly

The weather, a building, 2012

as an aerial view of Potsdamer Straße in 1967, with the library's future site clearly visible.

There are also two inserts. One is a photocopied page from the local newspaper, *Berliner Zeitung*, from November 1972, telling the story of the storm-damaged air dome and showing people carrying its contents away from the structure, the shelves of which stood four storeys high. The other is a picture of a Buchanan work: a sheet of card on a reflective surface, punctured with many holes.

But perhaps the book's most important feature – and the greatest clue to what Buchanan's project is actually about – is its opening sentence:

> We have often had occasion to note that subjectivity is social and that it is constituted by gaps.

Buchanan is quoting the writer Marina Vishmidt, in response to one of the artist's earlier projects. Reclaimed here, the sentence becomes the key that unlocks the library's metaphorical doors.

Buchanan isn't an author (although she is a very competent and elegant writer). She is a sculptor, an artist concerned with the volume of things in space; not just for what they fill up, but also for what they leave empty – the gaps between objects. She is also interested in what happens when those objects, or volumes, are overfilled and begin to leak. Many of her sculptural forms are punctured, like the sheet of card inserted into her book. In an exhibition in Auckland in 2013, she even made a hole in the gallery's wall, which allowed her voice to seep in from a speaker behind it; an unseen presence that slowly filled the space with language.

The Staatsbibliothek's journey across the city and its eventual exposure to the elements are perfect correlates to Buchanan's obsession with gaps. First, there are the literal holes and failures: the fact that the air dome was ripped open in an event where two opposing forces – the air that holds it up and the storm attacking it from outside – combined to create the rupture. There is

also the leaking of the commissioned fountain: the calcified basin and the drip-drip-drip that drove readers crazy.

Then there are the geographical gaps left by, or created for, the building's movement: the fact, for instance, that Buchanan chooses to show us an archival image of the site that the building *will* occupy, rather than an image of the building itself. There is also the movement of West Germany's collection from Marburg – comfortably removed from the dramas of Berlin – back onto Potsdamer Straße. And of course, there is the biggest gap of all, the one that defined Berlin and European politics for decades: the no-man's land that sliced through the city between East and West.

Buchanan's project is about volumes: books filled with words, architectural spaces waiting to be occupied, the sounds of dripping or an air dome tearing. What she also understands here, and articulates so beautifully, is that to give something physical form is not the same as giving it meaning. Instead, meaning comes from what that form does to the gaps in and around it: the space between an artwork and our bodies; the air around us when we enter or leave a building; the gaps between the words on a page; the space between the words and our imaginations as we give those words form inside of us; the gaps left when a library collection is blown apart by history.

In the Staatsbibliothek's movement through Berlin, Buchanan finds an ideal metaphor for the way the German capital's subjectivity has been constituted. *The weather, a building* relives history to extrapolate its physical consequences – its ability to leave real marks on real space. The book itself ends up doing the same thing. It's a sculpture, a thing with real physical consequences: the loop between form and content within it is endless. The result is a strange, refracted, three-dimensional space inside two covers – a complex hall of mirrors in which those gaps that determine our subjectivity are precisely the spaces Buchanan makes us fall into: between locations, between competing states, between language and meaning.

Secret Power, 2015

No Place to Hide

On 29 April 1945, the 2nd New Zealand Expeditionary Force liberated Venice. General Bernard Freyberg's men entered the floating city victorious, the war all but won, and secured Hotel Danieli on the Grand Canal as the New Zealanders' club. The luxury didn't last long though. Churchill wanted the New Zealand Division in Trieste, a few hours east of Venice. The British Prime Minister wasn't as worried about the Germans still there as he was that the Yugoslav Partisans, led by his ally Josip Broz Tito, would get to the important port city first.

The New Zealanders and the Yugoslavs arrived in Trieste within hours of each other. The last of the Germans held out until the New Zealand Division entered the city, preferring not to surrender to the Partisan forces. With the occupiers out of the way, the New Zealanders and Yugoslavs faced a thornier issue: who would get Trieste. Neither side budged, and what followed became known as the 'Forty Days'. It was the first standoff of the Cold War: Tito's Partisans on one side, with Stalin's Red Army (potentially) behind them; the New Zealanders with the 8th Army at their backs. As VE Day came and went, there wasn't much to celebrate in Trieste. The two sides were just trying not to start another war.

THE ITALIAN VICTORY, North Africa before it, and New Zealand's delicate handling of Trieste were the country's first major contributions as a global

force. Not the sad failures of World War I, in which our men were used as trench fodder, or the disaster of Greece in 1941, but tactical victories that cemented the country as a close ally of Britain and America: a partner rather than a source of young bodies.

After the United States suspended its ANZUS treaty commitments to New Zealand in 1986 in the wake of its adoption of an anti-nuclear policy, it was easy to assume that old closeness had gone, that the US had con-signed New Zealand to being a bit-player in global geopolitics. But in 1996, Nicky Hager published *Secret Power*, which showed that rather than having been sidelined, New Zealand was in fact a crucial partner in a Western intelligence-sharing alliance. There were even spying bases in the Waihopai Valley. Nuclear ships or not, it was clear that New Zealand and the United States were working together extensively on security issues.

Then, in 2013, a young US intelligence contractor decided to change the world and tell us all exactly what was going on, and what New Zealand's role was in Five Eyes – an alliance that was conducting a new, clandestine form of warfare: the post-9/11 construction of a massive, global surveillance system.

And so, seventy years, almost to the day, after New Zealand first declared its military victory there, I found myself back in Venice. Back, amid the heat and lumbering tourists, to see Simon Denny, at the 56th Venice Biennale, put Edward Snowden and New Zealand's contemporary political significance to the test.

THE SPEED OF Denny's international ascendancy has been extraordinary. He was in Massimiliano Gioni's exhibition 'The Encyclopedic Palace' at the 2013 Venice Biennale, and the Biennale de Lyon in 2015. He is represented by two of the most influential art dealers in the world, Friedrich Petzel in New York and Daniel Buchholz in Berlin. He has had solo exhibitions at major contemporary art institutions in Vienna, London, Frankfurt and New York.

This momentum made him the ideal artist to represent New Zealand at the 56th Venice Biennale. If a New Zealander were ever going to leave a mark on this event, he was the one, at this moment, who would do it.

Using Hager's *Secret Power* as his starting point – and the title of his project – Denny's proposal for Venice was to examine material from the Snowden leaks and New Zealand's role in the Five Eyes network. Hager himself was going to be a special advisor. News soon followed about the venues: the Marciana Library on Piazzetta San Marco, and Marco Polo Airport. Both were hands down the most prominent sites New Zealand had ever secured at Venice.

Denny's proposal had all the swagger, confidence and smarts that have made him one of contemporary art's rising stars. It was also consistent with the kind of zeitgeisty content he regularly draws upon. He has made projects about high-profile tech conferences, the redesign of New Zealand's passport for a post-9/11 world, Samsung's corporate culture and the Kim Dotcom raid. Denny has always struck me as an artist analogous to a 'cool-hunter': freelance culture scouts who make their living by staying ahead of the trend curve, selling their insights about changing cultural behaviours to big brands and corporates – a trade immortalised in William Gibson's 2003 novel *Pattern Recognition*.

Consequently, I have never been able to entirely figure out whether he is a critic of the corporate neoliberalism that provides him with so much of his subject matter, or an artist deeply embedded within, and beholden to, that system. Denny never takes up a singular or obvious political position in relation to his material; he simply holds up a mirror to the culture around him. But this could easily be seen as a strategic ambivalence; a posture that makes him equally palatable to the collectors who are part of the economic systems he puts in play, and the art world liberals and critics who like to pretend they're not.

So, as I flew from Berlin to Venice for Denny's big reveal, on a delayed EasyJet flight full of grumpy curators and writers who'd spent three hours

pacing a cramped departure lounge, I had several inter-related questions. Given the magnitude of Snowden's leaks, could Denny actually add anything to our understanding of government surveillance, its impact on our lives and our complicity in it? Was he prepared to lay his own position on the line? And was he really going to take a risk here, or just cherry-pick 'local' content (New Zealand's role in Five Eyes) to serve his international ambitions?

The answers, as I walked through sliding doors into one of the grandest rooms in Europe – a room Denny had filled with server racks, office desks, diagrams, infographics and national flags – were crystal-clear within seconds.

WHEN THE BERLIN WALL came down, I was ten. I remember sitting on the floor and watching it on the television news; seeing young Germans pulling each other up onto it, dancing, drinking beer.

At least, I think that's what I remember. Such has been the power and pervasiveness of that footage ever since, it could be a false memory. But I do remember being aware of it when it happened, and understanding it was important. I'd grown up in a politically conscious family. My earliest memory is of my father heading around the corner from our Sandringham house to Eden Park during the 1981 Springbok tour. Mum and Dad had also travelled a lot when they were young, including through the Wall to East Berlin.

So it makes sense that we would have been watching the Wall coming down. And it would have been consistent. My awareness of most major news events when I was a kid came from the television. The *Rainbow Warrior* sinking. Tiananmen. The San Francisco earthquake.

Personal events too. The day my parents got the call, when I was five, that my grandmother had died, I was crouched in front of the television watching *Top Cat*. I heard my mother on the phone. It was another eight or nine years before I fully understood that my grandmother had been murdered.

SOMETIMES, THE SCREEN brought the personal and the global together. Two years after the Wall came down, I watched an ancient city burn with my father. It was Dubrovnik. It was the first time he told me our family was from Croatia. Up until then we'd been Yugoslavs, or Dallies. Even at that distance from the events themselves, the television was creating new definitions for us.

Denny has made me rethink these moments, and their significance. What I have only recently started to recognise is how much his work represents a generational mode of seeing I've known all my life. Denny is three years younger than me. Our formative years were bracketed by two defining events: that moment, in 1989, when an East German official accidentally reconnected the world, and the decision, twelve years later, of a group of men, some not much older than us, to fly planes into a pair of skyscrapers.

In between, we were shaped by the quickest technological revolution in human history. We aren't the digital natives. We're the ones just before them; born on the cusp of X and Y into the nuke-infested geopolitics of our Boomer parents, but raised in an age when machines with screens first showed us the world, then connected us to it in ways we never imagined, then became worlds in themselves. This hasn't just changed how we receive information. It's changed how we see.

Denny has also recognised that the free market idealism our generation was weaned on has a shadow side: the creation of the most extensive surveillance system ever imagined, a system New Zealand is a part of. For Denny, opportunity and oppression aren't separated by a wall; they're fuelled by exactly the same information, and run on the same technological networks.

IN LATE 2014, Denny presented his largest exhibition in New Zealand up to that point: 'The Personal Effects of Kim Dotcom' at Wellington's Adam Art Gallery.

The Personal Effects of Kim Dotcom, 2014

The Adam is a difficult space to work with. Each of its rooms, stairwells and narrow platforms are simple enough on their own terms. But cumulatively, the complex architecture and changes of levels present artists and curators with real challenges. As evidence of this, Denny was one of only a handful of artists in the gallery's history to be given the entire building for a single, unified project.

'Personal Effects' had already been shown at two venues, in Vienna and Colchester, but the Adam version was the most expansive iteration. It also represented an important moment for the New Zealand art scene. Denny had been living in Germany for a few years, had established himself as New Zealand's most internationally successful young artist and had been announced as the country's representative at the 2015 Venice Biennale. This was his opportunity, then, to flex his sculptural muscles at home on a greater scale than his previous contributions to the 2012 and 2014 Walters Prizes (won by Kate Newby and Luke Willis Thompson respectively), or any of his shows with his dealer Michael Lett.

He was also putting the project's conceptual underpinnings to the test. In Europe, if Dotcom is known at all, it is as an internet novelty. But in New Zealand, Dotcom was, from the time of his arrest in 2012 until the general election of 2014, one of our most politically disruptive figures.

In January 2012, Dotcom, a German who lived in New Zealand, was arrested by domestic police at the request of American authorities. He was the founder of the enormous file-sharing and storage website Megaupload, one of the largest such sites on the planet. The US Department of Justice's indictment against him alleged that he and his service had 'generat[ed] more than $175 million in criminal proceeds and caus[ed] more than half a billion dollars in harm to copyright owners'. His house was raided in an unusually dramatic way for New Zealand law enforcement: helicopters, armed officers, the works – an American request carried out with American vigour.

It became a PR disaster for the various authorities and politicians connected to it, or to Dotcom himself. Television journalist John Campbell tried

The Personal Effects of Kim Dotcom, 2014

to get to the bottom of who knew what and when; an investigation that implicated and damaged Auckland's former mayor John Banks and bloodied the nose of the prime minister, John Key. Everything about Dotcom and his case was huge: the police tactics; the political stakes; the sums of money involved; the house and the ridiculous property seized from inside it; the scale of Megaupload; and the man himself.

But even bigger was the discovery that Dotcom had been spied on illegally by New Zealand's signals intelligence service – the Government Communications Security Bureau, or GCSB. The GCSB, which is the official New Zealand arm of the Five Eyes network, is not allowed to spy on New Zealanders. Someone had forgotten to check Dotcom's immigration status. As a permanent resident, he was, for the purposes of the legislation, as much a New Zealander as Denny or me.

Denny, living in Berlin, was a user of Megaupload, and discovered that the service he relied on to stream English-language television and movies had been shut down and was in fact owned by a German living in his hometown of Auckland.

It was a gift. Not only did Dotcom's movement from Germany to New Zealand reverse Denny's own journey, but the Dotcom story also encapsulated some of the defining internet debates of our age – about copyright, data storage, information sharing and surveillance. Denny had already been exploring these themes in *All you need is data: the DLD 2012 Conference REDUX*, which was shown in Munich, and later in New York (and after that, in the 2014 Walters Prize). The massive installation recreated, as panels, the speaker details and notes of every conference presentation at one of the world's major gatherings of tech and internet agenda setters. Denny presented the panels as a relentless parade mounted on steel railings, which herded viewers like they were in an airport security area.

Dotcom's own weirdness also helped Denny's cause: the fact that he'd become one of the world's best online gamers; that he'd been given residency in New Zealand under an unusual high-net-worth provision in

the immigration legislation; that he'd made up his own name; and, as it emerged, that he had an enormous narcissistic streak – a desire to have his drama play out in public, and to have his face everywhere.

Denny's starting point was the list of 'personal effects' seized from Dotcom by the New Zealand Police and the US Department of Justice (DOJ) following the raid on his home. It is a document easily available on the internet. It is also a twenty-first-century readymade, perfectly embodying the tension that operates between the world of 'things' we occupy and the parallel reality we spend more and more of our time in, online.

Denny's approach at the Adam was to re-actualise the list in physical space, reclaiming it from its digital existence by acquiring identical pieces, replicas or stand-ins for each and every item on it. As viewers entered the gallery, they were confronted with some of the more gauche aspects of the inventory: an MDF replica of a 108-inch television; a massive jetski; and a full-scale Predator figure from the eponymous movies, disassembled and spread across the floor. An annoying soundtrack came from an adjoining space, which turned out to be the Megaupload jingle on incessant repeat. This combined with a heavy-metal track from yet another screen, showing a group of men hand-building a motorcycle. A custom-made motorbike filled much of the gallery's front window. There was also a Michael Parekowhai 'security guard' sculpture, still in its packing case – a substitute for the seizure list's ambiguously noted 'Fiberglass sculpture, imported from the United Kingdom with Entry No. 83023712'.

The least clear item on the list was also the most unbelievable: '$175,000,000 in United States dollars'. It is the same amount the DOJ listed in their indictment. But there was no way Dotcom could have had that much cash at his mansion. Was the item, then, in fact referring to the total amount of money in all of the bank accounts seized around the world?

Denny embraced this ambiguity by flattening it into its most literal form: shredded cash – the equivalent amount 'converted to 144kg [of] granulated out-of-circulation New Zealand currency . . . courtesy of the Reserve Bank

of New Zealand'. It was the exhibition's most bravura sculptural moment, as bags and bags of destroyed currency spilled down the Adam's stairs.

In a space on the lower floor, Denny presented half-filled computer server racks, with other servers stacked on pallets. These were stand-ins for the servers containing all of Megaupload's data, which had been put on ice by authorities. Nearby was another promotional video, though this time instead of a custom motorbike, the fussy construction shown on screen was that of a Hästens bed – one of the world's most expensive, and Dotcom's sleeping platform of choice.

The most dominant mode Denny used to re-present Dotcom's possessions was a series of canvases arranged around the walls, not dissimilar to the ones he had made for *All you need is data*: ugly digital prints that relayed the details, from the DOJ's list, of seized items. Most were bank accounts in many different countries and in many different names: a Westpac account in the name of Kim Dotcom; Chinese and Singaporean accounts belonging to Megaupload Ltd; a ton of them, around the world, for 'KIM TIM JIM VESTOR'. Then there were the pseudonyms, side-companies and bit-players in the Megaupload drama – Megateam Limited, Vestor Limited, Megasite, Inc., Finn Batato, Bram van der Kolk, Julius Bencko, and so on.

Each was presented in exactly the same way, with an image of either the bank's logo itself or a found photograph of the logo in situ – on a street sign or an ATM, for example. At the top of each was a red-and-white banner deploying the branding and typography of Megaupload that read, simply, 'Kim Dotcom'. Just below that was a black banner stating 'Seized Property'. They were glitchy thumbnails for giants; frozen portals to frozen money, as inert and valueless as the shredded cash tumbling down the stairs.

'Personal Effects' thrust us deep into the financial and acquisitive world of Dotcom. He was everywhere. But despite his pervasiveness, this wasn't a show about him at all. Nor was it primarily about money, or politics, or Dotcom's stuff. Its main achievement was to illustrate Denny's immense sensitivities as a sculptor. In Dotcom and Megaupload, he had found a match

for his own artistic ambitions and interests: the scale; the slippage across national borders; the line between online and physical space. His great trick here wasn't to make a comment about the rightness or wrongness of Dotcom's internet crusade or of the DOJ's claims to his property. It was to take on the sculptural legacy of the readymade and examine how it might occupy a post-digital world.

It was also the first time I recognised just how formal and structured Denny's sculptural imagination was. Everything was organised according to a strict spatial logic: the monumentalising centrality of the collapsed Predator figure and the fake TV as you walked in; the horizontal sight lines of perfectly spaced panels, contrasted by the verticality of a row of personalised licence plates; the posed cascade of the bags of shredded cash; the considered arrangement of ephemera in vitrines. It was edgy and contemporary content, sure. But it was a pretty uptight way to present it.

It was also a show about currencies. Everything in it was an examination of connections between points – bank accounts accessed via the internet, the servers that connected Megaupload subscribers to their content and the cash which, shredded and worthless, had lost its connectivity. Denny was inviting us to think about what happens when we hold still things that demand, for their meaning, to be constantly in motion – money, data, online images. What better way to explore this than a list of frozen assets that belong to a man whose alleged crime was to loosen copyrighted material from the chains of legal ownership, and let it roam free in the imagined, lawless, shifting world of the internet.

THE MEDIA COVERAGE and press releases in the lead-up to a Venice Biennale usually focus on the national pavilions – who's representing what country, what they'll be doing if their country has a permanent pavilion in the Giardini, or what they'll be showing, and where, if they don't.

The Personal Effects of Kim Dotcom, 2014

Once the biennale opens, the national focus dies away a little, and attention turns to its curated sections. The Giardini's Central Pavilion and the nearby Arsenale are always handed over to a guest curator, who puts together a major international exhibition – a group show to end all group shows. It's one of the most prestigious opportunities a contemporary art curator can receive. The success or otherwise of this exhibition also has a big bearing on whether the entire biennale – national pavilions included – is seen as a winner.

In 2015, the curator was Okwui Enwezor – a Nigerian who has spent most of his adult life in the States, and is currently director of Munich's Haus der Kunst. Things weren't very promising from the moment Enwezor's say-nothing title 'All The World's Futures' was announced. The situation got even more desperate when word spread that he was building his show around Karl Marx's *Das Kapital*. In a Piketty world, it seemed ludicrous to delve so deep into a leftist economic past. In an event that acts as the beating heart of an art world fuelled by mega-capitalism, it seemed even sillier.

In the days after the biennale opened, many critics' fears materialised. They slammed Enwezor's vision as pious, dreary, grim and relentless. That's not how I saw it. Or actually, that's exactly how I saw it – I just thought this was its strength rather than its fatal weakness. But that's because I didn't think his exhibition, which included over a hundred artists and art collectives, was about Marx at all. It was an attempt to understand what the left looks like in a world in which neoliberalism has managed to squash and absorb all forms of political critique. It revisited Marx not as a solution to our capitalist ills, but as a central part of the intellectual landscape that led to the creation of unfettered markets and the economic structures that underpin the international art world. Marx, in other words, is as responsible for our current mess as the Chicago School.

With that in mind, the exhibition's defining question became how we might take on this baggage and find new forms for imagining a political future. A world without two sides – communism and capitalism – is a world

without binarism. But a world without binarism is also a world of fear and uncertainty. If Marx was in Enwezor's thesis there was also plenty of Slavoj Žižek, whose 2008 book *Violence*, written well before the Snowden revelations or the Syrian crisis, argued that right-wing politics, neoliberal business practices and panic (particularly about immigration) are all used to suppress free thought in a post-1989 world.

In an interview published just as the biennale was preparing to open, Enwezor told *Artforum*'s editor Michelle Kuo that:

> We have reached a point where we cannot have one homogenized narrative, one view of the future, a singular idea of what constitutes the good life, even though we have inherited certain monolithic cultural, social, and political ways of thinking about the world. This monolithic narrative has become increasingly untenable and can no longer hold That's why there are multiple insurgencies occurring around us – political, intellectual, philosophical, economic. There is a search for alternatives.

The art world was clearly implicated here: because although it is increasingly global, it is still definitively bourgeois and monolithic. And it is very white. Enwezor's solution was to explore what these multiple insurgencies – these 'alternatives' – might look like, and where they might come from.

The answer, in his framework, was Africa. As well as Marx, he placed blackness at the heart of his biennale, in a way it never had been before. Enwezor extended this to the architecture itself, commissioning the black architect David Adjaye to design many of the exhibition spaces. Adjaye also designed what Enwezor described as the exhibition's 'central nervous system': the ARENA. This was a theatre in the round, smack in the middle of the Central Pavilion, where daily performances took place, including a reading of *Das Kapital* directed by yet another black artist, Isaac Julien.

Everywhere, there were artworks from African, African-American and black British artists that slid along Enwezor's charged political spectrum of

capital, labour, violence, protest and avant-gardism. A superb new film by Steve McQueen about the murder of a young man in Grenada, for example. New paintings by Chris Ofili, a black British painter who lives in Trinidad. A huge video work by John Akomfrah, the founder of Britain's Black Audio Film Collective. Live performances by the jazz pianist Jason Moran. And a breathtaking installation by the young Ghanaian Ibrahim Mahama, in which he lined the vast walkway that slices through the Arsenale with jute sacks, material used in his home country for the trade and shipment of raw commodities like cocoa beans.

None of it felt politically correct. Rather, it felt like a necessary correction. Africa is still the place, and the idea, that the West can't control, the source of its visceral fears: Ebola, the ecological destruction of the Niger Delta, the rise of Islamic radicalism driven by Boko Haram, Al-Shabaab, remnants of Al Qaeda, and Islamic State. It is the place from where insurgencies are launched, and in Enwezor's view, it is also the locus for upheaval in contemporary art. No wonder so many people hated his show – Enwezor was putting the art world on notice.

As I moved through the rest of the biennale, the only things that measured up for me were works that carried the same polemical charge. In the Belgian Pavilion, the artist Vincent Meessen had placed his country's colonial legacies in the Congo on the block. As well as taking on Leopold's heart-of-darkness horrors, Meessen included a brilliant documentary about the impact of Congolese thinkers and writers on Situationism; an uncharted history that suggested one of the most important European forerunners of postmodernism had blackness at its core.

In the German Pavilion, Hito Steyerl made as much impact as she had two years earlier in Istanbul. Her video work *Factory of the Sun* was like nothing I've seen or experienced before, or since. Viewers entered a dark space, which Steyerl had turned into a motion capture studio – the entire room gridded in equidistant blue lines. Plastic deckchairs were arranged so that viewers could get comfy and watch her revolutionary film: a pseudo-

biography about a woman stuck inside a computer game, which turns human movement into light. In the game, Deutsche Bank, which has become the world's dominant power, uses drone technology to 'eliminate' resistance and student protest. The young people murdered by drones then become avatars inside the game. It is complex and surreal, but is also a remarkable portrait of our time: a world of capital and information flows, corporate superpowers, YouTube, drone technology, gaming and the Occupy movement. It is like Snowden and William Gibson coming together – a satirical peek at the world's future, which doesn't seem funny or unrealistic at all.

ON 15 SEPTEMBER 2014, just a few weeks before Denny's 'Personal Effects' opened at the Adam, Kim Dotcom staged a public meeting at the Auckland Town Hall, dubbed 'The Moment of Truth'. This was, Dotcom promised, the moment he would finally reveal that John Key had known more about him, and the raid on his house, than he had publicly stated. The journalist Glenn Greenwald flew into Auckland to participate. Key labelled Greenwald, somewhat hot-headedly given his key role in the Snowden story, as 'Dotcom's little henchman'.

The town hall was packed; thousands also watched on YouTube. On the panel alongside Greenwald were Laila Harré – the leader of the Dotcom-funded Internet Party, which was running in the 2014 general election – and Dotcom's lawyer, Robert Amsterdam. There were also two video links: one to London and Julian Assange, in self-imposed exile in the Ecuadorian Embassy; and one to Russia, from where Snowden himself offered up new revelations about the New Zealand government's involvement in the Five Eyes intelligence network. Snowden also adamantly refuted Key's claims that New Zealanders weren't being systematically spied on.

In the end, however, there was no smoking gun, no 'moment of truth'. In a blistering press conference afterwards, New Zealand journalists

Hito Steyerl
Factory of the Sun, 2015

hammered Dotcom. *Metro*'s editor Simon Wilson also took on Greenwald for intervening in New Zealand's political process just days before an election.

None of this addressed what seemed to me the most important aspect of Dotcom's event: the fact that two of the most prominent 'outlaws' of the early twenty-first century – Snowden and Assange – were engaging directly in New Zealand's political discourse. More than any of the abstractions, ifs and whens about New Zealand's complicity or otherwise in mass surveillance, this was concrete evidence that New Zealand's geographical distance is of little consequence. The real moment of truth here was the realisation that New Zealand is implicated in all of it.

THAT SNOWDEN HAD chosen to participate in 'The Moment of Truth' set the scene perfectly for Denny's Venice project, which took as its starting point the defence contractor's leaked slides.

In the Marciana Library and Marco Polo Airport, Denny had found two venues that, like the slides, embodied relationships between information and global power. Marco Polo – named, obviously, after one of Europe's early heroes of globalisation – was the first Italian airport built after 9/11. The Marciana, meanwhile, was an essential building in the civic life of Renaissance Venice: the repository for its knowledge of the world at the height of its global influence. Designed by Jacopo Sansovino and decorated, in parts, by the greatest Venetian painters – Titian, Veronese, Tintoretto – it is a space that shifts between architectural reality and painted illusion. Its soaring ceiling has *trompe l'oeil* effects designed to double its height. Around the walls, figures of philosophy and charity and faith stand in scalloped alcoves that don't actually exist. It is a giant hall of mirrors; an allegorical trick in which its decoration is a humanistic doppelganger for its political function as the state's 'official' library.

Denny's intervention in the Marciana initially seemed horrifyingly cold and corporate. Viewers entered through sliding glass doors and a transparent portal, on one side of which were the Five Eyes national flags, and on the other, a bizarre upside-down illustration of New Zealand. The main part of the room was filled with two lines of 'modded' computer server racks. Between the rows were two magnificent globes: Vincenzo Coronelli's 1688 representations of the celestial and terrestrial worlds.

In a parallel to the Wunderkammer of early museums and libraries, Denny had turned his server racks into elaborate display cases. The left-hand row was filled with objects that were all some sort of reiteration, translation or stand-in for an image from a Snowden-leaked slide. Denny had collated these into themes: imagery about the National Security Agency's 'Treasure Map' programme, for example; the UK Government Communications Headquarters' instructions on the 'Art of Deception'; slides explaining invasive computer programmes with creepy names like 'FoxAcid' and 'Mystic'.

The case that dealt with invasive programmes contained ugly Perspex bar graphs, a giant image of a wizard holding a cellphone-topped staff, fantasy playing cards and transparent cartoons of acid barrels. At its centre was an eagle, its wings spread and bursting through the top of the box, clutching a roped-up globe in its talons. It was Denny's translation of a seminal NSA graphic, in which America's national bird grips the undersea cables that connect the world. The original image is one of the most insidious emblems of the NSA's desire to 'collect it all'. Denny's version, lifted from two dimensions into three, was even stranger and more ridiculous.

Denny performed a similar transformation in the 'Treasure Map' rack. The Treasure Map revelations were some of Snowden's most shocking; here was a programme that gave the Five Eyes partners the ability to map the entire internet and every device connected to it – a tool for total, unaccountable omniscience. At the dead heart of Denny's cabinet was the head of the T-800: the iconic robot skull from *Terminator 2*. For anyone who

grew up in the 1990s, it is a pop-culture image with the force of a religious icon. In Denny's version, pristine sword blades emanated from it in a starburst, a halo of cold steel. This was his interpretation of one of the most disturbing examples of the NSA's visual culture. *Terminator 2* was a film about the unintended consequences of technology; that in advancing so quickly, we have created the potential for machines to strip us of our human freedoms. It is remarkable, then, that the NSA would choose as its logo for its most egregiously oppressive programme a robot skull with glowing red eyes, which looks almost exactly like the Terminator.

What Denny did so effectively here was short-circuit the NSA's narrative by turning its own imagery on itself. Alongside the T-800 there were tiny Macs, cellphones and human beings: all lifted and laid out exactly as they were in Treasure Map slides. Elsewhere, there were Warhammer figurines, references to gaming culture, images of Penn & Teller, translations of flow-charts, graphs and other forms of nerdy data and infographics.

It's easy to describe this imagery as dystopian: evidence of a nefarious la-la-land in which our NSA overlords use gamer and sci-fi archetypes to cloak their activities in fantasy. But Denny also showed that it is highly effective design. The NSA slides weren't made to brief Black Ops tough guys on sensitive missions or convince grey-haired senators of an invasion's merits. They were made to inspire hackers, geeks and programmers, a lot of whom grew up playing *Dungeons & Dragons*, watching sci-fi, clocking *Doom* and abusing each other on 4Chan. The pop references aren't flippant or acci-dental at all. They are targeted, precise and extraordinarily readable for the young men and women charged with implementing and overseeing such an epic surveillance system. People like Snowden, who is, it's easy to forget, even younger than Denny.

The amount of visual information was overwhelming. Denny's use of transparent materials like glass, Perspex and plastic, along with blue-ish backlighting, made the racks' internal spaces even harder to comprehend. They were disorienting and repellent; boxes we could see straight through,

Secret Power, 2015

Scaled imagery from NSA MYSTIC FOXACID, QUANTUMTHEORY & other SSO/TAO styles

but that also pushed back out at us. Cartoon wizards and TV magicians bounced off bearded Tintoretto gods. And yet everything was incredibly still. The NSA might have wanted to collect it all, but Denny had frozen it all; stopped the information's flow, completely. You could practically hear the room creaking in his grip.

AT THE HEART OF 'Secret Power' was a nagging question: who was the design genius behind the NSA slides? In searching for the author of the Snowden material, Denny's collaborator David Bennewith (who also designed Ruth Buchanan's book discussed in the previous chapter) discovered David Darchicourt, whose LinkedIn profile states, as though it were the most ordinary thing in the world, that he was Creative Director of Defense Intelligence at the NSA from 2001 to 2012. These days, Darchicourt is a designer for hire. Like many freelancers, he puts his portfolios online as a way to hustle for work.

Denny and Bennewith raided Darchicourt's portfolios and gave them the same treatment as the Snowden slides. The server racks on the right-hand side of the room were filled with the results. Among them were sculptural re-interpretations of exhibition displays for the 'National Cryptologic Museum', wacky motivational board games and Darchicourt's LinkedIn self-portrait – a computer-drawn caricature. The links between Darchicourt's freelance work and the visual language of the Snowden slides were obvious: if Darchicourt wasn't making them himself, he was almost certainly involved in setting the brand guidelines.

Darchicourt was clueless about what Bennewith and Denny were doing, even when they hired him to make new illustrations about New Zealand. In response to their brief, he created a cartoon-cyborg tuatara – New Zealand's national reptile, WiFi-connected and a lot more active than its real-world counterpart. The largest of his illustrations

was a world map with New Zealand at the centre and south at the top. In it, New Zealand takes up most of the globe. Key tourist attractions are identified with cartoons – the Cape Rēinga lighthouse, SkyCity, Rotorua's hot pools, Kaikōura. Sally Field hovers over Dunedin as the Flying Nun. And in a knowing wink to Nicky Hager, Waihopai is marked, while red lines denoting submarine internet cables link Aotearoa to Australia and the US West Coast.

And the reason south is at the top? Just before entering 'Secret Power', visitors passed through a vestibule where there was a beautiful fifteenth-century map by Fra Mauro. It is one of the first attempts to map the world, and south is where north would normally be; the world is upside down. This was the first point on an essential linking thread – from Fra Mauro's map, through Darchicourt's crazy interpretation of New Zealand's place in the world, through Coronelli's globes and that terrifying eagle clutching our networked planet.

'Secret Power' was a rigid installation made up of spheres and boxes and lines. Within it, Denny showed us that the world no longer has an up or down, a left and right, a then and now. Everything is visible, all the time; everything is connected; everything is information to be exploited.

FOR THE MARCO POLO leg of his Venice project, Denny had the entire ceiling of the Marciana photographed and a replica printed at a 1:1 scale. This was then applied to the airport's floor so that it ran across passport control and through to the baggage hall. It was vast. Every day for months, tourists trundled their wheelie-cases across it.

Denny was making a point here about how these transitional zones grant us the freedom of movement while simultaneously tracking and examining us at every step. While this clearly connects with the overarching themes of 'Secret Power', it also felt an awful lot like stating the obvious. Its most

Secret Power, 2015

interesting aspect was pointed out by both Denny and the writer Chris Kraus in the lavish 'Secret Power' publication, where they each reminded us that Snowden had spent more than a month living stateless in the transit zone of Moscow's Sheremetyevo Airport. But this wasn't a connection the work itself led viewers to.

Within the scheme of Denny's achievements at Venice, however, these weaknesses were minor. 'Secret Power' is a major turning point for New Zealand art – not just because of its international critical response, but because it represents a profound generational shift in the national discourse: a different politic, a different understanding of our place in a post-9/11 world, a different way of seeing.

Denny's main innovation in 'Secret Power' was his committed lack of imagination; he didn't make anything up. All of his material was sitting on the internet, waiting for someone with his synthetic capacities to come along and see the connections. It is pattern recognition of the highest order.

With this project, he has also pioneered a form of collage using the logic of screens, and layers. In digital environments, objects can be spun in any direction to reveal new views but remain complete. Denny does that too, not by lifting information from behind the screen, but by sucking forms through it, allowing us to witness their warping and weirdness as they move from the code-produced dimensions of the machine world into the actual dimensions of ours.

What 'Secret Power' has made me realise is that Denny, although he may be ambivalent in a traditional left/right sense, is a deeply political artist. The great sophistication of his position is that his political and cultural radicalisms have nothing to do with his content, and everything to do with his formal power as a sculptor. He is capable of knocking images off their axes and planets off their poles. He is a hacker of real space; he likes to break things and see how much physical chaos he can cause.

Amid all the froth and the money, all the air-kissing and air-travel and ego-inflation, artists like Denny understand that the art world is the ideal

space from which to launch their visual insurgencies. Steyerl is another example. Others include Trevor Paglen, and the filmmakers Laura Poitras and Omer Fast. All explore the relationships among technology, surveillance and the unseen powers that now decide how we live. They also all share a deep understanding of the fact that 'the visual' is the fundamental way power is now exercised.

Years ago, we were told that image saturation and 24-hour news cycles would numb us to what we were seeing – starvation in Rwanda, atrocities at Srebrenica and so on. The years since 9/11 have proved that to be wrong. Our lives are now completely shaped by images. No matter how often we see them, their narrative and cultural force is enhanced, rather than diminished, by their circulation. The planes hitting the towers. Abu Ghraib. Guantanamo. 7/7. A black man holding a bloodied cleaver in Woolwich. The thermal outline of Dzhokar Tsarnaev cowering under a boat tarp in a suburban Massachusetts backyard. Islamic State militants slaughtering innocents on the tideline of the Mediterranean.

The twentieth century, from its start to its end in 1989, was shaped by words. But in the global era, images have taken over as the possessors of revolutionary force. They exceed our linguistic abilities to define and corral them; they are slippery things that operate within networks of our making, but run on their own rules. Their impact hasn't made us all the same. It has made us fractured and fractious, confused and angry and unpredictable.

I came to Venice without any hope for what I'd see and with doubts about what Denny could do, that it would be just another stop on this strange, bourgeois tour we call the international art world. But what I encountered was a space of interrogation and hard truths, full of blackness and revolutions and visions, both terrifying and productive, for what, and where, the future of the world might be.

Secret Power, 2015

Becky Nunes
Hokianga Harbour, 2016

Postscript **4 January 2016**

In the villa of a friend, after too much wine and whisky, I rave about Simon Denny and why what he did at Venice matters not just to New Zealand art, but to New Zealand's sense of early twenty-first-century self. It's well past midnight, and I'm drunk. But I'm not saying anything I don't believe.

The villa is in Kohukohu, a tiny township on the Hokianga Harbour, which opens into the Tasman Sea near the top of the North Island.

I've tried to spend as much of the summer out of Auckland as possible. I'm starting to hate the city; particularly its obsession with property, which is turning it into a zombieland filled with venal monsters and terrified young people crippling themselves with debt. Property is a vampire, sucking the life – politics, culture, art – out of the city. It is heartbreaking, and exhausting, to watch.

In November, Judy Millar had gone up to Berlin for a few weeks, and had left the keys to her Anawhata house with Kyra and me. It was the first time the three of us had been together there since James was a baby. One afternoon, as the sun blazed and the wind died down, we went for a walk around a cliff to a headland where we could stand and look north up the coast, a line of beaches and churning surf stretching all the way to the horizon. When we got back to the house, I checked my phone. The patchy network coverage had picked up a Guardian notification. Hundreds of people were dead or wounded in Paris.

Later that month, I stayed out there by myself, to finish a story for *Metro*. Turkey shot down a Russian plane while I was asleep.

STRAIGHT AFTER CHRISTMAS, we hit the road again and eventually wash up in Kohukohu, with our friend Erica.

Economically, Northland, of which the Hokianga is its watery heart, is on its knees; a victim not just of its nineteenth-century history but its abandonment by twentieth-century industry. Towns like Kaitāia, Dargaville and Kohukohu – once surrounded by farmers and landowners rich on meat, dairy, wool and logging – thrived into the middle of last century. Now, though, they're in deep trouble. Northland is New Zealand's version of America's Midwest – a region built around industries that promised to last forever. But, just as Detroit shows, no industry ever does, and the western side of Northland is having to redefine itself before its populations completely disappear.

Although it's the first time I've visited Erica there, it isn't my first time in Kohukohu, or the Hokianga. Both sides of my family connect to the harbour. My mother's people – a mix of British, Māori and Croat – settled in Herekino, in the middle of the forest, not far north of Kohukohu. My father's grandfather (Antonio, who I'm named after), also Croatian, was one of the throngs of men from the Dalmatian coast who settled in the North to dig in its ancient swamps for kauri gum – which was, until synthetic replacements were invented, one of the world's most prized resins.

Antonio's daughter was my grandmother, Veronica. One of her proudest moments was when, as a young woman, she danced with the prime minister, Gordon Coates. Coates had made it into Parliament as the Kaipara representative with the support of Northland's Dalmatian men. He was also instrumental in keeping them out of internment camps in World War I. Because they were 'Austrians' (Dalmatia was part of the Austro-Hungarian

Empire), men like my great-grandfather were technically enemies of the state. Coates argued vigorously in their defence. A generation later, many of their sons, including my great-uncle James, served in World War II.

Dancing with Coates, though, didn't stop my grandmother from wanting to escape her Dallie upbringing. She eventually left Northland with a man called William Byrt and moved to Hāwera, in Taranaki. She never spoke Croatian with her children. William died when the oldest of their three sons, my father, was twelve. Twenty years later, living alone, she was killed in her home, in a burglary gone wrong.

As well as spending summers as a kid in Herekino and Kaitāia with relatives, I'd been to Kohukohu a few times in my early teens because my closest friend's family is from there. While I'm at Erica's, I send him a message, with a photo of her house, via Twitter. Three minutes later, we've established it was the house his grandfather was born in; a man who'd gone on to serve in the RAF as part of the crews that drench-bombed German cities like Dresden. Erica's own grandfather, we figure out, flew with him.

The harbour is a literal reminder that globalisation is no new thing; that the fall of the Wall in 1989 wasn't the start of something but rather the latest chapter in an ancient process. Before Fra Mauro made his map of the world, before Marco Polo left Venice, Kupe landed in the Hokianga from Hawaiki. No wonder it is a place so full of ghosts.

In the first half of the 1800s, European missionaries like Jean-Baptiste Pompallier led religious colonisations here. Beautiful wooden churches sprinkle the entire winding length of the harbour on both sides, like clumps of the wild ginger the local council has signs up warning against. The Hokianga is basically jungle – once things take hold, they spread, quickly. But the things that take root also have to co-exist with what is already there. Much of the religion practised in Hokianga's old churches – particularly the Catholic ones – is heavily influenced by Māori belief.

The arrival of Europeans in this part of the country also resulted in the trade of weapons, human remains and artifacts under chiefs like Hongi

Hika. It was a genuinely global trade, which drove the Musket Wars, which in turn ravaged the Māori population and laid the groundwork for a later European land grab.

It is exactly this place, and these histories, that Shane Cotton's work draws upon. Ngāwhā, not far from the Hokianga, is his ancestral homeland.

The Hokianga was also the site of one of the most breathtaking examples of ecological destruction in the British Empire: Northland's massive deforestation. Drive through the region now and it's covered with shitty, commercial pines that grow in a handful of years and are harvested and sent, usually unmilled, offshore. In the nineteenth century, it was kauri – the magnificent native trees that became an above-ground goldmine for European traders. Forests that had taken thousands of years to grow were decimated in a handful of decades, with many of the trees floating off to Europe and America via the Hokianga's gaping mouth. Kohukohu villas like Erica's were built with that timber.

ON OUR SECOND night there, a pair of locals join us for dinner. They are Lise Strathdee and her Italian partner, Claudio Annicchiarico. Lise's mother is the New Zealand artist and writer Barbara Strathdee, who lived for many years in Trieste, where Lise was raised. Lise went on to be a trend-spotter – like William Gibson's fictional coolhunter heroine Cayce Pollard – for some of Britain and Europe's major fashion labels, before she and Claudio threw in a life bouncing between London, Milan and New Zealand for permanent residence in their pink Kohukohu house.

As soon as Lise arrives, she quizzes me about my whakapapa; Erica has already told her that I trace my roots to here. I describe it to her, and tell her about my friend's grandfather too. Sufficiently spooked, we all settle down to dinner, and the first thing Lise brings up is Prada Marfa. I grin. I tell her about the Lost Horse Saloon, then about a dinner I attended in

Marfa, where I met a German who'd met the late New Zealand artist Julian Dashper when he visited the Texan town. Dashper had also spent time in Trieste with Lise's mother.

We get drunker. We talk about Denny and London and Gibson and pattern recognition. We talk about surveillance and Syria. Claudio tells us about the taro he was given by a local man, which is said to have descended from the original plants Kupe brought with him from Hawaiki. Though it grows a little bitter in his garden, he says, it's his most precious crop.

James is asleep in one of the bedrooms, wiped out after spending the day on Ōmāpere beach. This year he will start at school; a healthy, bright, funny kid, the least likely scenario presented to us in Berlin made brilliantly real. Somewhere nearby too is the manuscript of this book, in which I'm still trying to figure out how to write about the strangeness of these past five years.

The house, which had been occupied by a recluse for twenty years before Erica bought it, is alive again with voices, trying to make sense of how this has happened – how we've been thrown together in this building in the middle of this scarred landscape, still haunted by the legacy of all the timber and bodies and amber gold that poured out of its harbour and into the sea.

THE FOLLOWING MORNING, we meet, hungover, and Lise shows us the cottage she has on her property. She wants to set up an artist's residency here, and grills me about whether I think it's viable. We walk up the hill to an old building that would make an incredible artist's studio – high ceiling, tongue-and-groove walls like the ones in Shannon Te Ao's *two shoots*, flooded with natural light, with views across the harbour.

Yes, it is viable. In fact, it's perfect. There is also no reason, I say to Lise, that it couldn't become a New Zealand equivalent to Marfa. Not by building massive minimalist sculptures that put it on the map, but in the sense of art's

potential as a force for change: for the interaction between bodies, landscapes, skies and histories, in a broken place that deserves better.

A broken place that makes me realise the artistic energy captured in this book – thinking about the rest of the world, trying to figure out how New Zealand fits within it, trying to make things that speak to us and to the global conversations we want to be part of – has its roots in something deeper, and older, and more complicated than we often give it credit for.

Shane Cotton is from here. Ralph Hotere too. The severed heads that were sent overseas, many of them from here, are starting to find their way home. So are the bones of Pompallier, which were brought back by a hīkoi that included several local kuia and kaumātua, so they could be interred in a Hokianga church. They were exhumed in Paris – where Fiona Pardington found the casts of her ancestors' heads. The Hokianga is also just a short trip, as the crow flies, up the west coast from Millar's house at Anawhata; the place that stopped her going crazy, and where the wind and weather matched her. Barrie Bates's family, Croats, would have had connections here too.

It is a place to have conversations about how New Zealand's nineteenth-century legacies continue to haunt us in the age of Snowden, where even these creaking villas in the jungle are connected and surveilled. It is a place where the failures of colonialism *and* capitalism are visible in the boarded-up windows, worn-down pubs, empty stores and degraded lives. It is a place to examine the strange contingencies of our need for faith, or at least for something spiritual – for some connection between our outer and inner worlds. And it is a place, above all, to understand how our histories of violence, personal and collective – accidents of birth, murders, bombs dropped from planes, beheadings, the exploitation of labour, the digital invasions of our privacy, the propagation of immigrant fear – are the forces that shape our lives: the forces that so much of our best art springs from and kicks against.

It is the place where this all started.

List of Illustrations

Pages 76–77: Shane Cotton, installation view of 'The Haymaker Series I–V', 2012. Acrylic on linen, five panels, each 2200 x 1800 mm, overall dimensions 2200 x 9000 mm. Collections of Christchurch Art Gallery Te Puna o Waiwhetu and Dunedin Public Art Gallery (with funding from Dunedin Public Art Gallery Society); image courtesy of the artist and Michael Lett. Photograph by Alex North.

Page 80: Fiona Pardington, *Moonlight de Sade*, 2010. C-type photograph, size variable. With thanks to the Musée de l'Homme (Muséum National d'Histoire Naturelle), Paris, France. Courtesy of the artist and Starkwhite, Auckland.

Page 86: Billy Apple with *B.E.A Flight over East Berlin* in London, 1961. Courtesy of the Billy Apple® Archive. Photograph by Frank Apthorp.

Page 93: Billy Apple with *Neon Floor #1* at APPLE, 161 West 23rd Street, New York, 1969. Courtesy of the Billy Apple® Archive.

Page 99: Photograph of Billy Apple removing *Body Activities* (1970–73), Serpentine Gallery, London, 1974, which became part of the new work *'A Requested Subtraction', 10/4/74*. Courtesy of the Billy Apple® Archive.

Pages 102–103: Becky Nunes, Interior of Billy Apple's house with kitchen table, 2016.

Pages 106–107: Billy Apple in his warehouse looking at a self-portrait from 1969 (photograph by Ira Mazer), Auckland, 2011. Courtesy of the Billy Apple® Archive. Photograph by Mary Morrison.

Page 109 (top): Billy Apple with Craig Hilton at the University of Auckland's School of Biological Sciences laboratory, 22 December 2009. Courtesy of the Billy Apple® Archive. Photograph by Mary Morrison.

Page 109 (bottom): *The Immortalisation of Billy Apple® (Stage 1): Incubator*, 2010. Courtesy of Craig Hilton and Starkwhite. Photograph by Jennifer French.

Page 112: Steve Carr, still from *American Night*, 2014. Single-channel video, duration fifteen minutes (looped). Courtesy of the artist and Michael Lett.

Pages 116–117: Steve Carr, installation view of *Transpiration*, Dunedin Public Art Gallery, 2014. Six-channel video, duration fifteen minutes (endless loop). Courtesy of the artist, Michael Lett and the Dunedin Public Art Gallery. Photograph by Max Bellamy.

Page 122: Peter Robinson, installation view of *Gravitas Lite*, Cockatoo Island, at the eighteenth Biennale of Sydney, 2012. Polystyrene, dimensions variable. Courtesy of the artist and Hopkinson Mossman. Photograph by Sebastian Kriete.

Page 130: Donald Judd, *100 untitled works in mill aluminum*, 1982–86. © Judd Foundation/VAGA, licensed by Viscopy, 2016.

Page 133: Dan Flavin, *Untitled (Marfa project)*, 1996. © Dan Flavin/ARS, licensed by Viscopy, 2016.

Pages 136–137: Peter Robinson, *Ruses & Legacies*, 2013. Mixed media, dimensions variable. Courtesy of the artist and Hopkinson Mossman. Photograph by Servet Dilber.

Page 141: Uriel Sinai, 'Unrest Continues in Turkey with Anti Government Protests', 2013, Getty Images.

Pages 146–147 and 150: Peter Robinson, installation views of *If You Were To Work Here: The Mood in the Museum*, Auckland War Memorial Museum, 2013. Felt-covered wooden dowel rods. Commissioned by the Auckland Art Gallery Toi o Tāmaki on the occasion of the fifth Auckland Triennial, 2013. Courtesy of the artist, Auckland Art Gallery Toi o Tāmaki and Hopkinson Mossman. Photographs by Jennifer French.

Page 154–155: Shannon Te Ao, still from *two shoots that stretch far out*, 2013–14, single-channel video, duration 13.46 minutes. Courtesy of the artist and Robert Heald Gallery, Wellington.

Page 160: Becky Nunes, Judy Millar's studio, Henderson, Auckland, 2015.

Pages 164–165: Judy Millar, installation view of *Space Work 7*, Adam Art Gallery, Wellington, 2014. Mixed media, 20 m x 2600 mm. Courtesy of the artist and Adam Art Gallery. Photograph by Shaun Waugh.

Pages 170–171: Becky Nunes, Judy Millar's Anawhata studio, 2015.

Page 174: Judy Millar, *Call Me Snake*, commissioned as part of 'Scape 8: New Intimacies', Christchurch, 2015. Wood, steel frame and digital print, 9 x 7 x 6 m. Photograph by Judy Millar.

Page 179: Judy Millar, *Proof of Heaven II*, 2014. Acrylic and oil on canvas, 1400 x 950 mm.

Page 183: Judy Millar, two installation views of 'The Model World', Te Uru Waitakere Contemporary Gallery, Titirangi, 2015. Courtesy of the artist and Te Uru Waitakere Contemporary Gallery. Top photograph by Jennifer French; bottom photograph by Simon Devitt.

Pages 186 and 189: Ruth Buchanan, page spreads from *The weather, a building*, 2012, published by Sternberg Press and co-designed by David Bennewith and Ruth Buchanan. Courtesy of the artists and Sternberg Press.

Page 192: Simon Denny, installation view of 'Secret Power', at the 56th International Art Exhibition of La Biennale di Venezia, 2015. Courtesy of the artist and Michael Lett. Photograph by Michele Crosera.

Pages 198, 200–201 and 206–207: Simon Denny, installation views of 'The Personal Effects of Kim Dotcom', 2013, Adam Art Gallery, Wellington, 2014. Courtesy of the artist, Adam Art Gallery and Michael Lett. Photographs by Shaun Waugh.

Page 212: Hito Steyerl, installation view of *Factory of the Sun*, German Pavilion, La Biennale di Venezia, 2015. Single-channel HD video in architectural environment, duration 23 minutes. Courtesy of the artist, Andrew Kreps Gallery, New York, and KOW, Berlin. Photograph by Manuel Reinartz.

Pages 216–217, 220 and 223: Simon Denny, installation views of 'Secret Power', 2015. Courtesy of the artist and Michael Lett. Photographs by Jens Ziehe.

Page 224: Becky Nunes, *Hokianga Harbour*, 2016.

The day after 9/11, I was sitting in the Artspace offices with then director Robert Leonard. I was twenty-two and an intern, charged with sorting the gallery's archives, which would become the basis of my master's thesis in art history. There was often a TV on in the background and that day it was replaying the planes hitting the towers, over and over.

Much of my relationship with contemporary art is connected to that time in late 2001. I was completing my master's degree; New Zealand was at Venice for the first time; Artspace and the Govett-Brewster Art Gallery were actively pushing internationally focused programmes; I had published my first article in a 'real' magazine, *Art New Zealand*. With 9/11, the affective quality of images and artworks – not just what was in them but how they could, in the moment of encounter, alter how we think and feel about the world – gained a new, heightened importance for me; a cultural urgency that offered a path out of the dryness of late postmodernism. This book, I've now realised, reflects that transformation in my thinking.

As I hope is clear, I've tried to allow as much as possible of this book to be shaped by my conversations with artists, the time I spent with their work, and the time I spent on the road thinking about both. This is also why I decided to keep references to a minimum. It was important for me that I keep readers in the room, without the distraction of having to match a number in the text to a footnote somewhere else.

That said, I want to acknowledge the writers and texts that have influenced my thinking throughout the writing of this book.

This influence is most obvious in terms of how the moment of encounter with an artwork is processed, rather than in the specific content of the chapters themselves. The books and essays that have had the most impact on me in this regard are:

Alpers, Svetlana, *Roof Life*, Yale University Press, New Haven and London, 2013.

Bennett, Jill, *Practical Aesthetics: Events, Affects and Art after 9/11*, IB Tauris, London and New York, 2012.

Joselit, David, *After Art*, Princeton University Press, Princeton and Oxford, 2013.

Malcolm, Janet, *Forty-One False Starts: Essays on Artists and Writers*, Farrar, Strauss and Giroux, New York, 2013.

Nelson, Maggie, *The Art of Cruelty: A Reckoning*, WW Norton, New York, 2011.

Solnit, Rebecca, *River of Shadows: Eadweard Muybridge and the Technological Wild West*, Penguin, New York, 2003.

Sontag, Susan, *Regarding the Pain of Others*, Picador, New York, 2004.

Steyerl, Hito, 'In Defense of the Poor Image', *e-flux*, journal 10, November 2009, www.e-flux.com/journal/in-defense-of-the-poor-image/

A number of texts have either influenced my arguments about the infrastructure of the contemporary art world, or been arguments about the art world that I've felt the need to agitate against. These include:

Foster, Hal, *Bad New Days: Art, Criticism, Emergency*, Verso, London, 2015.
Fox, Dan, *Pretentiousness: Why it Matters*, Fitzcarraldo Editions, London, 2016.
Lee, Pamela M, *Forgetting the Art World*, MIT Press, Cambridge, 2012.
Obrist, Hans Ulrich, *Ways of Curating*, Allen Lane, London, 2014.
Serota, Nicholas, *Experience or Interpretation: The Dilemma of Museums of Modern Art*, Thames & Hudson, London, 1996.
Thornton, Sarah, *Seven Days in the Art World*, WW Norton, New York, 2008.

Locally, two texts, which don't make for an obvious pairing, have been essential in my approach to encountering contemporary New Zealand art. They are Martin Edmond's *Dark Night: Walking with McCahon* (Auckland University Press, Auckland, 2011) and Robert Leonard's *Nostalgia for Intimacy: The Gordon H. Brown Lecture 10* (Art History, Victoria University of Wellington, Wellington, 2012).

Leonard's text is part of his larger art-history-cum-exhibition project, in which he is examining the dramatic changes in New Zealand art during his own professional life. In it, he tracks the shift from '. . . a very intimate (enclosed, inward-looking) discourse to being a not-so-intimate (porous, outward-looking) one', writing that:

Obviously, on an immediate and individual level, intimacy will never go away However, intimacy is no longer a defining or distinguishing condition of New Zealand art. The internationalists got what they wanted. We are now part of the wider art world. Our problem now is that that world is so huge we are completely swamped by it – our efforts dissipated. Our artists and curators face a new set of problems.

I don't subscribe fully to Leonard's formulation. But grappling with his thesis has played a vital role in developing my own 'intimacy' with the art and artists in this book.

Edmond's text is a brilliant, semi-imagined account of what happened to Colin McCahon when he went missing in Sydney just before a major exhibition. As a piece of speculative non-fiction, it is also, I think, a great example of art writing, one unconfined by the orthodoxies of local art history, which instead builds an empathetic portrait of an artist based on biographical fragments, psychogeography and intense encounters with McCahon's paintings.

The following sections give details about the key writers and other background sources I've made use of for each chapter.

Clammy Pipes, and Other Monsters

Yvonne Todd is a rare thing in contemporary New Zealand art: an artist about whom, over many years, there has been a great deal of very good critical writing. Much of this is collected in the archive section of *Creamy Psychology: Yvonne Todd*, edited by Robert Leonard (Victoria University Press, Wellington, 2014). The book also includes several new essays. My contribution, titled 'Sons and Lovers', about Todd's Gilbert Melrose works, was the starting point for this chapter, in which I first outlined my thoughts about monstrosity and self-portraiture in Todd's practice. Other writers collected in *Creamy Psychology* have discussed related issues at length – especially the suburban, the Gothic, and the Freudian in Todd's photographs. Most notable among them are Leonard, Misha Kavka, Justin Clemens and Megan Dunn.

Binelli, Mark, *Detroit City Is the Place To Be*, Picador, New York, 2012.

Dunn, Megan, 'Seagulls Kipling: Megan Dunn interviews Yvonne Todd', *Circuit: Artist Film and Video Aotearoa New Zealand*, 31 January 2014, www.circuit.org. nz/blog/seagulls-kipling-megan-dunn-interviews-yvonne-todd

Herrick, Linda, 'Yvonne Todd wins $50,000 Walters art prize', *New Zealand Herald*, 17 July 2002, www.nzherald.co.nz/lifestyle/news/article. cfm?c_id=6&objectid=2098032

Latour, Bruno, 'Love Your Monsters: Why We Must Care for Our Technologies as We Do Our Children', *The Breakthrough Journal*, Winter 2012, http://thebreak-through.org/index.php/journal/past-issues/issue-2/love-your-monsters

Sontag, Susan, *On Photography*, Penguin, London, 2008.

Todd, Yvonne and Serena Bentley, *Wall of Seahorsel: Yvonne Todd*, Centre for Contemporary Photography, Melbourne, 2011.

Luke Willis Thompson/Kalisolaite 'Uhila, The Walters Prize 2014

Cleland, Stephen (ed.), *The Walters Prize 2014*, Auckland Art Gallery, Auckland, 2014.

Hamilton, Scott, 'The Artist as Haua', EyeContact, 14 October 2014, http://eye-contactsite.com/2014/10/the-artist-as-haua

Tonga, Nina, 'Roaming All Levels', *Off the Wall*, no. 6, August 2014, www.arts.tepapa. govt.nz/off-the-wall/7959/roaming-all-levels

Death in Palmerston North

Here I need to acknowledge the transformative effect the exhibition 'The Hanging Sky', and the writing that accompanied it (collected in the book of the same title, published by Christchurch Art Gallery in 2013), had on me. But in writing this chapter I also

wanted to develop some of the arguments the show and book put forward, and to take them in alternative directions.

In the book, Justin Paton provides a close reading of Cotton's recent work, based on several encounters with his paintings. Robert Leonard explores the relationship between Cotton's deployment of surrealist techniques and toi moko. And Geraldine Kirrihi Barlow writes about her personal connection, as someone affiliated with Ngāpuhi, with the heads themselves, and how that affects her experience of Cotton's paintings of them.

Borchardt-Hume, Achim, *Rothko: The Late Series*, Tate Publishing, London, 2008.

Curnow, Wystan, '"Te Maori" and the Politics of Taonga' in *The Critic's Part: Wystan Curnow Art Writings 1971–2013*, Christina Barton and Robert Leonard (eds), with Thomasin Sleigh, Adam Art Gallery Te Pātaka Toi, IMA Brisbane and Victoria University Press, Wellington and Brisbane, 2014.

Gilbert, Jarrod, *Patched: The History of Gangs in New Zealand*, Auckland University Press, Auckland, 2013.

Hickey, Dave, 'Coping with Paradise' in *Pirates and Farmers*, Ridinghouse, London, 2013.

McCarthy, Cormac, *Blood Meridian or, The Evening Redness in the West*, Picador, London, 1989.

Panoho, Rangihiroa, *Māori Art: History, Architecture, Landscape and Theory*, Bateman, Auckland, 2015.

Robley, Horatio Gordon, *Moko, or Maori Tattooing*, Chapman & Hall, London, 1896 (unabridged facsimile by Elibron Classics, 2004).

Rubin, William (ed.), *'Primitivism' in 20th Century Art: Affinity of the Tribal and the Modern*, Museum of Modern Art, New York, 1984.

Smart, Pamela G, *Sacred Modern: Faith, Activism and Aesthetics in the Menil Collection*, University of Texas Press, Austin, 2010.

Strongman, Lara (ed.), *Shane Cotton*, Victoria University Press, Wellington, 2003.

Fiona Pardington, *Moonlight de Sade*

Baker, Kriselle and Aaron Lister, *Fiona Pardington: A Beautiful Hesitation*, Victoria University Press, Wellington, 2016.

Baker, Kriselle and Elizabeth Rankin (eds), *The Pressure of Sunlight Falling*, Otago University Press, Dunedin, 2011.

Sade, Marquis de, *Philosophy in the Boudoir*, Penguin, New York, 2006.

Live Forever

When it comes to Billy Apple scholarship, Christina Barton has done more than any other art historian to understand the significance of Apple's practice in the context not just of New Zealand, but in late twentieth century art. She was the curator of his Auckland Art Gallery retrospective and has also written numerous books and exhibition catalogues about him, including *Billy Apple®: A Life in Parts* (Auckland Art Gallery Toi o Tāmaki, Auckland, 2015); *Billy Apple®: British and American Works 1960–69* (The Mayor Gallery, London, 2010); and *The Expatriates: Frances Hodgkins and Barrie Bates* (Adam Art Gallery Te Pātaka Toi, Wellington, 2005).

I've tried to complement Barton's deep, rigorous and career-defining art historical project with a more journalistic portrait of the man behind the work; something I hope will help a wide audience understand the human complexity at the heart of his practice.

Curnow, Wystan, 'Working with Billy Apple' and 'Billy Apple: As Good as Gold' in *The Critic's Part: Wystan Curnow Art Writings 1971–2013*, Christina Barton and Robert Leonard (eds), with Thomasin Sleigh, Adam Art Gallery Te Pātaka Toi, IMA Brisbane and Victoria University Press, Wellington and Brisbane, 2014.

Gray, Zoe, Nicolaus Schafhausen and Monica Szewczyk (eds), *Billy Apple®: Source Book 7/2009*, Witte de With Center for Contemporary Art, Rotterdam, 2009.

Quin, Ann, *Berg: A Novel*, Dalkey Archive Press, Champaign, Illinois, 2001.

Steve Carr, *Transpiration*

Hyde, Lewis, *Trickster Makes This World: How Disruptive Imagination Creates Culture*, Canongate, London, 2008.

Scattered Pieces

For an artist who has achieved so much international attention in recent years, it's surprising to find so little new writing about Peter Robinson. Artspace's current director Misal Adnan Yildiz did, however, publish a short interview with Robinson to accompany his exhibition *SYNTAX* (Misal Adnan Yildiz, 'An Interview with Peter Robinson', Artspace, Auckland, 2015, http://artspace.org.nz/doclibrary/public/syntax-brochure-final.pdf). In that, Robinson and Yildiz talk about several of the projects I also discuss in this chapter, including his installations in Istanbul and Paris. In his questions, Yildiz draws a distinction between the 'identity politics' of Robinson's earlier installations and the way his current work seems to deal 'with trans-national borders, post-gender society and neo-liberal policies' – themes I also pick up with Robinson.

Burke, Gregory (ed.), *Bi-Polar: Jacqueline Fraser and Peter Robinson*, Creative New Zealand Toi Aotearoa, Wellington, 2001.

Butler, Brian D (ed.), *Peter Robinson: Ack and Other Abdications*, Clouds, Auckland, 2011.

Devenport, Rhana (ed.), *Peter Robinson: Snow Ball Blind Time*, Govett-Brewster Art Gallery, New Plymouth, 2010.

Stockebrand, Marianne, 'The Making of Two Works: Donald Judd's Installations at the Chinati Foundation', *Chinati Newsletter*, vol. 4, 2004, www.chinati.org/pdf/making2works.pdf

Thorne, Sam, '13th Istanbul Biennial', *frieze*, no. 159, November–December 2013, www.frieze.com/article/13th-istanbul-biennial

Parallel Worlds

This chapter draws on several pieces of writing developed over many years, which go all the way back to a small book I made with Judy Millar in 2003, *Judy Millar: How to Paint Backwards*, published by Gow Langsford and John Leech galleries.

Bjerkhof, Sven, *Asger Jorn: Restless Rebel*, Prestel Verlag, Munich, 2014.

Christov-Bakargiev, Carolyn (ed.), *Arte Povera*, Phaidon, London, 2005.

Emmerling, Leonhard (ed.), *Judy Millar: You You, Me Me*, Kerber Verlag, Bielefeld, 2009.

Gross, Jennifer, *Giraffe-Bottle-Gun: Judy Millar*, Kerber Verlag, Bielefeld, 2009.

Ruth Buchanan, *The weather, a building*

Verwoert, Jan, 'In Focus: Ruth Buchanan', *frieze*, no. 152, January–February 2013, http://friezenewyork.com/article/focus-ruth-buchanan?language=en

No Place to Hide

Simon Denny has had a great deal written about his work in recent years, with a particular flurry of publishing in the lead-up to the 56th Venice Biennale. Most notable amongst the various essays is Travis Jeppesen's 'Data Mine' (*frieze*, no. 171, pp. 178–183), in which the author explores the role of political ambivalence in Denny's recent installations. Chris Kraus also wrote an excellent essay, 'Here Begins the Dark Sea', for the large book that accompanied Denny's Venice exhibition (*Simon Denny: Secret Power*, edited by Mary Barr and Robert Leonard, Mousse Publishing, Milan and Koenig Books, London, 2015). In this she discusses the relationship between Denny's and Nicky Hager's work, alludes to Edward Snowden's time in Sheremetyevo International

Airport, and describes Denny turning an 'anthropologist's eye to the NSA's corporate culture'.

The chapter's title has been taken directly from Glenn Greenwald's *No Place to Hide: Edward Snowden, the NSA and the Surveillance State* (Hamish Hamilton, London, 2014).

Alloway, Lawrence, *The Venice Biennale 1895–1968: From Salon to Goldfish Bowl*, New York Graphic Society, Greenwich, 1968.

Cox, Geoffrey, *The Race for Trieste*, William Kimber & Co., London, 1977.

Curnow, Wystan, 'The Coatesville Debacle: Simon Denny Assays The Personal Effects of Kim Dotcom', *Art New Zealand* 153, pp. 51–55.

Enwezor, Okwui and Michelle Kuo, 'Global Entry: Okwui Enwezor talks to Michelle Kuo about the 56th Venice Biennale', *Artforum International*, vol. 53, no. 9, May 2015, pp. 85–90.

Gibson, William, *Pattern Recognition*, Penguin, London, 2003.

Oliver, Henry, 'The Art of Success', *Metro*, no. 388, November 2014, pp. 58–65.

Proctor, Jacob, '1000 Words: Simon Denny', *Artforum International*, vol. 53, no. 9, May 2015, pp. 338–341.

Steyerl, Hito and Laura Poitras, 'Techniques of the Observer: Hito Steyerl and Laura Poitras in Conversation', *Artforum International*, vol. 53, no. 9, May 2015, pp. 307–317.

Acknowledgements

I first began talking to Sam Elworthy from Auckland University Press in late 2013, when I was Critical Studies Fellow at Cranbrook Academy of Art in Michigan. Sam had read an article I'd written about Shane Cotton in the *New Zealand Listener* and was interested in seeing if we might find a way to work together on something longer. Since that first Skype conversation, Sam and his team – especially Anna Hodge and Katrina Duncan – have been tireless supporters of this book and collaborators in making it what it is. Tara McDowell, Linda Tyler, Lara Strongman, Rebecca Lal and Marie Shannon also gave generous, intelligent feedback at various points in the book's evolution, which was so very much needed, and so warmly received.

Tina Barton and Robert Leonard are important figures throughout this book, both for their curating and their writing. Over the years, they have also, for me, variously been influences, mentors, collaborators, sounding boards and friends. Without the rigour, ambition and energy they bring to their own work, I'm not sure I ever would have developed my own enthusiasms for contemporary New Zealand art to the same degree. Thank you, both.

To paraphrase Billy Apple, critics have to live like everybody else. During the time it's taken me to write this, I've been making my living writing and publishing regularly – particularly for Auckland's *Metro*. With the support and at times necessary brutality of my remarkable editor there, Simon Wilson, I was able to use the magazine as a space to test ideas and develop new ways of discussing contemporary art, which have been much expanded here.

It was inevitable that some of that work would find its way into this book. It opens, for example, in Berlin on May Day – a crucial moment in the development of my thinking about this project – which I wrote about in *Metro* in July 2015, as part of an extended review of Simon Denny's 'Secret Power' at the 56th Venice Biennale. Other elements of that article are reproduced throughout the prologue and in the chapter dedicated to Denny. Similarly, the chapter on Billy Apple is an adapted version of a feature I wrote for *Metro* in April 2015. Without Simon's critical feedback and guidance, those pieces would never have evolved into what they now are.

In late 2014, Victoria University Press, in association with City Gallery Wellington, published an excellent book on Yvonne Todd's work, titled *Creamy Psychology*. Robert Leonard, who is City Gallery's senior curator, asked me to write about Todd's 'Gilbert Melrose' works for it. Aspects of that essay are reproduced in the chapter on Todd. Huge thanks to Robert and to Fergus Barrowman at VUP, for the opportunity to write about that body of work, which laid the foundations for the extended discussion of Todd's practice here. The encounter with Steve Carr's *Transpiration* has been adapted from an

essay published in the Winter 2014 issue of *Art New Zealand*. *Art New Zealand* was the first magazine I ever wrote for, and in the intervening years, since 2001, editor William Dart has been an unwavering supporter of my work, for which I'm most grateful.

The artists discussed in this book could just as easily have said they didn't want to be involved. Instead, they made themselves available time and again for what must have seemed an endless series of conversations and emails. There is no book without you. Thank you all. Thanks also to their representatives, for help in securing high-quality images of their work. And special thanks to Becky Nunes, a truly remarkable photographer whose studio shots, when I first saw them, made me think about the book's potential in entirely different ways.

Thanks to Creative New Zealand for the financial support we writers desperately need, and are so happy to get. To the faculty of Cranbrook Academy of Art for the thinking time you gave me, for your friendship and for helping me fall in love with Detroit. To the friends in London, Berlin, Copenhagen and Sydney for putting me up, and for putting up with me – a hospitality that didn't just make this whole enterprise affordable, but has, at times, found its way into the book.

To my parents, Neville and Lexie, for surviving everything, and for not blinking when I told you I was leaving law school to look at pictures instead.

And finally, to Kyra and James. Everything, to Kyra and James.

Anthony Byrt, June 2016

First published 2016

Auckland University Press
University of Auckland
Private Bag 92019
Auckland 1142
New Zealand
www.press.auckland.ac.nz

© Anthony Byrt, 2016

ISBN 978 1 86940 858 9

Publication is kindly assisted by

ARTS COUNCIL OF NEW ZEALAND TOI AOTEAROA

A catalogue record for this book is available from
the National Library of New Zealand

Cover image: Shannon Te Ao, still from *two shoots that stretch far out*, 2013–14.
Courtesy of the artist and Robert Heald Gallery, Wellington.
Cover design by Kalee Jackson
Book design by Katrina Duncan

This book was printed on FSC® certified paper

Printed in China by 1010 Printing International Ltd